Apple Pro Training Series

Aperture 2

Ben Long / Richard Harrington / Orlando Luna

Apple
Certified

Apple Pro Training Series: Aperture 2
Ben Long, Richard Harrington, Orlando Luna
Copyright © 2008 by Ben Long, Richard Harrington, Orlando Luna

Published by Peachpit Press. For information on Peachpit Press books, contact:

Peachpit Press
1249 Eighth Street
Berkeley, CA 94710
(510) 524-2178 or (800) 283-9444
Fax: (510) 524-2221
http://www.peachpit.com
To report errors, please send a note to errata@peachpit.com.
Peachpit Press is a division of Pearson Education.

Apple Series Editor: Serena Herr
Editor: Stephen Nathans-Kelly
Production Coordinator: Laurie Stewart, Happenstance Type-O-Rama
Contributing Writer: Michael Cohen
Technical Editor: Charlie Miller
Technical Reviewers: Joseph Schorr, Patti Schulze
Copy Editor: Dave Awl
Compositor: Chris Gillespie, Happenstance Type-O-Rama
Indexer: Jack Lewis
Media Production: Eric Geoffroy
Cover Illustration: Kent Oberheu
Cover Production: Chris Gillespie, Happenstance Type-O-Rama

ISBN 0-321-53993-1
9 8 7 6 5 4 3
Printed and bound in the United States of America

Contents at a Glance

Table of Contents

Image Editing

Getting Started

Welcome to the official Apple Pro training course for Aperture, Apple's all-in-one post-production tool for photographers. This book is a comprehensive guide to Aperture. It uses a variety of real-world photography projects to show the many uses of the application.

Whether you're a professional photographer, someone who uses photographs in your work, or just someone who is passionate about photography, Aperture's RAW workflow, powerful image organization tools, and flexible editing tools give you more control and greater efficiency than ever before.

And it doesn't matter whether you're a seasoned guru or a beginner in digital shooting: Aperture will help you create beautiful prints and engaging websites. So let's get started.

The Methodology

This book takes a hands-on approach to learning Aperture. The lessons are designed to take you through a real-world workflow of importing, organizing, rating, editing, exporting, printing, publishing, and archiving your images, and performing all the other tasks associated with a photo shoot. The projects represent a cross-section of specialty photography genres and types of shoots. Whether or not your type of photography is specifically featured, you'll find that the techniques taught here can be applied to any type of photography.

Aperture has an extensive list of keyboard shortcuts and a variety of ways to navigate through its interface and menus. We focus on the most common keyboard shortcuts you can use to increase your efficiency, and on the interface views and navigation schemes that are most effective in a professional setting. Aperture's Help menu includes a comprehensive list of keyboard shortcuts, and a handy printed card of keyboard shortcuts comes in the product box.

Course Structure

This book is designed to teach you to use Aperture in the context of a professional workflow, using 12 project-based, step-by-step lessons and accompanying media files. It is divided into three sections, as follows:

Importing and Organizing

Lessons 1–3 focus on importing and image management. After a tour of the interface, you'll learn to import, sort, compare, and rate images quickly and efficiently; apply keywords and metadata; search your archive efficiently; organize images into folders and projects for different intended uses; and archive images in a way that's easy, secure, and intuitive.

Image Editing

Lessons 4–8 start out with the basics of image editing and move on to Aperture's more advanced image-processing features. You'll learn to make basic adjustments—such as exposure, white balance, cropping, and straightening—and then move on to RAW-specific adjustments, tonal correction, color correction, and finally enhancements such as retouching, cloning, sharpening, noise reduction, and applying filters for specific effects.

Printing and Publishing

Lessons 9–12 focus on the final stage of any workflow: creating the final product. You'll learn to deliver your images for client review in everything from printed contact sheets to compelling web galleries and slide shows, and to deliver your final images as exported images, custom photo books, or prints.

Lesson 11 focuses on showcasing and promoting your work, with special sections on creating a dynamic web portfolio, Keynote presentation, podcast, and a custom leave-behind flip book to show off your work, as well as sections on how to access your portfolio from your iPhone, iPod Touch, or Apple TV.

Finally, Lesson 12 and Appendix A tackle some advanced topics such as automating and scripting workflows, tethered shooting, and advanced image management—such as moving your image archive back and forth between your laptop and your desktop computer. Appendix B explores ways you can integrate Aperture with iPhoto and the advantages of migrating images from your iPhoto library into Aperture.

System Requirements

Aperture leverages the Core Image layer in Mac OS X and your GPU (graphics processing unit) to achieve real-time performance previously not available for RAW files. Applications such as Final Cut Pro are designed to scale from G4-based systems all the way up to fully equipped Mac Pro systems.

Although this is also the case with Aperture, certain hardware is required in order to take advantage of its real-time performance capabilities. In particular, a good graphics card, a Macintosh computer with a dual 2 GHz or faster processor, and a 17-inch monitor or larger are recommended to get optimal performance with Aperture. Minimum and recommended system requirements are constantly evolving as new configurations of hardware and software become available. To check for the latest requirements, go to www.apple.com/aperture/specs.

Before beginning to use *Apple Pro Training Series: Aperture 2*, you should have a working knowledge of your computer and its operating system. Make sure that you know how to use the mouse and standard menus and commands, and also how to open, save, and close files. If you need to review these techniques, see the printed or online documentation included with your system.

Copying the Aperture Lesson Files

To follow along with all the lessons, you'll need to copy the lesson files onto your hard drive. The lesson files are located on the DVD accompanying this book. You'll need approximately 5 GB of free disc space on your hard drive.

1 Insert the *APTS_Aperture2* DVD into your computer's DVD drive.

The Finder window will open, displaying the contents of the DVD. If the window doesn't appear, double-click the *APTS_Aperture2* DVD icon to open it.

2 Double-click the Lessons.dmg file to open and mount the disc image on your desktop. Inside the disc image, you'll find 11 lesson folders.

3 Create a new folder on your hard drive. Name the folder *APTS_Aperture_ book_files*.

The location of this folder is important. You'll be adding lessons and referring to this folder throughout the book.

4 Drag the 11 lesson folders from the disc image into the APTS_Aperture_book_files folder you just created. The files will be copied onto your hard drive.

5 Eject the DVD.

NOTE ▶ The content on this book's DVD is built for Aperture 2. If you're opening an Aperture library created with version 1.0, 1.1, or 1.5, Aperture will inform you that it's updating the library structure and creating previews for version 1.5. Images inside the library may also be migrated to take advantage of the RAW processing functions available in Aperture version 1.5. For information on migrating images, see Aperture's documentation.

Keeping Your Work Environment Neutral

Your work area affects how you judge your images. Your eyes are both your best friend and your worst enemy when it comes to evaluating images. Paint the wall behind your display a bright shade of red, and you've just desensitized your eyes to that hue. Your

brain has a built-in filtering system that constantly compensates for your viewing environment. As a result, if you work in a room painted bright red and manually adjust the color of an image, it will undoubtedly result in unwanted excess red values.

Adjusting Your Work Environment

1 Paint your walls a neutral gray.

2 Purchase daylight-balanced lighting for your work area. These lights are readily available in specialty lighting stores and can replace fluorescent and other types of lighting.

3 Dim the lights so that your display's luminance is brighter than the room.

Okay, you don't have to paint your office to do the lessons in this book, but taking all of these steps will create a work environment that will help you more accurately evaluate the color and quality of your images.

Adjusting Your System Preferences

The look of your default desktop background and interface colors is awe-inspiringly stylish. The experts who created these backgrounds and colors are certainly talented artists. However, when you're making critical color corrections and working with images in postproduction, it pays to be bland. Here's how to adjust your System Preferences to neutralize your workspace.

1 In the Finder, choose System Preferences from the Apple menu.

2 Select Display.

3 Choose your working resolution, and choose Millions from the Colors pop-up menu.

NOTE ▶ If you're using an LCD display, make sure you select the native resolution of that display. Native resolution information can be found in the manufacturer's documentation.

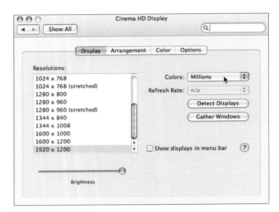

4 Click the Show All button in the upper-left corner of the System Preferences pane.

5 Click the Desktop & Screen Saver icon. If the Screen Saver pane appears, click the Desktop button to view the Desktop pane.

6 Choose Solid Colors from the list at the left. Then, choose the Solid Gray Dark color square.

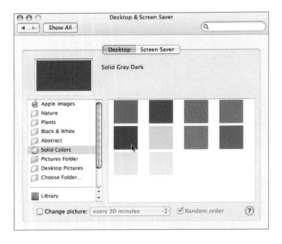

7 Click the Show All button.

8 Choose Appearance.

9 Choose Graphite from the Appearance pop-up menu, and choose Graphite from the Highlight Color pop-up menu.

If you've been using Mac OS X's default setup, you should now notice that your close, minimize, and maximize buttons are gray instead of red, yellow, and green.

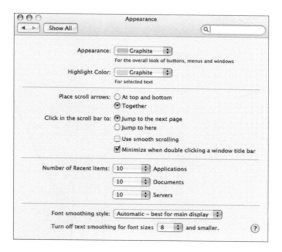

10 Close System Preferences.

Welcome to your new life working in a dark cave.

Calibrating Your Display

One of the most important aspects of managing your photos is achieving predictable color. Mac OS X uses a built-in color-management technology called ColorSync, which uses industry-standard ICC profiles to manage your color across multiple devices. Displays and printers often ship with ICC profiles that can be installed along with their drivers. These generic profiles are a good starting point, but in order to implement an advanced color-management workflow, all of the devices in your production loop should be calibrated with instruments such as colorimeters and spectrophotometers. Colorimeters are used to measure color values on LCD or CRT displays; spectrophotometers measure the wavelength of light across the visible spectrum of colors and can be used to profile both displays and printers.

Unfortunately, it's beyond the scope of this book to walk through the process of color calibrating your display, input devices, and output devices. But you should know that it's an important part of setting up any digital darkroom. For more information on color calibration, see the Apple Pro Training Series book *Color Management in Mac OS X: A Practical Approach*, by Joshua Weisberg.

About the Apple Pro Training Series

Apple Pro Training Series: Aperture 2 is part of the official training series for Apple Pro applications, developed by experts in the field and certified by Apple Computer. The lessons are designed to let you learn at your own pace. If you're new to Aperture, you'll learn the fundamental concepts and features you'll need to master the program. Although each lesson provides step-by-step instructions for making specific changes to your Aperture library, there's plenty of room for exploration and experimentation.

For those who prefer to learn in an instructor-led setting, Apple also offers training courses at Apple Authorized Training Centers worldwide. These courses, which use the Apple Training Series books as their curriculum, are taught by Apple Certified Trainers and balance concepts and lectures with hands-on labs and exercises. Apple Authorized Training Centers have been carefully selected and have met Apple's highest standards in all areas, including facilities, instructors, course delivery, and infrastructure. The goal of the program is to offer Apple customers, from beginners to the most seasoned professionals, the highest-quality training experience.

To find an Authorized Training Center near you, go to www.apple.com/software/pro/training.

For a complete catalog of Apple Pro Training Series titles, visit www.peachpit.com/applepro.

Apple Pro Certification Program

The Apple Pro Training and Certification Programs are designed to keep you at the forefront of Apple's digital media technology while giving you a competitive edge in today's ever-changing job market. Whether you're a photographer, digital technician, photographer's assistant, studio manager, or stock photo manager, these training tools are meant to help expand your skills.

Upon completing the course material in this book, you can become Apple Pro certified by taking the certification exam at an Apple Authorized Training Center. Certification is offered in Final Cut Pro, Final Cut Server, Color, DVD Studio Pro, Logic Pro, Motion, Soundtrack Pro, and Shake. Apple Pro Certification gives you official recognition of your knowledge of Apple's professional applications while allowing you to market yourself to employers and clients as a skilled, professional-level user of Apple products.

To find an Authorized Training Center near you, go to www.apple.com/software/pro/training.

Companion Web Page

As Aperture 2 is updated, Peachpit may choose to update lessons or post additional exercises as necessary on this book's companion web page. Please check www.peachpit.com/title/0321539931 for revised lessons or additional information.

Resources

Apple Pro Training Series: Aperture 2 is not intended as a comprehensive reference manual, nor does it replace the documentation that comes with the application. For comprehensive information about the program features, refer to these resources:

User Manual: Accessed through the Aperture Help menu, the *User Manual* contains a complete description of all features.

Aperture product website: www.apple.com/aperture.

Importing and Organizing

1

Lesson Files APTS_Aperture_book_files > Lessons > Lesson 01 > Memory_Card.dmg

Time This lesson takes approximately 60 minutes to complete.

Goals Open Aperture

Import RAW images from a memory card

Add metadata to images

Apply ratings to images

Perform nondestructive image adjustments

Export versions of images

Lesson 1
Exploring the Aperture Workflow

Apple Aperture is an all-in-one post-production tool designed for photographers. It provides the essential tools photographers need after a photo shoot. Using Aperture, you can easily import, organize, and edit your photos. Aperture also makes it easy to publish, export, and archive your images effectively and efficiently.

The best way to appreciate the efficiency of the Aperture workflow is to simply get started. In this lesson, you'll import some RAW images into Aperture, organize the images, perform basic edits, and output Aperture-enhanced files. This lesson will serve as an introduction to the workflow we'll utilize throughout the book, as you perform essential tasks that we'll explore in greater depth in later lessons.

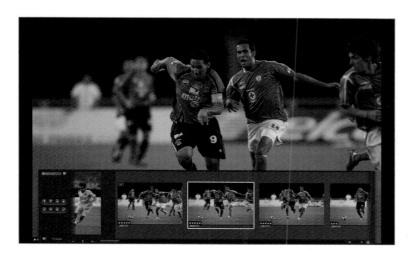

Before opening Aperture, be sure that you've read "Getting Started" on page xiii, that you have the proper system requirements and resources, that you've copied the lesson and project files to your hard disk as instructed, and that you've calibrated your display for optimal color accuracy.

Opening Aperture

There are three ways to open Aperture:

▶ By double-clicking the Aperture application icon

▶ By defining Aperture as your default image application and inserting a camera card or attaching a camera

▶ By clicking the Aperture application icon in the Dock

Let's start by opening Aperture from the Dock.

Adding Aperture to the Dock

You can add Aperture to the Dock as you would any other Mac OS X application.

1 Click the desktop (or the Finder icon in the Dock) to make sure you're in the Finder.

You should see the word Finder next to the Apple logo in the upper-left corner of your screen.

2 Choose Go > Applications or press Shift-Command-A.

The Applications folder opens in a Finder window.

3 Locate Aperture in the Applications window and drag the Aperture application icon to the Dock.

> **NOTE ▶** If you inadvertently release the mouse button outside the Dock, the Aperture icon will be moved to your desktop. If that happens, drag it back to the Applications folder and try again.

4 Close the Applications window.

Launching Aperture

Now that Aperture is loaded in the Dock, you're ready to open Aperture and get to work.

> **NOTE ▶** If you're upgrading from a previous version, during installation Aperture will ask you whether you want to upgrade your library. Once you open a library with Aperture 2.0, you won't be able to move backwards and open it with an earlier version of the software. Be sure to back up your library first if this is an issue.

1 Click the Aperture icon in the Dock to open the application.

When you open Aperture for the first time, the Welcome screen appears.

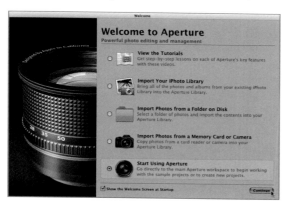

The Welcome screen has five options plus a checkbox. Let's take a look at all of the options before we move on.

▶ **View the Tutorials**—points your web browser to QuickTime movies about Aperture (note that this requires Internet access)

▶ **Import Your iPhoto Library**—allows you to import the existing iPhoto library

▶ **Import Photos from a Folder on Disk**—allows you to import from a variety of media, including hard disks, flash drives, CDs, and DVDs

▶ **Import Photos from a Memory Card or Camera**—looks for a mounted camera or media card to import from

▶ **Start Using Aperture**—opens directly into Aperture

▶ **Show the Welcome Screen at Startup**—allows you to bypass the Welcome screen in future sessions by deselecting this checkbox.

2 Make sure Start Using Aperture is selected, and then click the Continue button in the lower-right corner of the Welcome screen.

Aperture prompts you to set it as the default application for your digital camera.

3 Click the Use Aperture button to select Aperture as the default application for importing images from a connected camera or media card.

NOTE ▶ If you've previously opened Aperture and selected either Use Other or Use Aperture, this screen will not appear. If you aren't sure Aperture has been set as your default image-capture application, do the following when Aperture opens: Choose Aperture > Preferences. In the Preferences window, choose "When a camera is connected, open" > Aperture, if it's not already chosen. Close the Preferences window.

Next, Aperture asks if you'd like to import a sample project. You can import these projects if you'd like extra media to practice with. We'll be importing images from a disk image of a camera memory card, which will simulate the traditional input process.

The Main Window

The Aperture interface changes as you perform certain tasks. For example, when you choose to import photos the Import Pane opens to offer you needed controls. Likewise,

you can easily perform image-editing tasks in a Full Screen view which minimizes the user interface to give you the largest area for adjusting your images.

Let's take a quick look at the main window to get familiar with the Aperture interface.

Toolbar Viewer

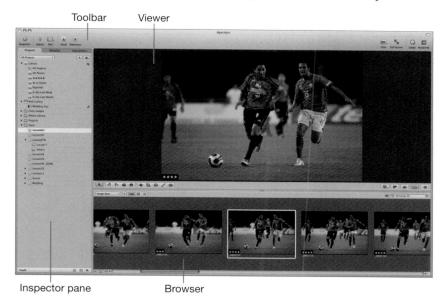

Inspector pane Browser

▶ **Inspector pane**—The Inspector pane consolidates three essential controls. With the Inspector pane you can access projects, adjust metadata, and control image adjustments. Each task is offered by individual inspectors, the Projects inspector, the Metadata inspector, and the Adjustments inspector. To switch inspectors, click the tab at the top of each window.

▶ **Browser**—The Browser displays the thumbnail images for a project or an album. Whenever you select an item in the Projects inspector, images appear in the Browser. You can view images in the Browser in three different ways: in Filmstrip view, in grid view, and in list view.

▶ **Viewer**—When you select one or more images in the Browser, those images appear in the Viewer. The Viewer is a useful area to examine images at a larger size or to compare images side by side.

▶ **Toolbar**—The toolbar offers a collection of buttons and tools and is located at the top of the main window. The toolbar gives you the most commonly needed tools and can be customized to match your needs.

Configuring Your Browser for This Lesson

For the exercises in this lesson, we'll be referencing many of the images in this project by their version name. Therefore, you'll want to be sure your Browser is configured to show version names.

1 Choose View > Metadata > Customize or press Command-J to open the Metadata Preferences window.

2 Make sure the Browser checkbox is selected, and then select the Set 2 radio button to activate the Set 2 option.

3 Choose Grid View – Expanded from the Set 2 pop-up menu. This will display the version name beneath each image.

4 Click the Close button in the upper-left corner to close the Metadata Preferences window.

Importing Images from a Memory Card

The most common source for images you'll import into Aperture will be the memory cards from your digital camera. When you're shooting images on location, it's not uncommon to shoot hundreds or even thousands of images in a day. This is called a high shot-rate shoot. On some high-shot-rate location shoots, the photographer shoots until the camera's memory card is full, and then swaps out the full card for an empty one.

For this exercise, we'll use a disk image based on a media card. This will simulate having a compact flash or SD card loaded into your system.

> **NOTE** ▶ If it's not running already, Aperture will open automatically when a supported camera is connected and your system senses a media card with images.

1 In the Finder, navigate to APTS_Aperture_book_files > Lessons > Lesson 01.

2 Double-click **Memory_Card.dmg** to mount a disk image.

NO NAME

Macintosh HD

The card may take a moment to appear. When it's mounted, you'll see a removable media icon called **NO NAME** on your desktop.

3 Switch back to Aperture.

We can now specify where we'd like the imported images to be stored.

Import Options

In this lesson you'll import from a memory card. Aperture offers several additional ways to import images that we'll explore in a hands-on way throughout the book. Here is a quick overview of the available options.

▶ **Importing from Your Digital Camera or Card Reader**—Lesson 1

▶ **Importing Folders of Images from the Finder**—Lesson 2

▶ **Adding Metadata to Images During Import**—Lesson 3

▶ **Adding Images from one project to Another**—Lesson 3

▶ **Importing Your iPhoto Library**—Lesson 4

▶ **Importing Image Files Stored on Your Computer**—Lesson 5

▶ **Adjusting the Image File's Time When Importing**—Lesson 6

▶ **Transferring Projects from Another System**—Lesson 8

▶ **Shooting with a Camera Tethered**—Lesson 12

Choosing a Destination Project

Aperture uses projects to organize the media you import into the application. Projects are similar to Events in iPhoto, in that they can be used to group several images that are similar. A project can hold dozens, or even thousands, of images.

> **TIP** As your collection of images grows, you'll organize it using a hierarchy of folders, projects, and albums. You can create as many projects as you need, then name them so they're easy to identify and access. When you want to refine your organization further, you can subdivide a project with albums.

Let's open the Import dialog and import some sample images.

1 Choose File > New Project to create an empty project.

A new untitled project is added to the Projects inspector.

2 Name the project *Lesson01*, then press Return.

 🗄 Lesson01

The new project is selected in the Projects inspector. The Projects inspector displays your organizational hierarchy. It can contain projects, albums, folders, books, Web Galleries, and Web Journals.

3 Click the Import button in the toolbar located at the top of the screen to open the Import pane.

4 Click the memory card **NO NAME** to select it.

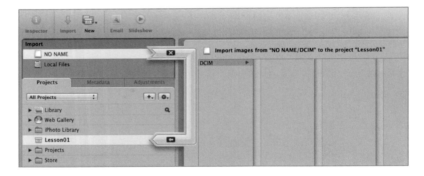

The Import arrow points towards Lesson01, indicating that this is the selected project where the images will be stored.

NOTE ► You can choose to import from your iPhoto library, a tethered camera, a card reader, or a folder on your computer. Aperture supports a wide range of images in their native formats, including the following:

► GIF	► PNG
► DNG	► PSD
► JPEG	► RAW files from a variety of supported digital cameras
► JPEG2000	► TIFF

Working with Aperture's File Structure

Aperture offers flexible ways to store your images. Some users choose to let Aperture manage images in their organized library. Others prefer to simply have the images referenced in the library based on their current location. Which one you pick depends on your needs. Let's explore how Aperture can organize your digital images.

Using the Library

Aperture will use a library to track every project, album, and image, whether the images are stored in the Aperture library file or on another hard disk. When you installed Aperture, it automatically created a library file in your Pictures folder.

Aperture Library

> **NOTE** ► You can easily specify a different location for your Aperture library (such as a bigger hard disk) by opening Aperture's preferences. Simply choose Aperture > Preferences and indicate where you moved the library file or where you'd like the new library stored.

Understanding Masters and Versions

Aperture handles all images in a nondestructive manner. This means your original image is always preserved as a digital *master* file. Any adjustments you make to an image inside of Aperture are performed on a *version* of the original file. The first appearance of an image in Aperture is considered the first version of the image. It's important to understand that although versions appear as images in the Browser and Viewer, and behave like image files in the Projects panel, they are not actually new image files.

Versions are instructions; Aperture uses them to show adjustments made to the master file. Because version files are quite small, you can make countless versions of a full-resolution RAW image without significantly increasing your storage needs. Additionally, you can always return to your untouched master file at any time. This makes it easy to try different adjustments without fear of permanently changing an image.

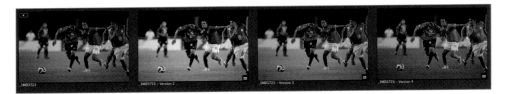

Each Version of the image can be manipulated independently without affecting the Master file.
Versions take up very little space, as they only contain instructions on how to modify the image.

If you make an adjustment to an image, you don't need to rename it or perform a Save As operation. The version you created is saved within your project. Of course, anytime you make an adjustment to a version, you can create a full image file that incorporates the adjustment by simply exporting or printing the version.

Managed Images and Referenced Images

Aperture gives you precise control over how masters are organized on your hard drive. Many users prefer the convenience of a *managed* library approach, which allows the software to keep the library organized. Aperture manages your original images (called *masters*) by ensuring that they're always accessible. Additionally, a managed library provides benefits like one-click backup of masters to vaults.

> **NOTE ▶** Even though images are added to the library, their original file format is preserved. You can also easily remove or extract images from the library if needed.

If you choose to import images to your library, but only want Aperture to link to those images (instead of copying them into your library), then you're using the *referenced* images approach. Using a referenced image approach can be beneficial if you need to incorporate a large existing portfolio of images into your library. The referenced approach allows you to add images from multiple locations (or even drives) without duplicating the files. This way of working lets you save disk space and gives you the flexible option to store less frequently used images offline (such as on an external hard drive that you don't keep connected at all times).

One approach is not inherently better than the other. It's really a matter of personal choice. Using referenced images in your Aperture system offers flexibility. On the other hand, using managed images offers a greater level of convenience by reducing the time spent managing your assets.

Choose a Location for the Imported Images

Now that you understand your library options, let's specify a method for the images added in this lesson. The controls you need are located on the right side of the Import panel.

1 Click the Store Files pop-up menu to see your options.

Aperture lets you specify where the images are copied. You can add images to your managed Aperture library. Additionally, you can target your Pictures folder or a specified folder. If your photos reside on an organized hard drive, you might even choose to leave the images in place. For more information on media management, see Appendix A, "Advanced Media Management for Professionals."

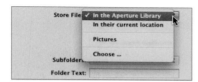

2 For this exercise, choose "In the Aperture Library."

Because these images are on a memory card which in most cases would be erased and reused, we've chosen to add the images directly to the library.

Before adding the images, let's add essential information to the files.

Adding Metadata on Import

As digital images proliferate in your library, the use of metadata becomes essential. By adding appropriate information (aka, tags) to your images, such as copyright, you can increase the likelihood of protecting your photographs and ensuring proper credit.

Aperture makes it easy to add copyright information when you import images. International Press Telecommunications Council data can also be added to your images. IPTC data is often required in the newspaper and press industries for submissions. Again, both copyright and IPTC metadata can be added afterward, but it's more efficient to add it as you import.

1 Choose Add Metadata From > IPTC – Expanded at the right side of the Import dialog.

Aperture adds several metadata input fields.

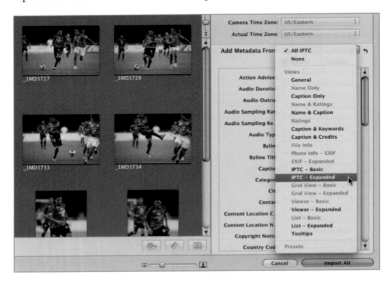

2 Type *John McDermott* in the Credit field.

3 Click the Copyright Notice field.

4 To apply the appropriate symbol, press Option-G, which is the keyboard shortcut for the copyright symbol ©.

> **TIP** The shortcut for the trademark symbol ™ is Option-2, and the shortcut for the registered-trademark symbol ® is Option-R.

5 Type *John McDermott* after the copyright symbol.

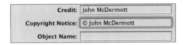

6 Type *Mexico City* in the City field.

7 Type *Mexico* in the Country Name field.

> **NOTE** ▶ There are a number of additional metadata fields in the Import dialog, but most are appropriate only for individually selected images. Any metadata that you add when importing will be applied to all of the images that we import. You can always add metadata after import, which will be covered in Lesson 3.

8 Click the Browser, then press Command-A to select all the images.

9 Click the Import All button in the lower-right corner of the Import dialog.

> **TIP** ▶ To see the status of your import tasks, choose Window > Show Activity. You can watch the progress as Aperture completes its tasks.

> **NOTE** ▶ If the disk image were an actual memory card, Aperture would ask whether you want to erase the imported images from the media card after import. It's better to erase media cards using the erase function on your camera rather than using Aperture or other software on your computer. Media cards are formatted for specific camera models, and the camera will do a better job than a computer of completely erasing the card.

After importing, Aperture creates previews of the imported images. If these were RAW files or you were importing several more images, this process could take considerably more time.

Understanding RAW Files

As stated earlier in this lesson, Aperture is revolutionary in its handling of RAW image files. Many of the images we'll use throughout this book are RAW images. If you're new to a RAW workflow, here's a brief explanation of the format and what makes it so special.

The image sensor in a digital camera is made up of millions of individual light-sensitive elements. When struck by light, these elements convert light energy to voltage values. Then an analog-to-digital chip converts the voltage values into digital data. At this stage,

the data is in "raw" form. Many cameras allow you to save the raw data in a proprietary Camera RAW image file, without processing the image in another file format.

NOTE ▶ In some ways, the relationship between a camera's image sensor and Aperture is much like the relationship between the human eye and the brain. The image sensor in a camera is similar to an eye's rods and cones. In the same way that Aperture processes the data from the camera's image sensor, our brains process information from our eyes' rods and cones.

The RAW format allows up to 16 bits of color to be stored, or 65,536 colors per channel. The analog-to-digital converters in high-end digital cameras use a 10- to 14-bit color space and then store images in a 16-bit RAW format. If you choose to process the data in your camera in a format other than RAW, you may be reducing perfectly good color information.

The decision to save in a RAW format is an option on many cameras. The RAW format contains the unprocessed image data plus additional, specific information about when and how a frame was shot. (This information is called metadata, which we touched on briefly earlier in this lesson.) If you decide to save your images as JPEG or TIFF files on the memory card, the camera processes the data in a format that may reduce the image's bit depth, thus permanently affecting its color.

Decisions you make for the camera's image settings (such as sharpness and color) become permanently etched into the saved JPEG or TIFF files. Saving to a RAW format allows you to make such image-processing decisions during the post-production workflow instead. Some cameras have a RAW+ mode that enables you to save RAW data and a processed version concurrently, which you may prefer if you plan on printing directly from the camera to a personal printer. Using this mode does, however, take up additional storage, as you are storing two files for each image.

There is no one RAW standard. RAW files have different nuances from manufacturer to manufacturer. Even products from a given manufacturer may have different versions of

RAW. Aperture supports most of the major RAW variants, including CR2, CRW, DNG, NEF, and OLY, and Apple will continue to expand support as new RAW versions appear.

NOTE ▶ Mac OS X has some built-in basic support for RAW images. RAW images can be previewed directly in the Finder's column view and in the Info window. Apple's Preview application can also open RAW images. These mechanisms exist solely for preview purposes, and they provide basic information about file size, format, and pixel count without requiring you to open the image in a digital imaging application.

Understanding Other Image Formats

In addition to RAW, Aperture works with a number of processed-image file formats, including JPEG, PSD, DNG, and TIFF.

JPEG (Joint Photographic Experts Group) JPEG is often the default setting for point-and-shoot digital cameras, and most of the photos displayed on web pages are in this format. (The file extension is .jpg.) JPEG allows for a significant reduction in the file size of photographic images, but it is a lossy compression format. That means it groups the image data on the basis of the human eye's inability to perceive certain values. The less-perceptible areas are averaged together, and information is lost. This is referred to as lossy compression. Because of this lossy compression, it's important to always keep a digital original of JPEG images in a lossless format.

PSD (Photoshop Document) This is the proprietary format for Adobe Photoshop files. It supports layers as well as a number of other proprietary features within Photoshop. Many applications, including Aperture, can display files in this format.

TIFF (Tagged Image File Format) Originally created by Aldus for PostScript printing, this flexible file format is universally read by most image-processing and layout applications. Files in this format have the extension .tif. The TIFF specification is controlled by Adobe Systems (which purchased Aldus several years ago).

Rating Images

One of the first tasks you'll perform after you import your images will be making selects. Because of the convenience of digital, you may find yourself with several images to review. One way to narrow down which images are worth using involves using ratings.

As you review your images, Aperture makes it easy to rank or even reject images. The intuitive ranking system is based on stars. You can rate an image from one to five stars (with five being best). Additionally, you can apply a negative or Reject rating, which appears as an X.

The ratings you assign to your images appear as a badge overlay on each image. Besides viewing ratings, you can also use them to sort your images quickly. We'll explore ratings in-depth throughout the lessons in this book, but let's get started with a basic example.

1 Choose View > Browser Only.

Aperture rearranges its interface to make more room for the Browser; this makes it easy to view all of the images in the project.

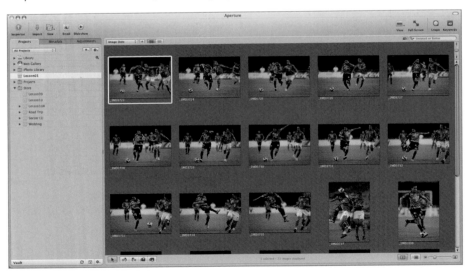

TIP You can adjust the slider in the lower-right corner to affect the size of the thumbnail images.

2 To show the control bar, choose Window > Show Control Bar (or press D).

3 Select the first image in the Browser, **_1MD3723.**

This image is good, but certainly not a five-star image.

4 Click the Increase Rating button three times to assign a three-star rating.

5 Press the Right Arrow key to select the next image, **_1MD3724.**

This image appears to be a top select.

6 Click the Select button (the green checkmark) to mark the image as a select (or five-star) rating.

7 Click the Right Arrow key to select the next image, **_1MD3725.**

With the image selected, you can quickly assign a rating using the number keys.

8 Press the 4 key to assign a four-star rating.

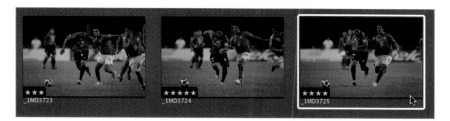

MORE INFO ▶ A quick way to precisely assign ratings is to know their shortcuts.

+	Increase rating	2	Apply two stars
-	Decrease rating	3	Apply three stars
9	Apply Reject	4	Apply four stars
1	Apply one star	5	Apply five stars

9 Use your own judgment on the next four images and assign ratings.

10 Select image _1MD3730.

This photo has the hand of the front player's arm cut off, which makes the image unusable.

11 Click the X button in the control bar to reject the image.

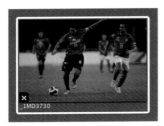

12 Press the Right Arrow key to switch to the next image, _1MD3731.

Nothing appears to happen, but if you look closely, you'll see that the rejected image has been hidden. This is because the Browser's search field is set to show Unrated or Better.

13 Apply a five-star rating to image _1MD3731.

14 Continue rating the next fourteen images using your own judgment.

Now that you've made some selects, let's make them easier to see.

15 Click the search field and choose ***** from the pop-up menu that appears.

Aperture adjusts the Browser and shows you only the five-star images. Depending on how you rated images, you'll see two or more images in the Browser.

Adjusting Images

Once you've narrowed your images down to your essential selects, you can then turn to Aperture's powerful image adjustment controls. With several controls to choose from, Aperture can repair damaged images, compensate for improper camera settings, and make stylistic enhancements.

The adjustment controls are found in the Adjustments inspector and the Adjustments pane of the Inspector HUD (Heads Up Display). Each area offers identical controls, whether it's the Inspector pane on the left side of the screen or the floating Inspector HUD.

Working with Nondestructive Edits

Aperture is designed to protect your images as soon as you import them into your library. As we discussed earlier, Aperture identifies your original images as digital masters. What you see in the Viewer and Browser are versions, which contain any edits or adjustments you make.

Let's go ahead and try out three of Aperture's nondestructive image adjustments on an image.

Adjusting White Balance

You can use the White Balance adjustment controls to fix the color temperature and color tint of an image. If an image has areas that are supposed to be white, then you can use the White Balance eyedropper to make an automatic adjustment to the color temperature and tint. If the adjustment is not to your liking, you can use the manual controls to fine-tune the image.

1 Select the image _1MD3731 in the Browser.

It's often easier to make adjustments to an image when you can clearly see it. Aperture offers a Full Screen mode to maximize the viewing of an image.

2 Press F to enter a Full Screen editing view.

NOTE ▶ Your editing controls are hidden by default when you view an image full screen. This is where the Inspector HUD (heads up display) is essential.

3 Press H to open the Inspector HUD.

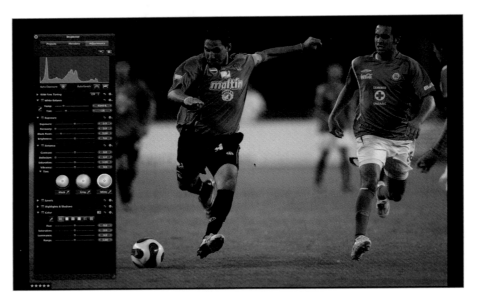

4 In the Adjustments pane of the Inspector HUD, click the White Balance eyedropper to activate it. If the eyedropper is not visible, click the disclosure triangle next to the words "White Balance."

To make it easier to see, the pointer changes to the Loupe. The Loupe is designed to show you a magnified view of the target area. By default, the magnification is set to 100 percent (full size).

TIP ▶ If needed, you can increase the magnification of the Loupe by clicking the magnification pop-up menu in its lower-right corner.

5 Position the target area of the Loupe over the logo under the player's chin.

6 Click to sample the off-white pixels.

The white balance of the image is adjusted based on where you click. The tonality of the image is shifted cooler to compensate for the white balance issue. You can try clicking on each of the the three logos to see different white balance adjustments.

Adjusting Saturation

You can use the Enhance controls to affect several properties of the image, one of which is the Saturation parameter. By adjusting the saturation of the image, you can either boost the color or tone down the color in the image by desaturating.

Let's give the Saturation parameter a try.

1 In the Enhance area of the Inspector HUD, drag the Saturation adjustment slider to the right to boost the saturation.

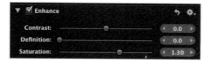

In this example, we used a value of 1.30 to boost the overall color of the image by 30%.

TIP Don't overdo the tweaks you make with the Saturation adjustment slider. Although many people prefer the look of saturated images, you can lose subtle details that help define the image.

2 Drag the Vibrancy slider to the left in order to reduce the intensity of color in areas that are not skin tones.

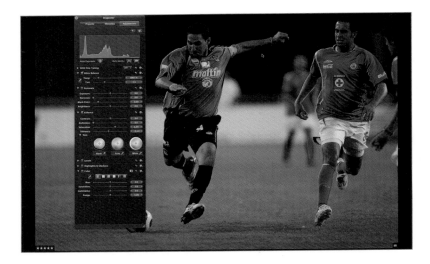

In this image, a value of - .10 worked well.

Converting to Grayscale

Many photographers need to deliver their work as both color and grayscale images. This is often the case with news photographers who may not know if their images will be printed as grayscale or color. Aperture makes it easy to create effective grayscale images.

Let's create a grayscale image in addition to the color one we've been working with.

1 Press F to exit Full Screen view.

2 Select the image _1MD3731 in the Browser.

3 Choose Images > Duplicate Version.

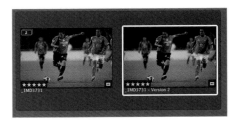

A new version is created based upon the current version of the image.

4 Press Control-M to add a Monochrome Mixer adjustment.

You can use the Monochrome Mixer control to manually create a grayscale image. The target for the RGB sliders is an aggregate value of 100%. If you use numbers that total greater than 100%, the image will brighten.

5 Use the following values in the Monochrome Mixer:

Red: 75%

Green: 35%

Blue: -10%

Although there are several more Image Adjustment controls, you should have a good idea how the controls work. We'll explore the Image Adjustments fully in Part Two of this book.

Exporting Images

Once you've selected and edited photos, you'll likely need to export them for use by a client or in another application. Aperture offers robust support for standard web and print formats. These export options ensure that you can use your images for their intended purposes.

You can always choose to export the original master image in its untouched state, but you're more likely to want to export your edited image. When you select a version to export, the adjustments are permanently applied to the exported image.

Let's export TIFF files for use in a print project.

NOTE ▶ Although most print jobs use the less-compressed TIFF format, many newspapers prefer JPEG files due to their ease of transfer.

1 Click in the Browser, then press Command-A to choose all of your five-star selects.

2 Choose File > Export > Versions.

A sheet opens and asks you to specify a location and format.

3 Navigate to your desktop where you'll temporarily store the files.

4 Choose TIFF – Original Size (8-bit) from the Export Preset pop-up menu.

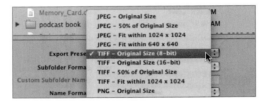

5 Choose Custom from the Subfolder Format menu.

6 Enter *Soccer Selects* into the Custom Subfolder Name field.

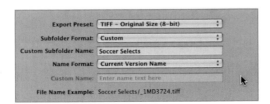

7 Click the Export Versions button to write the TIFF files.

The selected images are exported to a folder on the desktop.

8 Click OK to close the dialog.

> **NOTE ▶** If you want to see the progress of an export job, you can choose Window > Show Activity. The Activity window will tell you the progress of each export action.

Backing Up a Project

To ensure that you don't lose any image data in the event of a disk crash or other calamity, you should make regular backups while working on a project and archive the entire project when you're finished. Aperture provides several mechanisms for backing up and archiving content.

One way to back up is to export all of the versions and the master images of a project to a storage device or an optical disc such as a DVD. This will provide you with duplicates of your original data and your final images, but you won't have any of the project elements that you created in Aperture, meaning you won't be able to go back and change any of your edits. Nor will you have any of the stacks, albums, or other organizational structures that you created within your project.

To preserve all the version information and organizational structures, you need to export the entire project. An exported project preserves *all* of the work that you've done within the project, and it can be easily re-imported into Aperture, or even imported into another copy of Aperture on another computer.

1 In Aperture, click to select the Lesson01 project in the Projects panel.

2 Choose File > Export > Project…

3 In the dialog that opens, select a location for the exported project and name it *Lesson01*.

4 Click the Save button.

5 Switch to the Finder and look in the specified location. You should see a project file.

Lesson01.approject

To import the project into Aperture at any time, choose File > Import > Projects command.

> **TIP** ▶ You can also export a project simply by dragging it from the Projects panel to a location in the Finder.

Backing Up the Library

Aperture allows you to back up your Library to an optimized data package called a *vault*. A vault includes all your original images, all the versions you create, and image metadata. It preserves the structure of your Projects panel, including all projects, albums, folders, web galleries, web journals, books, and Light Tables. You should back up your Library to a vault periodically.

Creating a Vault

You should use an external hard drive when backing up your library. This provides extra protection for your data (placing the vault on the same drive as your images defeats the purpose of backing up data). For the purposes of this exercise, you'll save your vault on your internal hard drive. In reality, you should save the vault on a separate, external hard drive.

1 Choose Add Vault from the Vault Action pop-up menu at the bottom of the Projects panel.

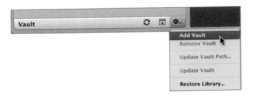

The New Vault Contents dialog appears, indicating the number of managed files that will be included in the vault.

2 Click Continue. The Add Vault dialog appears.

3 Navigate to the APTS_Aperture_book_files > Lessons > Lesson 01 folder.

4 In the Vault Name field, type *Backup Vault*, and then click the Add button.

Backup Vault appears below the Projects panel. You can click the Show or Hide Vaults button to view or hide the vault list. You created the vault, but it's empty at the moment. Next, we need to update it with the contents of the Library.

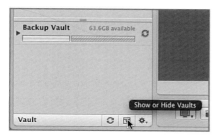

5 Click the Update button.

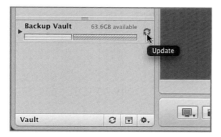

A dialog appears asking you if you would like to update the vault.

6 Click the Update button.

A progress indicator appears. Since this is the first time we are updating, the entire Library is being duplicated to the vault. Future updates will be incremental, only copying the changes since the previous update, and thus will be speedier.

Notice that the Update button is now grayed out. This indicates that the vault is in sync with the Library. As soon as we make changes to a project, the button will turn red, indicating that we need to sync the vault.

Creating Multiple Vaults

What's nice about vaults is that although the initial backup takes a long time, future back-ups are speedy, because Aperture only has to update new or changed files.

> **NOTE** ▶ Referenced master files are not backed up when you use a vault. You must back up those files manually.

For extra safety, you might want to create an additional vault on yet another disk, perhaps one that you keep off-site for added security. Because hard drives are relatively inexpensive, keeping multiple vaults on multiple drives is an affordable, easy safeguard against lost images and projects.

You create an additional vault using the same procedure that you used to create an initial vault.

1 Connect an additional drive and turn it on.

2 Choose Add Vault from the Vault Action pop-up menu.

3 In the Add Vault dialog, navigate to your external drive.

4 Click the Add button.

Aperture will begin to create the new vault. Bear in mind that you will now need to update both vaults to keep both Library backups up-to-date. However, you don't need to have both vaults connected at the same time. For example, you can update one vault daily, and the other weekly. To update multiple vaults simultaneously, choose File > Vault > Update All Vaults.

> **NOTE** ▶ You can't create a vault on an optical medium such as a recordable DVD. To store Aperture content on a CD or DVD, you'll have to export the projects to a hard disk and then burn them to the optical disc.

Restoring Your Aperture Library

The hope with data backup is that you'll never need it. With that said, hard drives can fail for a variety of reasons (from drops to power surges to defects). If you do need to restore your library, Aperture can automatically rebuild it from a vault.

1 Connect the hard drive that contains the vault that you want to restore.

2 In Aperture, choose File > Vault > Restore Library.

3 In the Restore Library dialog, choose Source Vault > Select Source Vault.

4 Navigate to the vault on your external drive and click Select. Then click Restore.

By default, Aperture will restore your library to the default location inside your Pictures folder. However, you can specify a different destination by opening the Library Destination pop-up menu and choosing Select Destination.

In this lesson you performed several of the steps in an Aperture workflow. This lesson will serve as a touchstone as you move through the subsequent lessons in this book. Although we explored only the major steps for each stage, the lessons that follow will delve much deeper into Aperture's powerful toolset.

Lesson Review

1. What is the function of Aperture's Projects inspector?

2. How do you select a new location for your Aperture library?

3. True or false: A RAW camera file includes the captured digital image and no additional data.

4. What happens when you choose ***** from the pop-up menu in Aperture's Search field?

5. Where will you find Aperture's adjustment controls?

Answers

1. The Projects inspector displays your organizational hierarchy. It can contain projects, albums, folders, books, Web galleries, and Web journals.

2. Choose Aperture > Preferences and indicate where you moved the library file or where you'd like the new library stored.

3. False. The RAW format contains the unprocessed image data plus additional, specific information about when and how a frame was shot.

4. Aperture adjusts the Browser and shows you only the images in your library that you've given five-star ratings.

5. The adjustment controls are found in the Adjustment inspector and the Adjustments pane of the Inspector HUD.

2

Lesson Files APTS_Aperture_book_files > Lessons > Lesson02

Time This lesson takes approximately 120 minutes to complete.

Goals Navigate the Browser

Accelerate your workflow using Quick Preview

Organize your images into stacks

Rotate images

Use the Loupe to evaluate images

Compare and rate images

Evaluate images using the Light Table

Lesson 2
Evaluating Images: Compare and Select

Photographers shoot far more images in today's digital era than they did in the days of film. Shooting ratios vary from photographer to photographer, but can exceed by a factor of 20:1 the number of images they would capture on a typical shoot when working with film. As a result, photographers are dealing with considerably higher volume when it comes time to choose the perfect shot. Fortunately, Aperture has a number of tools designed to help you quickly sort and organize large numbers of images.

In this lesson you'll import, organize, compare, and rate a selection of images. You'll use Quick Preview to accelerate the process of sorting through these images. And you'll use stacking to save time and space as you choose your favorite shots.

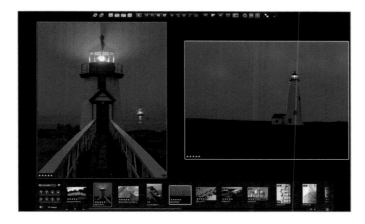

Generating Aperture Previews

Aperture can create JPEG previews of your images during the import process. You can set the size and quality of the previews in Aperture's Preferences window.

1 Open Aperture.

2 Choose Aperture > Preferences.

3 Click the Previews button in the toolbar.

4 All three checkboxes should be selected by default; if not, select the boxes that aren't.

5 Drag the Preview Quality slider to 6 Medium.

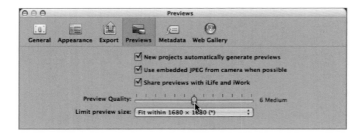

Adjusting the Preview Quality to 6 Medium results in an image with a reasonable file size, and image quality that's more than high enough for the upcoming exercises.

6 Click "Limit preview size:" and in the pop-up menu that appears, choose a resolution that corresponds to your display's maximum pixel setting.

NOTE ▶ Setting the preview to correspond to your display's resolution will limit the file size but maintain a high-quality, 100% preview of your image. Larger previews may be a good option when using Aperture's library across iLife applications. The iLife applications use the previews rather than the Master image.

TIP ▶ Existing images can be updated by Control-clicking a project or image and choosing "Update Previews" for "Project or Update Preview."

7 Close the Aperture Preferences window.

Continue to experiment with Preview settings adjustments until you find the ones that best correspond to your workflow.

Now that you've set your Preview parameters, it's time to import.

Importing from a Folder

Aperture allows you to import from a variety of sources, including CDs and DVDs, hard disks, and just about any other media that you can mount on your computer. Let's start by importing a group of images from photographer John Fleck that are stored in a folder on the Lesson Files disc. The images vary from RAW unedited images to processed images in TIFF and JPEG formats. The acquisition sources include images shot with different cameras and images that are scanned from film that span several years.

1 Click the New button in the toolbar located at the top of the screen and select Project from the menu that appears.

2 Name the project *Lesson02*; then press Return.

3 Click the Import button in the toolbar to open the Import pane.

4 Navigate to **APTS_Aperture_book_files > Lessons > Lesson02**.

5 Drag the Import Pane split between the folder hierarchy and the thumbnails all
the way up.

6 Drag the Thumbnail size slider to the left until all the thumbnails appear.

Do not click Import All. The fun is just beginning.

Using Quick Preview During the Import Process

Importing images doesn't mean it's time to take a break while the images load. Quick
Preview accelerates your workflow by switching what you see on screen to either a gener-
ated Aperture preview or an embedded JPEG, when available. By default, Aperture will
try to decode your images onto the screen at the highest possible quality level. This can
be especially processor-intensive and time consuming when decoding RAW images.

Earlier in the lesson you set parameters for preview generation. Previews are generated
in the background while the import is in progress and will continue after the import is
done until the previews have been completed. Aperture allows you to continue to work
on the existing project (or any other projects in your library) while the import process
progresses.

You can speed up your working process by using Quick Preview. You'll use Quick Preview
throughout the book except when you're performing image-processing functions. To pro-
vide accurate feedback, image-processing functions require a view of the original pixel
data, which you don't get with Quick Preview. Quick Preview isn't restricted to importing;
it's an option that you can use to accelerate your working process at any time.

Let's begin by using Quick Preview to quickly scan through the images, and rotate images that are not correctly rotated.

1 In the Import window, click Import All.

The Import window closes and the import process icon appears next to Lesson02 in the Projects panel.

NOTE ▶ Aperture can prevent you from importing a duplicate image. In the Import dialog window, mark the option Do not import duplicates. With this checked, the Import window will not show any images that are already in your Aperture library.

2 Click the V key to set the Viewer to a split screen with the Browser on the bottom and the Main Viewer above the Browser. You may need to press the V key more than once to get to the split-screen view.

TIP ▶ The V key cycles you through three different views: the Main Viewer, the Browser, and a split view displaying both the Main Viewer and the Browser. You can also go to View > Cycle View Mode to change the view using the menu.

3 Click the Quick Preview button in the lower-right corner of the Main Viewer.

The Quick Preview button turns yellow to indicate that it's active.

4 Select the first image in the Browser, SingaporeSheets.

Depending how long you take to complete these steps, the Import Complete dialog may appear. If it does, simply click OK and continue with the steps.

5 Press the Right Arrow key to navigate to the next image.

6 Hold down the Right Arrow key to navigate quickly through the images.

7 Stop on the first framed building shot that requires an adjustment to orientation, image **02615544**.

8 Click the Rotate Counterclockwise button in the lower-left corner of the Viewer.

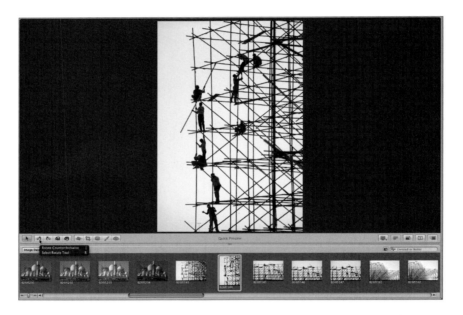

9 Press the Right Arrow key once to select image **02615545**.

10 Press the Left Bracket ([) key to rotate the image counterclockwise.

Take a few moments to allow the import to complete if it didn't finish while you were performing the steps.

11 Click OK when the Import Complete dialog appears.

> **TIP** ▶ You can perform the exact same steps without activating Quick Preview. Turning on Quick Preview will make your navigating experience faster, regardless of the computer you're using.

Navigating the Browser

The Browser is a flexible area where you'll select and view your images in a variety of ways. Navigating the Browser to select images is very intuitive.

1 Press the V key to cycle through your different views until only your Browser is visible.

2 In the lower-right corner of the Browser, drag the Thumbnail slider to the halfway point.

3 Drag the scroll bar on the right side of the Browser all the way to the bottom until the last image, **0V8I1607**, appears.

4 Double-click the last image, **0V8I1607**.

The view cycles to a Main Viewer-only view with the selected image displayed.

NOTE ▸ The default behavior for double-clicking an image is to switch the selected image(s) to the Main Viewer-only view. This default behavior can be changed in Preferences.

5 Double-click the image in the Main Viewer.

The view cycles back to the previous Browser-only view.

6 Use the arrow keys to navigate to **02617890**, so the last image of the arched bridge is selected.

Using arrow keys you can quickly navigate to images. The Browser view will automatically scroll as you change your selection.

7 Locate the Shuttle control in the upper-right section of the Browser, and drag the Shuttle control slider up.

TIP ▶ You can use the J-K-L keys as shortcuts for the Shuttle control. From a stopped position, pressing J begins an upward movement; K will stop a scroll; and L will initiate a downward movement. Pressing the J or L key more than once accelerates the movement. If the scroll is already moving in one direction, then the J or L key will throttle back the speed of the movement.

8 Press the V key to cycle the View mode back to a split-screen view between the Main Viewer and the Browser.

9 Drag the scroll bar at the bottom of the Browser all the way to the left.

10 Click the **SingaporeSheets** image to select it.

The image displays in the Main Viewer.

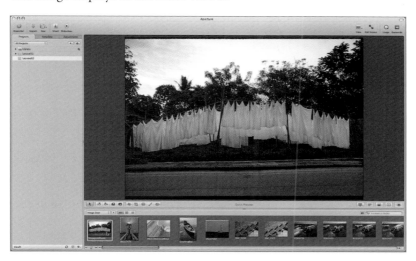

Selecting and Rotating Multiple Images

Rotating groups of images requires you to select multiple images. Images can be rotated at any time. For the sake of good housekeeping, you'll be rotating the images you've just imported.

1 Using the mouse, drag out a selection that includes the fourth image in the first group of the building frame under construction (**02615546**), and the last image of that group (**02615547**).

Both images should appear in the Main Viewer.

2 Press the Left Bracket key to rotate both of the selected images counterclockwise.

3 Click to select the wider sun-flared shot in the next group, image **02615561**.

4 While holding down the Shift key, press the Right Arrow key to add image **02615562** to the selection.

5 Press the Left Bracket key to rotate the two selected images counterclockwise.

6 Press the V key twice to cycle your view to a Browser-only view.

7 In the lower-left section of the Browser, drag the Thumbnail slider to the left until all your thumbnails are visible.

8 Select the third freight container, image **02615985**.

9 While holding down the Command key, select the bridge shot, **02617889**.

NOTE ▶ Holding down the Command key while selecting allows you to select images that are not adjacent to one another in the Browser.

10 Press the Left Bracket key to rotate the selected images counterclockwise.

You now have the good Aperture housekeeping seal of approval. The images are rotated to their proper positions.

Working with Stacks

In traditional photography, photographers sorting through mounted 35mm transparencies after a shoot often stacked those transparencies according to a particular criterion and placed their favorite image on top (or separated it from the stack). Though the process is different in the digital era, the concept is the same: There is a preferred image in each stack, and the other images are alternatives in case the client wants a different one or a different exposure is deemed better for printing.

These stacks usually comprised a burst of images attempting to capture a special moment or a variety of exposures referred to as "bracketing." Many digital cameras offer a feature called "auto-bracketing." Shots are fired in sequence with the main exposure locked down, and additional shots are exposed at higher and lower values.

Auto-Stacking

To help photographers organize a series of similar digital images, Aperture offers the capability to auto-stack images before or after importing them. When you auto-stack images as they're being imported, Aperture uses the images' timestamp metadata to group images shot up to one minute apart. Stacking is not permanent and can be undone or edited at any time. Stacking is a way of grouping images for viewing purposes only; it doesn't affect where they're stored within your Aperture Library.

The timing function used in auto-stacking can handle many situations. However, there are times you'll want to split or merge stacks manually. In these situations, you'll use the manual stacking tools to adjust the groups of stacks that require tweaking.

1 Press Command-A to select all the images in the Browser.

2 Choose Stacks > Auto-Stack from the menu or press Option-Command-A.

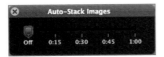

The Auto-Stack Images HUD appears.

3 Drag the Auto-Stack Images slider all the way to the right.

A number of stacks form, indicated by a darker grey background around each group, and a stack indicator in the upper-left corner of the first thumbnail of each stack.

4 Close the Auto-Stack Images window.

5 Choose Stacks > Close All Stacks from the menu.

NOTE ▶ Closing stacks saves you a significant amount of space in the Browser.

6 Click the background of the Browser to deselect all the images. You can also press Shift-Command-A.

There are a few images that will require manual stacking. You'll adjust these stacks next.

Editing Stacks

1 Drag the Browser Thumbnail slider to the right until the thumbnails scale to fill the Browser.

2 Select the second fire truck image, **02613433**.

3 Choose Stacks > Open Stack or press Shift-K.

4 Drag the unstacked fire truck image (**02613416**) to the right onto the first image in the stack (**02613433**).

A vertical green line will appear just to the left of the first image.

5 Release the mouse button.

The fire truck image, **02613416**, is now part of the fire truck stack.

6 Click **02615964**, the first image of the truck freight containers.

7 Shift-click **02615985**, the last image of the freight containers.

All the freight container images should be selected.

8 Choose Stacks > Stack or press Command-K to group the selected images into one stack.

NOTE ▶ Stacks are simply timing-based or user-defined groups of images that can aid in both the organization and amount of Browser space your images are occupying. Stacks can be created or split up at any time.

TIP ▶ Any manual stacking adjustments will be altered if you auto-stack after those adjustments.

The timing function used in auto-stacking can handle many situations. There are times you'll want to split or merge stacks manually. Use the manual stacking tools to adjust the groups of stacks that require tweaking.

9 Select the street shot 02616721.

10 Press Shift-K to open the stack.

11 Choose Stacks > Unstack from the menu or Shift-Command-K on the keyboard to ungroup all three images.

Stacks can be split in a variety of ways. You can use menu commands, keyboard shortcuts, or drag manually. You can also customize the toolbar to add buttons that will perform stack adjustment, including the Split Stack.

12 Choose Stacks > Open All Stacks.

Choosing the Pick of a Stack

The Pick of a stack is designated as your favorite image of the stack group.

1 Cycle through your View modes by pressing V until your view is a split-screen comprising the Main Viewer and the Browser.

2 Select the first shot of the half sunken bridge, image DSC_2244.

Good shot; let's take a look at the next version.

3 Press the Right Arrow key to select **DSC_2477**.

This version is a bit lighter. Let's go with this one as our Pick.

4 Choose Stacks > Pick or press Command-\ to make **DSC_2477** the Pick of the stack.

When you select a new image as the Pick of the stack you'll see an animation of the image-swapping in the Browser.

5 In the Browser, drag the fourth fire truck image, **02613437**, slightly to the left of **02613416**, the first image in the fire truck stack, until the vertical green line indicating position appears.

6 Release the mouse button. **02613417** is now the Pick of the stack.

TIP ▶ Be sure not to drag the image outside the stack. This would remove the image from the stack. If you do this accidentally, just drag the image back into position.

Next you'll explore the Stack mode. In this mode you can move between stacks very quickly and decide on your alternatives and Picks by comparing your Pick and alternatives side by side.

Using Stack Mode

Choosing the Pick of a stack using individual images or thumbnails may work when the images have significant differences. Working with the images side by side is a better option when the images have subtle differences. In Stack mode you can view your current Pick next to the alternatives in the stack.

1 Press I to hide the Inspector panel. This will yield some extra screen space.

2 Select **02615200**, the first shot of the domed architectural buildings.

3 Select Stack from the Viewer Mode button in the lower-right section of the Main Viewer.

The Main Viewer displays two images. Outlined in green will be your current Pick of the stack. Outlined in yellow is the second shot in the stack. The green and yellow outlines also appear on the corresponding thumbnails in the Browser. A small label appears above each image in the Main Browser, indicating the current Pick and which image of the stack appears.

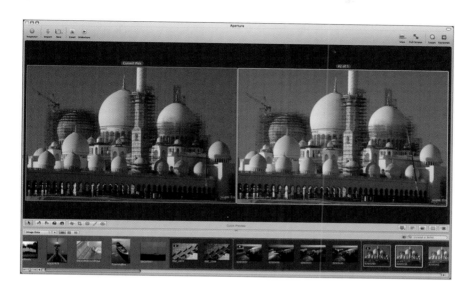

4 Use the Left and Right Arrow keys to dynamically switch the alternative shot.

Notice that you never leave the stack itself using the Left and Right Arrow keys. The Stack mode is designed to keep you within a selected stack.

5 Select **02615203** in the Browser.

NOTE ▶ In Stack mode you can select your alternative in the Browser.

6 Press Command-\ to select image **02615203** as your Pick.

The new Pick is now the first image in the stack.

7 Press the Down Arrow key several times until you get to the stack of the freight boxes, beginning with **02615964**.

Pressing the Up and Down Arrow keys will move you to the next or previous stack. You'll notice that the stack that you're leaving also closes in the Browser.

8 Press the Right Arrow key to compare the vertical shot to the horizontal Pick.

Good shot, but choose the second shot as your Pick.

9 Select the second shot **02615972** and press Command-\ to make it your Pick.

Understanding Picks—Promoting and Demoting

The images that are not the Pick of a stack can be arranged from left to right within a stack displayed in the order of preference. You'll take this opportunity to add buttons to the toolbar specific to stacking.

1 Control-click the toolbar and select Customize Toolbar.

The Customize Toolbar window drops down.

TIP In addition to customizing the Toolbar, you can change the keyboard short-cuts for Aperture. Choose Aperture > Commands > Customize to display the Command Editor. You can browse existing keyboard shortcuts or create your own.

2 Drag and position the Promote and Demote buttons to the left of the View button in the toolbar.

3 Drag and position the Separator to the right of the Demote button in the toolbar.

4 Press the Done button in the lower-right corner of the Customize Toolbar window.

TIP If you'd like to return to the default toolbar, drag the framed cluster of buttons on the bottom of the Customize Toolbar button and release over the toolbar.

5 Press the Down Arrow key to change to the stack beginning with the arched bridge shot **02617888**.

The vertical image of the bridge, **02617889**, is the alternate shot.

6 Click the Promote button. The vertical shot of the bridge, **02617889**, has been promoted to the Pick. The previous Pick, **02617888**, is now the first alternate.

7 Click the Demote button. The wider bridge shot, **02617888**, is now demoted to the end of the hierarchy.

8 Using the Down Arrow key, navigate to the stack of the frying pans beginning with **02611203**.

9 Press Command-Left Bracket on the keyboard to promote **02611203**, the frying pan shot without the hand.

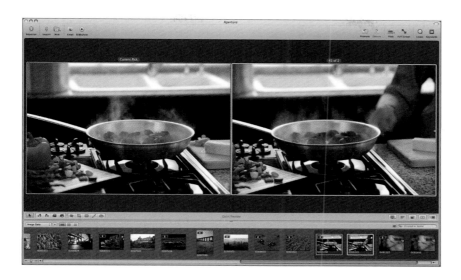

10 Switch the Main Viewer to Show Multiple.

NOTE ▶ Show Multiple is the default view when Aperture is launched, regardless of the view you were in the last time you quit the application.

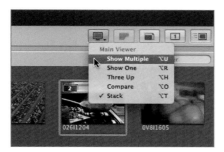

11 Choose Stacks > Close all Stacks from the menu. Only single images and the Picks of the stacks are visible in the Browser.

NOTE ▶ Adjusting the hierarchy of a stack by promoting and demoting will save you time when you're required to look for an alternative to your Pick. You won't have to search the stack because your second image in the stack has already been designated your first runner-up. Closing stacks when you're not working within a stack will free up screen real estate within the Browser to display more images.

Evaluating Images in Full-Screen Mode

One of Aperture's strengths is its ability to display images in a full-screen mode that reduces the interface to a bare minimum. You'll view images at full resolution and examine pixels at the finest level of detail possible by magnifying the pixels. This is a necessity when you're evaluating images for focus, detail, and lighting. Two features are of particular use when you want to evaluate images at full resolution: the Zoom feature and the Loupe tool.

Using Zoom to Evaluate Images

Let's evaluate the images from our import using Zoom and the Loupe to get a better look at them.

1 Press F to switch to Full Screen mode.

2 If the Filmstrip is not showing, position your cursor on the bottom of the screen for it to appear.

3 When the Filmstrip appears, go to the Action pop-up menu on the lower left and select Turn Hiding Off.

4 If the toolbar isn't showing, position your cursor at the top of your screen and click the toggle button on the right of the toolbar to lock the toolbar on screen.

For the purposes of this lesson you'll leave the toolbar and Filmstrip on screen. When you begin to work in Aperture on your own, you many want to hide these

items to increase the image size for certain operations. The keyboard shortcut for hiding/unhiding the Filmstrip is Ctrl-/.

5 Click the Quick Preview button (which may take a moment to display) to turn Quick Preview off.

Next, you'll be zooming in on areas to view pixels. With Quick Preview turned off, you'll be able to view actual pixels versus viewing the preview.

6 Select the building silhouette image **02615543**. The image appears in the Main Viewer.

7 Press Shift-K to open the stack.

8 Position your cursor over the figure on the bottom of the image and press the Z key. Aperture zooms in on the image, using the location of your cursor to center it.

You may notice a Loading window on the top center of the image. This indicates that the original image is being decoded on the screen.

You're currently viewing the image at a full 1:1 ratio. Viewing the full-resolution image allows you to make decisions based on actual pixels instead of a scaled view. When an image doesn't fit within the area of the Viewer, a small gray box appears on the right edge of the image with a red rectangle inside, showing the portion of the image that is currently visible in the Viewer. You can drag the red rectangle within the gray box to see other parts of the image. This is known as *panning*.

9 Drag the red rectangle in the gray box to pan around the image on screen.

At 100%, you can see that this image is focused on the foreground portion of the frame.

10 Press the Right Arrow key to select the next image, **02615544**.

11 Press the spacebar while dragging the image in the Viewer.

> **TIP** ▶ If you have a scrolling mouse you can use the scroller to pan images in the Viewer. Just place the pointer over the panning rectangle. Multidirectional scrolling mice such as the Apple Mighty Mouse can scroll up and down as well as left to right. Scrolling mice also work in the Browser: When you place the scroller anywhere in the Browser, all of the thumbnails scroll.

One of the most interesting visual elements of the images is the two figures in the upper-left area of the frame holding a pipe diagonally. Let's locate them and zoom in.

12 To begin, press Z to zoom out.

13 Select the vertical images **02615544** and **02615545**.

14 Position your cursor away from the images in the Viewer and press Z to zoom in.

15 Drag with the spacebar held down or use the zoom navigation box on the left image until you've located the men in the upper-left corner.

16 Drag with the spacebar held down or use the zoom navigation box on the right image until you've matched the content on the left.

17 Press and hold Shift-spacebar while dragging inside either one of the images.

Both images will move simultaneously.

NOTE ▶ Shift-spacebar dragging or Shift-dragging in the navigation zoom box will simultaneously move as many images as will fit in the Viewer. The number of zoomed-in images that will fit in the Viewer is affected by both the display size and the image size.

18 Select **02615547**, the last image in the stack.

19 Press Z to zoom out. Position your cursor over the figure in the upper-right area of the frame and press Z to zoom in.

20 Repeat the previous step several times over different portions of the image.

21 Press Command-\ to make **02615547** the Pick of the stack.

22 Press Z to zoom out.

Using the Loupe Tool

Using the Loupe tool is a convenient and effective way to view portions of an image up close in the Viewer or the Browser. There are two types of Loupes. The default Centered Loupe is a lens with a draggable lower-right extension as well as a pop-up menu. The Normal Loupe looks like a magnifying glass with a second lens on the handle.

Using the Centered Loupe

1 Select the **02615561** image in the Browser.

2 Click the Loupe button to select it in the toolbar or press the Accent Grave (`) shortcut key.

3 Drag the center of the Centered Loupe over the two figures in the upper-left area of the image that you focused on in the previous section, and release.

A small white circle appears in the center of the Loupe as you begin to drag. This circle represents the area of the image that will be zoomed in on after you release the Loupe.

4 Press Option-Shift-= to enlarge the Loupe. If the Loupe is already at maximum size, you won't see a change.

> **TIP** ▶ Press Option-Shift-Hyphen to reduce the size of the Loupe.

Let's increase the Loupe's magnification to get an even closer look at the top man's face in profile.

5 Select 400% from the pop-up menu on the lower-right corner of the Centered Loupe. You may need to reposition the Loupe by dragging to center the top man's face.

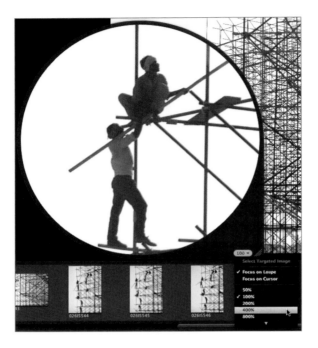

Note that the zooming beyond 100% is not aliased. You're viewing the scaled pixel information without blending applied. This allows you to accurately assess the pixel information.

6 Press Shift-Command-Hyphen three times to change the zoom factor to 50%.

NOTE ▶ Zooming to 50% is a quick way of subtly zooming in on part of an image while still viewing compositional elements.

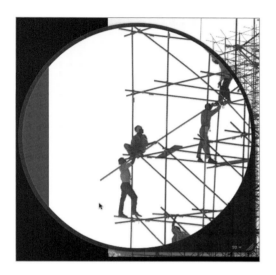

Wouldn't it be nice if you could zoom in on a portion of an image without covering it up? That's what you'll do next.

7 Drag the Centered Loupe to the right until it no longer overlaps with the image in the Main Viewer. You may need to press Option-Shift-Hyphen to reduce the size of the Centered Loupe.

8 Select Focus on Cursor from the pop-up menu on the lower-right corner of the Centered Loupe.

9 Position the Cursor over the image in the Main Viewer.

The Centered Loupe updates to reveal the area around the cursor as you move the cursor around. This is a great way of zooming in on different parts of an image without covering a portion of the frame.

10 Press Shift-K to open the stack.

11 Position the cursor over **02615563**, the last image in the stack.

The Centered Loupe updates to reveal a zoomed-in view of the thumbnail beneath the cursor.

12 Select 02615562, the second image in the stack. Position the cursor over different parts of the image in the Viewer.

13 Press Command-\ to designate this shot the Pick of the stack.

14 Press Shift-Command-= to return the zoom value on the Loupe to 100%.

Now that you've learned some ways to get a closer look at your images using the Centered Loupe, let's check out the Normal Loupe.

Using the Normal Loupe

1 Select the 02615630 image in the Browser. Press Shift-K to open the stack.

2 Select Use Centered Loupe from the menu on the lower-right corner of the Centered Loupe.

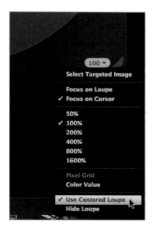

3 Position the smaller target circle of the Loupe over the man's eyes on the left side of the image.

That looks pretty good. Time to check the other images.

4 Select each of the alternate images in the stack and position the target circle on the Loupe over the eyes of both men in the alternative shots.

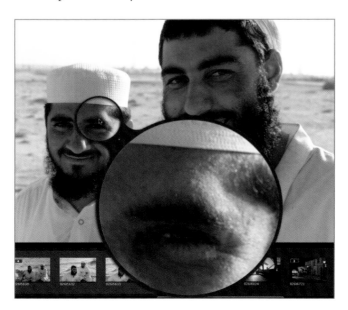

On the second and third images, the man in the foreground seems slightly out of focus; on the fourth image, the man in the background looks a bit off. For this group, the Pick of the stack will be based on the product of elimination.

TIP Although contrast and lighting can affect your perception of focus, in most cases, if you're not sure if the image is in focus, it's not!

5 Press the Shift-Command-Accent Grave (`) shortcut key to switch to the Centered Loupe.

NOTE ▶ The Loupe remembers the state it was in the last time you closed it. This includes the type of Loupe and the zoom percentage. You can use the Loupe anytime you want to in Aperture. It works in every area, whether it's a book, a Light Table, or a Web Gallery.

6 Press the Accent Grave (`) shortcut key to close the Loupe.

TIP The Loupe works great with multiple monitors. For detail on working with multiple monitors, see Lesson 5.

7 Press F or Esc to exit Full Screen mode.

Assigning Ratings

When you work with images in Aperture, you're constantly evaluating the quality of the images you've shot. Ratings in Aperture allow you to tag individual images according to their quality, from excellent (five stars) to poor (one star). You can also leave images unrated, or rate images with the dreaded Reject tag. This allows for a total of seven ratings.

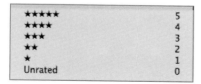

Rating images is an area where Aperture really shines. To rate your images, you'll use the buttons conveniently located in the control bar at the bottom of the main window and keyboard shortcuts.

1 Press D on the keyboard to display the control bar under the Browser.

2 Hold down Shift and press D to modify the contents of the control bar until only the Ratings buttons appear. There are two options: Ratings buttons only, or Ratings buttons plus Keyword controls.

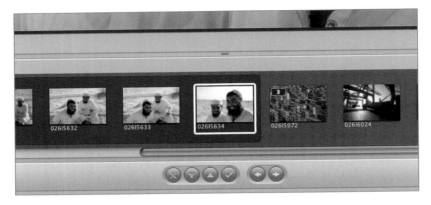

3 Select the horizontal Lighthouse image **DSC07087**.

4 Click the Select button on the control bar to assign a five-star rating to this image.

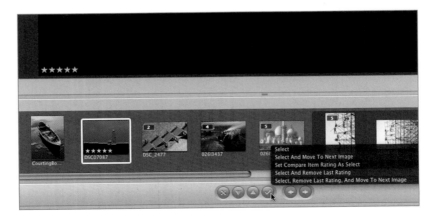

NOTE ▶ You should see 5 stars ("*****") displayed in the lower-left area of both the Browser thumbnail and the Main Viewer image. If not, press Y to turn on the Metadata overlay in the Main Viewer and U to turn on the Metadata overlay in the Browser. You'll learn how to adjust these overlays in Lesson 3.

5 Press the Right Arrow key to select the image of the downed bridge **DSC_2477**.

6 Click the Increase Rating button four times to assign a four-star rating to the image.

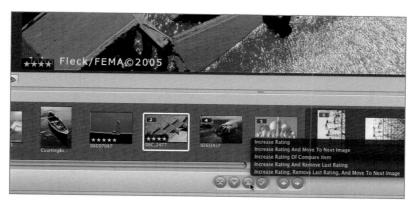

7 Click the numerical Stack indicator on **DSC_2477** to open the stack.

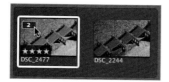

Note that the alternative shot is not rated when you assign a rating to a Pick. Close the stack by clicking the numerical Stack indicator again.

8 Close the stack of the downed bridge by clicking the Stack indicator.

9 Select the fire truck shot (**02613437**) and press \ to assign a Select five-star rating to the image.

10 Select **02615203**, the image of the domed buildings. Press the = key three times to assign a three-star rating.

Rating Groups of Images

Selecting groups of images can accelerate the rating process. Aperture has some clever ways of handling groups of images.

1 Select the first four images in the Browser: SingaporeSheets, DSC07479, DSC0186811x14Final, and CourtingBoatcolor.

2 These are all great shots. Press 5 or \ to assign a Select five-star rating to each of the images in the group.

3 Choose the last two images in the Browser: the frying pan (0261204) and the fruit (0V8I1605).

4 Click the frying pan in the Main Viewer.

5 Press 5 to make the frying pan a Select five star-rated image.

Five stars appear in the lower-left corner on each of the two images in the Viewer, as well as on the images' thumbnails in the Browser. The problem is that we wanted to apply the five-star Select rating only to the frying pan.

6 Choose Metadata > Unrated or press 0 to remove the Select rating you just applied to the two images.

You'll use the primary selection options to rate only the images you'd like to rate.

Using Primary Selection Options to Rate Images

Aperture features an innovative option for affecting metadata in one primary image or a group of images without altering your overall selection. Here's how it works.

1 Click the Primary Only button on the control bar. This allows you to make changes to the metadata of the primary selection only.

When you click the Primary Only button, the outline for the non-primary selection disappears.

2 Press \ to assign a five-star rating.

Only the primary image is rated.

3 Click the fruit shot. Press 3 to give this image a three-star rating.

4 Press P for Quick Preview. This will accelerate the loading of multiple images.

5 If it isn't open already, open the stack beginning with **02615547** and select all the images within the stack.

6 Select **02615547**, the first image in the Browser or Viewer.

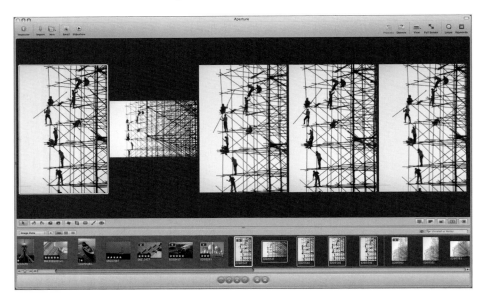

The reduced size of the images can make it difficult to properly assign a rating when viewing several images simultaneously.

7 Click the Viewer Mode button and select Show One from the menu.

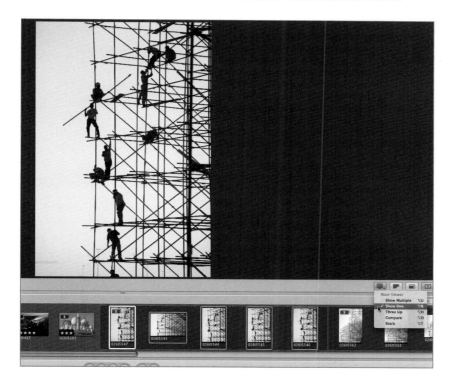

This is a terrific way of focusing on one image of a group without altering the selection. If you look at the Browser, the selection has not been modified.

TIP ▸ The keyboard shortcuts for the different Viewer modes all begin with the Option key. Interestingly enough, the corresponding letters spell out U-R-H-O-T. This is a legacy feature based on the second letter of each of the options in Aperture 1.x.

8 Assign ratings from left to right of 5-4-3-2-1 by selecting the images in the Browser one by one and applying the corresponding rating.

TIP ▶ You can use the arrow keys or buttons to change the primary selection without altering the overall selection as long as you don't click a non-selected image.

9 Press Option-U to switch back to Show Multiple view.

10 Press Shift-K to close the stack.

11 Click the Primary Only button to disable the mode.

NOTE ▶ Primary-only options can be used on several metadata functions including rotation, keyword applications, and simply as a tool for switching back and forth between an overall selection and a single primary image for evaluation.

Speed Rating

You can perform multiple functions in one keystroke in Aperture. The faster you finish rating your images, the quicker you can get back to shooting.

1 Choose Stacks > Close all Stacks.

2 Select **02615630**, the image of the two men sitting in the sand.

3 Press Control-\ on the keyboard. **02615630** is now a five-star image.

You're automatically moved to the next image of the freight containers.

4 Press 3 to assign a three-star rating to the current image, **02615972**.

This image really deserves a four-star rating. You'll increase the rating and move on to the next image in one step.

5 Press Control-= to increase the rating on **02615972** and move on to the next image.

6 Shift-click **02616721**. You should now have both **02616721** and **02616024** selected.

7 Press 2 to assign a two-star rating to both images.

8 Press Command-Down Arrow to move the selection over to the next set of images.

The two-image selection moves two images over and retains a two-image selection. You can use this technique to move quickly through groups.

TIP Use Command plus the Left and Right Arrow keys to move a selection over step by step. Use Command plus the Up and Down Arrow keys to move multiple steps at a time, depending on the size of the selection.

9 Press 3 to assign a three-star rating to two doorway shots, **02616723** and **02616724**.

You'll now put together a couple combinations to earn some racing stripes.

10 Press Shift-Right Arrow to add to the selection.

11 Click the Primary Only button and press 2 to assign a two-star rating to **02617320**, the image of the building with foliage in the foreground.

12 Click the Primary Only button to disable.

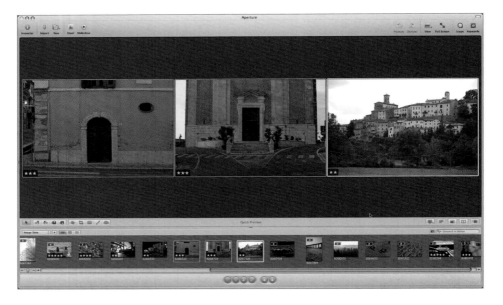

13 Press Command-Down Arrow, and press 5 to assign a five-star rating to all three images: **02617434**, **02617889**, and **02610973**.

TIP ▶ There are many more combinations that you can explore. Position your cursor over each of the four ratings buttons and a pop-up window will display available keyboard shortcut combinations.

NOTE ▶ It's not necessary to use keyboard shortcuts in Aperture to apply ratings or perform any other function. They are, however, a tool that many users may find can reduce the time it takes to get through a large number of images.

Evaluating Images on the Light Table

The Light Table in Aperture can be compared to your desktop table space in your office when shuffling around printed photos. That's where the similarity ends, however. With your digital Light Table you can scale photos, easily align them, and quickly switch into a full screen or swap the Light Table temporarily for the Viewer.

Creating a Light Table

1 Press I to open the Inspector.

2 Select the last four shots in the Browser: **02618653**, **02611022**, **02611204**, and **0V811605**.

3 Click and hold the New button and choose Light Table.

4 Name the Light Table *World Light Table* and press Return. Close the Inspector by pressing I.

5 Select and drag all four images onto the center of the Light Table grid.

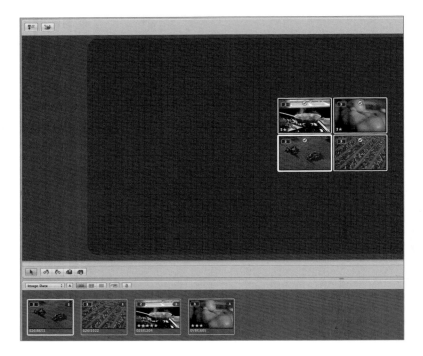

6 Click the grid background to deselect all images in the Light Table.

7 Select and drag the Frying Pan shot and the Fruit shot to the right side of the grid.

8 Click the grid background to deselect all the images in the Light Table.

9 Drag the frying pan under the fruit, using the yellow guides that appear to line up the shots.

Navigating the Light Table

Here's how you work with images in the Light Table.

1 Select the frying pan shot.

2 Drag the zoom slider in the upper-right area of the Light Table all the way to the right.

3 Click the Light Table Zoom Navigator or press N.

The Light Table zooms out and a frame appears surrounding the frying pan shot.

4 Click inside the frame and drag the frame onto the fruit shot and release.

5 Press N to zoom out and activate the Navigator.

6 Drag the Navigator frame over the overhead shot of the people and release.

Getting a Closer Look in the Light Table

1 Press the Accent Grave key (`) to activate the Loupe.

2 Drag the Loupe over the faces of the couple on the left.

The shot looks sharp.

3 Press the Accent Grave key (`) to hide the Loupe.

4 Select the overhead shot of the people.

5 Press 4 to assign a four-star rating to the shot.

6 Position the cursor over the background of the Light Table, hold down the spacebar, and drag to the left until the car shot is centered.

7 Select the overhead cars shot.

8 Press F to switch to Full Screen mode.

9 Press 5 to assign a five-star rating.

10 Press F to return to the Light Table.

You've rated and evaluated the remaining images on the Light Table.

NOTE ▶ The Light Table can be a terrific layout tool. You'll learn how to use the Light Table as a layout tool in Lesson 11.

Lesson Review

1. How does Quick Preview work?

2. What information does auto-stacking use?

3. What is the Pick of a stack?

4. What is stacking?

Answers

1. Quick Preview uses generated previews instead of decoding the original file. If the generated preview isn't available, Aperture will use the embedded JPEG if that's available.

2. Auto-stacking uses the timestamp metadata.

3. The first image in a stack is the Pick of the stack.

4. Aperture offers the capability to stack images before or after importing them as a way to organize series of similar digital images. You can auto-stack images while importing them, or stack automatically or manually afterward. When you auto-stack images while importing them, Aperture uses the timestamp metadata to group images that are shot up to one minute apart. Stacking is just a way of grouping your images for viewing purposes; it doesn't affect where they're stored within your Aperture Library.

3

Lesson Files APTS_Aperture_book_files > Lessons > Lesson03

Time This lesson takes approximately 180 minutes to complete.

Goals Import images using auto-stack

Filter search results using the Query HUD

Define and organize keywords

Edit IPTC metadata

Perform batch changes

Work with multiple projects

Use albums and Smart Albums

Find a project or element efficiently using project skimming

Lesson 3
Organizing Your Project

The purpose of organizing your images is pretty simple: You want to be able to find an image when you need it. What criteria you use is based on your workflow. Aperture offers a series of basic organizational options in the Inspector starting with the project itself.

In this lesson you'll use folders, albums, and smart albums to manage the overall structure of your images. You'll learn the different ways of viewing metadata. The ratings you applied in Lesson 2 will be used in combination with keywords you'll apply in this lesson as sort criteria in both the Browser and the Inspector.

Displaying Metadata in the Browser and Viewer

There are many ways of viewing metadata in Aperture. By default, Aperture will overlay metadata onto the images in the Main Viewer and Browser. The type of metadata you're viewing is easily modifiable by using one of the presets that come with Aperture. You can also create your own preset. You can quickly turn on and off metadata views via shortcuts or the menu. When the metadata views are on, you can also toggle between two different options.

1 If necessary, press Control-P to display the Projects tab in the Inspector pane. Make sure Lesson02 is selected in the Projects tab.

2 You should see both the Browser and Main Viewer. If necessary, cycle through your views by pressing V.

3 In the Browser, select the first image, **SingaporeSheets**.

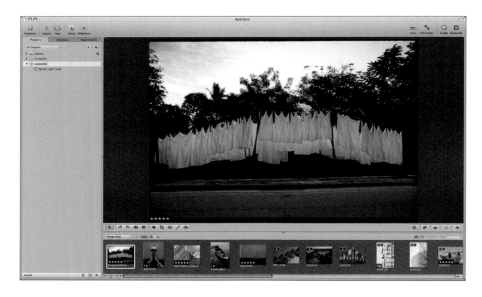

There's metadata information displayed in both the Main Viewer and Browser. In the Main Viewer, the five-star rating appears on the lower-left corner of the image. The five-star rating also appears on the thumbnails in the Browser.

4 Press the Y shortcut key to turn off metadata in the Main Viewer.

The five-star rating disappears from the lower-left corner of the image in the Main Viewer.

> **TIP** You can also choose to turn on and off metadata for the Viewer in the menu by choosing View > Metadata > Viewer.

5 Press the U shortcut key to turn off metadata in the Browser.

Metadata views are handled separately for the Browser view and the Viewer.

> **TIP** You can also choose to turn on and off metadata for the Browser in the menu by choosing View > Browser > Grid. The grid metadata view will also apply when working in the Browser's Full Screen or Filmstrip view. Viewing metadata in Light Table view is handled separately by choosing View > Metadata > Light Table or pressing Shift-G.

6 Press the Y key and then the U key to turn on the metadata view in both the Browser and Viewer.

7 Press the Shift-Y shortcut to change to a different set of metadata information in the Viewer.

The default second metadata set for the Viewer displays much more information. There is a compromise: The image size is slightly reduced.

8 Press the Shift-U shortcut to display the second set of metadata in the Browser.

9 Choose View > Metadata > Customize or press the Command-J shortcut.

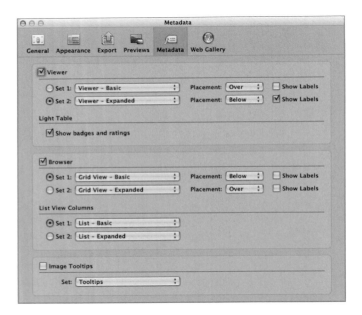

The Preferences window appears with the Metadata button selected in the toolbar. There are two sets of views for the Viewer, Browser and list view. Let's work with the Browser and Viewer options.

10 In the Viewer section, choose General from the Set 2 menu.

The metadata displayed in the Viewer updates.

11 In the Browser section, choose Over from the Placement menu for Set 1.

12 Close the Metadata Preferences window.

13 Press the Shift-U shortcut and then the Shift-Y shortcut to return to the original default views you began with.

The metadata display options are powerful allies in your ability to quickly determine the characteristics of the displayed images. And there's one more trick you still have up your sleeve.

14 Position the cursor over the image in the Main Viewer. Press the T key.

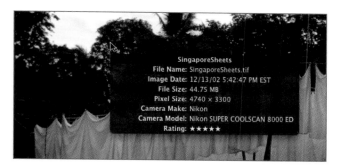

The Image Tooltip window displaying metadata appears. The window will disappear after about half a minute. The Image Tooltip window is a terrific place to quickly view the metadata of an image in any area of Aperture.

15 Position the cursor over the second thumbnail in the Browser.

The Image Tooltip window updates to display the information specific to the second image.

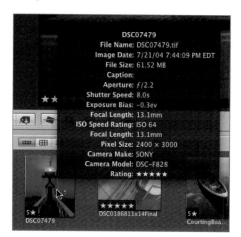

16 Press the T key to hide the Image Tooltip.

> **NOTE** ▶ Similar to the Loupe tool, the Image Tooltip window can be used for viewing information on images in any area of Aperture. The Image Tooltip information window can be modified in the preferences, much like the Browser and Viewer metadata.

Importing Using Auto-Stack and Custom Naming

It's a good idea to do as many operations as you can during the import process. Applying metadata and stacking and naming operations when you import images can end up saving you from having to do it later.

Auto-Stack and Rotate on Import

1 Verify that Quick Preview is on. If it's not, press P.

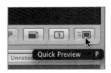

2 Verify that Primary Only is not active.

> **NOTE** ▶ Once you're in the Import window you won't be able to turn on and off Primary Only. You'll have to exit the Import window to access the Primary Only button or menu item.

3 Choose File > New Project or Command-N.

4 Name the project *Lesson03* and press Return.

5 Press Command-I to begin. The Import window appears.

6 Navigate to **APTS_Aperture_book_files > Lessons > Lesson03**.

7 Drag the Thumbnail slider in the lower-right corner until all the images fit.

In between the navigation and thumbnails, you may need to drag the pane adjustment upward to create more space for the thumbnails.

8 Drag the Auto-Stack slider centered below the thumbnail view all the way to the right.

The images in the stacks look like they belong together. Let's take some time to rotate the few images that need rotation.

9 Select the following seven images: **02612495**, **02612496**, **02612497**, **02612498**, **02613322**, **02613323**, and **02613326**.

10 Click the Rotate Counterclockwise button in the lower-left corner.

11 Click the background of the Import window to deselect any images as needed.

Now you're ready to put in some metadata and customize the naming of the images on import.

Custom Naming on Import

Aperture offers an amazing amount of flexibility in the way you can name your images. During the Lesson 02 import, Aperture simply used the original file name as the version name. You can also have Aperture change the original file name on import to match the version name you choose. In this section you'll create your own version name but leave the original file name intact.

1 Choose Edit from the Version Name menu on the right side of the Import window.

The Naming Presets window appears.

NOTE ▶ You can also access the Naming Presets by choosing Aperture > Presets > File Naming…

2 Click in the empty area at the bottom of the Name column on the left to deselect any of the default presets.

3 Click the "+" button in the lower-left corner of the Naming Presets window to create an untitled new preset.

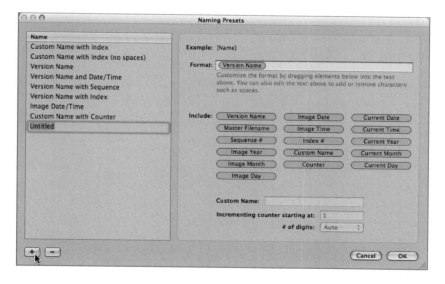

4 To name the preset, type *Custom Name Index Year Month* in the Custom Name field and press Return.

5 Click to the right of the Version Name preset in the Format field and press the Delete key to clear out the Format field.

6 Drag the Custom Name bubble to the Format field. Click to the right of the Custom Name bubble, then press the spacebar to add a space after Custom Name.

Leave the Custom Name field in the lower-right section of the Naming Presets window blank. This will require you to enter a name whenever you utilize this preset.

7 Drag the Index # bubble to the space at the right of the Custom Name bubble. Click to the right of the Index # bubble and press the spacebar to insert a space.

8 Drag the Image Year bubble to the right of the Index # bubble. Then drag the Image Month bubble next to the Image Year bubble, making sure not to leave any spaces between Image Year and Image Month. The result should match the graphic below.

The Example field in the upper-right area of the Naming Presets window displays a preview of the result of what's currently in the Format field.

9 Click the OK button to save this new preset.

The newly created preset will automatically be active and displayed next to Version Name in the right pane of the Import window.

10 Type *West Africa* in the Name Text field. Make sure that "Apply to Master filenames" is not selected.

The new preset you've created will result in a version name that includes the custom name you entered followed by an index number and the image year and month. Next you'll enter additional metadata to complete the import.

Time Adjustment and Additional Metadata

Most photographers keep the time zone on their camera set to their home time zone. In Aperture you can adjust the time zone to accurately reflect the time zone where the image was shot. When you import images shot at a specific location, it's a good time to add at least basic metadata such as the city and country.

1 Click the radio button next to Adjust Time Zone.

2 John Fleck's camera was set to US/Eastern. Make sure the Camera Time Zone is set to US/Eastern.

3 The images we're importing were shot in Nairobi. Set the Actual Time Zone to Africa > Nairobi.

4 In the Add Metadata From menu, select IPTC – Expanded.

5 Enter *John Fleck* in the credit field.

6 Enter © *John Fleck 2007* in the Copyright Notice field.

7 Enter *Nairobi* for the city and *Kenya* for the country.

8 Click the Import All button.

An animated icon appears next to the Lesson03 project. You can continue to work during Aperture import.

9 When the Import Complete dialog appears click the OK button.

 TIP Often, metadata is added by your camera automatically. Some newer cameras include a GPS module in the camera which can be used to "geotag" your images. If your image files contain GPS data you can choose Metadata > Show on Map… to display the image on a global map. This can be useful if you are shooting images for news or documentary purposes.

The import process is complete. The metadata that we entered is applied to all the images imported.

Using Keywords

With the West Africa images imported and organized into stacks, we're ready to start adding keywords. Keywords—descriptive words about the subject matter of an

image—are added to image versions and saved as metadata. They provide an automated way to filter, select, and organize your images. You can add keywords at any time and will often refine your keywords while you work. You'll add metadata using a variety of methods in following section.

Assigning Keywords Using the Metadata Inspector

1 If necessary, cycle the Viewer to a split-screen Browser and Main Viewer view by pressing the V key.

2 Press W to cycle through the Inspector tabs until the Metadata tab is active.

3 Select General from the menu under the Metadata tab.

4 Select the first three images: **West Africa 1**, **West Africa 2**, and **West Africa 3**.

Note that all the images in the Lesson03 project end in 200710. For brevity's sake, this exercise's steps will reference just West Africa plus the index number.

5 Type *West Africa Nairobi* in the keyword field under the Metadata tab.

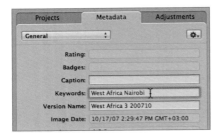

When a keyword is applied to an image, a badge is also attached. The badge can be displayed in both the metadata or by a predefined metadata set in the Browser or Viewer. The default view we're in for both the Viewer and Browser will display the badge on the lower-right corner of the image or thumbnail.

6 Click one of the non-primary images in the Main Viewer.

The field for keywords, in which you just typed, is blank. The information in the Metadata tab is specific to a single image. Any changes or additions made in the metadata affect only the primary selected image. Later in the lesson we'll learn how to apply keywords to multiple images.

Defining Keywords

For the sake of efficiency, it's best to assign keywords to groups of images. The first step is determining what words to use. The goal is to create keyword tags that will let you perform useful searches, both inside the project and within your entire Aperture library. So you need to think about how you might want to search.

For this project, let's assume we'll continue to work with this set of images; images from other shoots, however, will probably be organized in other projects. So we want to be able to search our entire library for West Africa Nairobi images.

In this project, we have three basic types of images: Solo, Group, and Cityscapes. We'll want to be able to search for any of those.For keywords, we'll use work, school, and leisure to differentiate between shots. Note that the images don't have to conform to only one of these categories. Creating your own keyword hierarchy is highly subjective; you need to find a balance between an effective number of keywords and the amount of time you spend creating and attaching keywords. You can apply as many keywords to an image as you like. Let's begin by opening the Keywords HUD.

Working in the Keywords HUD

1 To open the Keywords HUD, choose Window > Show Keywords HUD, or press Shift-H. You use the Keywords HUD to set keywords.

The Keywords HUD contains a number of predefined keywords organized by category, such as "Wedding." You should also see the West Africa Nairobi keyword that you added earlier.

TIP If you don't want to use the predefined keywords, you can delete them. For example, if you never shoot weddings, you can delete the Wedding category by selecting it and then clicking the Remove Keyword button at the bottom of the HUD.

You can group keywords hierarchically in the Keywords HUD. This allows you to keep your keywords organized by subject. Note that the "West Africa Nairobi"

keyword doesn't have a disclosure triangle next to it. This is because it doesn't have any subordinate keywords attached to it. Now we'll define the keywords we discussed earlier, but we'll include them all as subordinates of "West Africa Nairobi" to keep our Keywords HUD tidy.

2 With the "West Africa Nairobi" keyword selected, click the Add Subordinate Keyword button at the bottom of the Keywords HUD.

"West Africa Nairobi" becomes a keyword group, with one subordinate keyword: "Untitled."

NOTE ▶ Clicking the Add Keyword button always adds a keyword at the same level as the currently selected keyword. Clicking the Add Subordinate Keyword button always adds a new keyword as a child of the currently selected keyword.

3 Change the untitled keyword to *Group*.

4 With "Group" still selected, click the Add Keyword button. This will add another "Untitled" keyword at the same level as "Group."

5 Rename the new keyword *Solo* and press Return.

6 Click the Add Keyword button. Change "Untitled" to *Cityscape* and press Return.

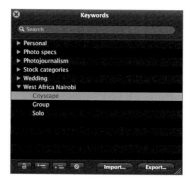

We're on a roll. Let's keep going.

Adding Keywords and Groups

Now let's add another layer of specificity to our keyword scheme. So far we've identified three categories for our group and solo shots: work, school, and leisure. We'll create two separate groups to house each set.

1 With "Group" selected, click the Add Subordinate Keyword button to create a new, untitled subordinate keyword. Rename it *Work*.

2 With the "Work" keyword selected, click the Add Keyword button to create a subordinate keyword below "Group."

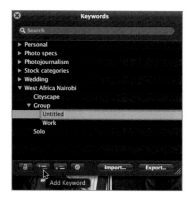

3 Rename the new keyword *School*.

4 With "School" selected, click the Add Keyword button and add "Leisure" as the third keyword subordinate to "Group."

5 Now select "Solo" and click the Add Subordinate Keyword button to add the keyword "Work" under "Solo."

6 With "Work" selected, click the Add Keyword button two times to create two new keywords at the same level as "Work." Rename these two *School* and *Leisure*. When you're finished, your keyword group should look like the following figure.

Note that it doesn't matter in what order you add the keywords. Aperture automatically alphabetizes them in the Keywords HUD.

TIP ▶ Open and close the keyword groups by clicking their disclosure triangles. Closing them gives you more room to work in the HUD but doesn't let you see what's inside the group.

These should be all the keywords that we'll need for this project. Of course, we can always add more later, either to the Keywords HUD for batch application, or to individual images using the Metadata inspector. It's important to understand that the hierarchical structure shown in the Keywords HUD is for organizational purposes only. Keywords don't actually have a hierarchical relationship. Now let's apply these keywords to some images.

Dragging and Dropping Keywords

The first way to assign keywords to images is to drag them directly from the Keywords HUD to the image or images.

1 Cycle the interface to Browser-only view by pressing V, making sure that all stacks are open (Option-'), that the Metadata inspector is open (Control-D), and that the Keywords HUD is open (Shift-H).

In the first stack of the project, you already added the "West Africa Nairobi" keyword to one of the images. Let's add this keyword to all the images.

2 Press Command-A to select all the images in the Browser.

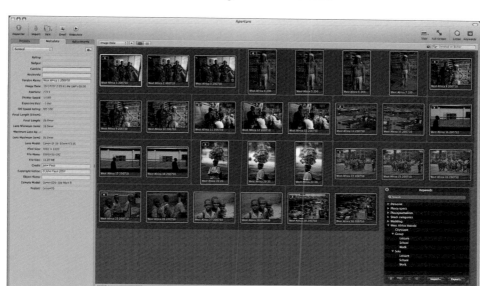

3 Drag the "West Africa Nairobi" keyword from the Keyword HUD onto any one of the selected images.

All the selected images now have the keyword "West Africa Nairobi."

4 Click the Show Keywords Tab button on the bottom of the Metadata tab or press Control-K.

5 Select the first stack of images, **West Africa 1-3**.

We need to add the keywords "Group" and "Work" to this stack.

6 Click Group to select it in the Keywords HUD, then press the Command key and click Work in the hierarchy below. When both are selected, drag them to any one of the three selected images.

In the Metadata inspector, you can see that both keywords were added to the image.

TIP ▶ You can click the Primary Only button if you only want to add metadata to the primary selection as you did in Lesson 2 with Ratings.

7 The Keyword summary area should look like this:

The Keyword summary area shows the keywords that are attached to the current primary selection. Although the keywords reference the hierarchy that they came from, the keywords in the hierarchy are not applied unless they're also dragged onto the selected images.

8 Press Shift-H to close the Keyword HUD.

Using Keyword Buttons

If you want to add keywords to just a few images, dragging from the Keywords HUD is easy enough. If you're working with large batches of images, though, you'll probably find it easier to use Aperture's Keyword buttons. Let's begin.

1 Cycle to the split Browser and Viewer view by pressing V.

2 Select Show Keyword Controls from the Window menu, or press Shift-D.

The control bar will show special Keyword buttons and controls on the left side.

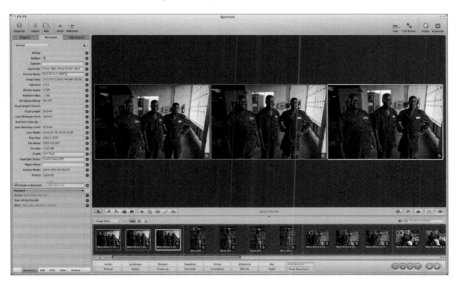

You can use the Keyword buttons to assign keywords with a single mouse click or keyboard shortcut. However, Aperture's Keyword buttons are initially configured with a set of default keywords, not the ones we defined in the Keywords HUD. So we have to

create a custom Keyword button set with the West Africa Nairobi keywords before we can apply them.

NOTE ► You can edit the Keyword buttons regardless of what images are open in the Browser or what layout you're using.

3 In the control bar, click the Select Preset Group pop-up menu and choose Edit Buttons.

The Edit Button Sets window opens, allowing you to create groups, or sets, of Keyword buttons. You can define as many keyword groups as you want and freely switch among them to perform different keyword functions.

4 Click the Photo Descriptors button set in the left column to select it. The contents of this set—the Keyword buttons it contains—appear in the middle column. The right column shows all of your currently defined keywords (your Keywords library).

5 Click the Add (+) button in the lower-left corner of the window to create a new keyword preset group.

6 Name the new keyword preset group *W Africa N (Solo)* and press Return. The Contents column will be empty, because the new preset group doesn't have any keywords in it yet.

> **TIP** ▶ Keeping group names short will make them easier to view in the control bar's Select Preset Group menu.

7 In the Keywords Library column, click the disclosure triangle next to "West Africa Nairobi" and the subordinates to see all of the keywords that you defined earlier.

To add keywords to the preset group, drag them from the Keywords Library column to the Contents column.

> **TIP** ▶ If you have a particularly large Keywords library, you can use the search field at the top of the Keywords Library column to find the keyword you'd like to add to your new set.

8 Click "West Africa Nairobi" and then Shift-click the last item, "Work (solo)," to select all the "Work (Solo)" images in "West Africa Nairobi."

9 Drag them all to the Contents column.

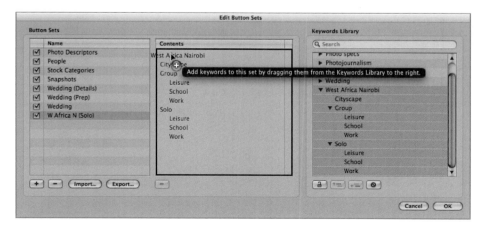

You can rearrange the order or delete keywords in the Contents panel by simply dragging them up and down.

10 Select Group and the corresponding Leisure, School, and Work keywords in the Contents column. Press the Delete key. The resulting Contents column should match the graphic below.

NOTE ▶ You can edit your Keywords library using the buttons at the bottom of the right column in the Edit Button Sets dialog. All four buttons—Lock/Unlock Keyword, Add Keyword, Add Subordinate Keyword, and Remove Keyword—work just like the equivalent buttons in the Keywords HUD.

11 Click the + button under Button Sets to create a new group. Title the group *W Africa N (Group)* and press Return.

12 From the Keywords library select West Africa Nairobi through the "Work (group)" keyword. Drag the keywords into the Contents column. The final result should match the graphic below.

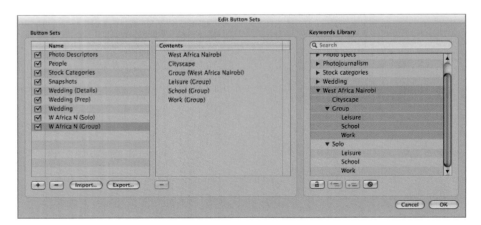

13 Click OK to save the new keywords and groups and close the Edit Button Sets dialog.

You may have noticed that the keywords "West Africa Nairobi" and "Cityscape" are in both groups. You can use the same keyword in as many groups as you'd like. It can be convenient to have certain keywords in multiple sets. Now that we've created the buttons, let's use them to apply more keywords.

Applying Keywords Using Buttons

Eagle-eyed observer that you are, you've already noticed that the Keyword buttons in the control bar are unchanged—the control bar is still showing the Photo Descriptors keywords. We have to select our button set in order to use it. Let's do that now.

1 Click the Select Preset Group pop-up menu and choose W Africa N (Solo). The West Africa Nairobi solo Keyword buttons now appear in the control bar.

2 If they're not already open, open all stacks by pressing Option-Apostrophe (').

3 Press Control-D to open the Metadata inspector and, if necessary, click the Keywords button at the bottom of the Inspector to show the Keyword summary area.

4 Select the four images in the second stack of the Browser. West Africa images 4–7 appear in the Viewer.

5 Click the Solo button on the control bar to apply the keyword to all four of the selected images. "Solo (West Africa N)" should appear in the Keyword field. The

parenthetical information lets us know that "Solo" is a subordinate keyword of "West Africa Nairobi."

6 Click the Work button to assign the keyword "Work" to the three images.

7 Select the next stack of three images, **West Africa 8-10**.

We want to apply the "W Africa N (Group)" keywords, but we need to change groups first.

8 Press the Period key (.) to change to the next preset group.

9 Click the Group button and then the Work button to assign the keywords.

The Keyword summary area in the Metadata inspector should show two keywords assigned to your images.

Applying Keywords Using Keyboard Shortcuts

Now let's try another method of assigning keywords: using keyboard shortcuts. Not having to use the mouse will greatly speed your keywording work.

1 With the three images still selected from the previous exercise, press Command-Down Arrow once to move the three selections to the next three images: **West Africa 11-13**, sequential shots of three workers next to several white bags of wheat flour.

2 Position the cursor over the Group button on the control bar.

A pop-up window displays the keyboard shortcuts for the button. Option-3 will add the "Group" keyword, and Shift-Option-3 will remove the "Group" keyword.

The default keyboard shortcuts for the keyword controls are as follows:

Add	Option-1	Option-3	Option-5	Option-7
Remove	Shift-Option-1	Shift-Option-3	Shift-Option-5	Shift-Option-7
Add	Option-2	Option-4	Option-6	Option-8
Remove	Shift-Option-2	Shift-Option-4	Shift-Option-6	Shift-Option-8

The keyboard shortcuts are assigned up to a maximum of 8.

3 Press Option-3 to assign the keyword "Group" to all three images.

NOTE ▶ If you're using a keyboard with an extended numerical keypad, the numerical keypad won't work for the Keyword control shortcuts. Instead use the numerical keys on your main Keyboard.

4 Press Option-6 to add "Work."

NOTE ▶ Although it's open here, the control bar doesn't have to be open for the keyword keyboard shortcuts to work.

5 Select **West Africa 14** in the next stack, and then use Shift-Right Arrow to select the adjacent image, **West Africa 15**.

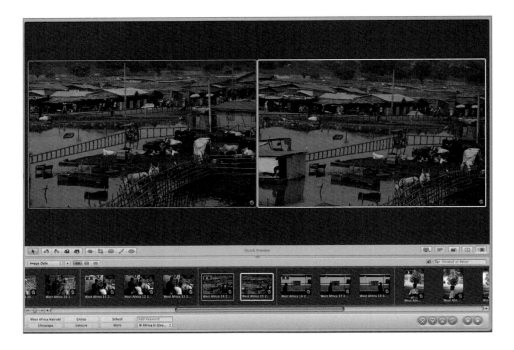

6 Assign the "Cityscape" keyword by pressing Option-2.

7 Press the Right Arrow key to select the first image of the next stack, **West Africa 16**. Hold down Shift and press the Right Arrow key twice to select the second and third images in the stack. **West Africa 16-18** should be selected.

8 Press comma (,) to switch back to our other preset group, "W Africa N (Solo);" then press Option-3 and then Option-4 to apply the keywords "Solo" and "Leisure."

9 Select the shots of the school children, **West Africa 22-28**.

10 Press period (.) to switch the preset group to "W Africa N (Group);" then press Option-3 and then Option-5 to apply the keywords "Group" and "School."

 Moving right along, let's learn how to apply keywords using the Lift & Stamp tool.

Applying Keywords Using the Lift & Stamp Tools

You've probably noticed that many of your images need the same keywords. Once you've gone to the trouble of assigning keywords to one image, you can easily copy those keywords to other images using Aperture's Lift & Stamp tools. The Lift tool lets you copy metadata and adjustments from one image and apply them to other images.

> **NOTE** ▸ In this exercise you'll keep Quick Preview active which limits the Lift & Stamp operations to metadata only. You'll learn how to perform Lift & Stamp image adjustments in Lesson 7.

1 Press V to cycle to a Browser-only view. If necessary, drag the Browser thumbnail slider to display all the images.

2 Select the first image **West Africa 4** in the second stack.

This is the portrait of the shirtless worker. We want to apply the same keywords from this image to other groups of images. Let's use the Lift & Stamp tools to do so.

3 Click the Lift button in the lower-left area of the Browser, or press Shift-Command-C.

The Lift & Stamp HUD appears with metadata lifted from the selected image. A checkbox appears next to each item allowing you to deselect the item if you don't

want to stamp that information onto another image. You can also select a line item
and press Delete to omit the item from the listing.

4 Click the disclosure triangle next to Keywords in the Lift & Stamp HUD to reveal the
lifted keywords.

5 Select **West Africa 19-21**, the stack of three images with the street vendor wearing his
merchandise on his head.

Note that the only keyword attached to these images is "World Africa Nairobi."

6 Click the Stamp Selected Images button in the Lift & Stamp HUD.

The keywords "Solo" and "Work" are stamped onto the images. The repeated keyword "West Africa Nairobi" is left alone.

7 Select the **West Africa 14** image.

8 Press Shift-Command-C to lift the metadata and replace the lift data from the Lift & Stamp HUD.

9 Select the **West Africa 29 & 30** images of the city.

10 Press Shift-Command-V to stamp the images with the lifted keywords.

11 Close the Lift & Stamp HUD by clicking the X in the upper-left corner.

Editing and Managing Metadata Views and Presets

The information displayed in the Metadata tab is a metadata view. This view is completely customizable. You can edit an existing view or create your own.

1 If necessary, press the W key to cycle through your Inspector tabs until the Metadata tab is selected. The last image, **West Africa 30**, should still be your primary selection.

2 Press Control-K to close the Keywords tab.

3 From the Action pop-up menu located in the upper-right corner of the Metadata tab, choose Edit "General" or press Control-I.

Minus signs appear to the right of each line item. Additionally, the IPTC area appears on the bottom of the tab.

4 Click the minus sign next to Focal Length (35mm), Maximum Lens Aperture, and Object Name.

Now let's add some information.

5 With the bottom IPTC tab still open, select the checkboxes next to City and Country Name.

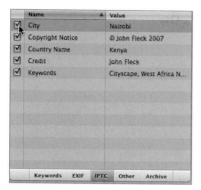

The new items are added to the list in General view. The order of the items in the Metadata tab can also be changed.

6 Position the cursor over the File Name field title in the Metadata tab list.

The background behind the File Name becomes highlighted. Drag File Name below Version Name.

NOTE ▶ You can add or subtract as many fields as you'd like. A subtracted field isn't deleted, just filtered from view.

7 Click the EXIF tab on the bottom of the Metadata tab or press Control-E. Select the checkbox next to Serial Number to add the field to the General view.

8 In the metadata view drag Serial Number right below the camera model.

9 Click the EXIF button or press Control-E to exit editing mode.

Creating a New Metadata View

You can create your own views with as many or as few fields as you like. In many cases it can be difficult to find specific information when so many fields are displayed. Creating a view with reduced fields may reduce your eyestrain as you scan a shorter list.

1 From the Action pop-up menu choose New View.

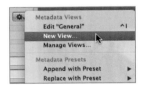

2 Type *Location* when prompted and click the OK button.

The IPTC tab opens automatically to display fields that contain user data entry.

3 With the IPTC tab open, select the checkboxes next to City, Country Name, and Keywords. All three items appear in the list.

4 Click the Show Other tab button to open the Other tab.

5 Select the checkboxes next to Camera Time Zone, File Name, Import Session, Picture Time Zone, and Version Name.

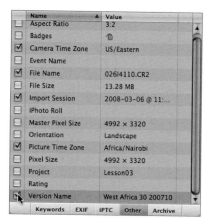

6 Position the cursor over the text Version Name in the Location set list and drag it to the top.

7 Drag the File Name field right below the Version Name field.

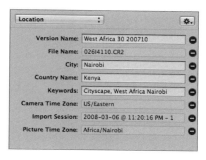

8 Click the Other tab button to close the tab and finish editing the fields for the Location preset.

9 From the Action pop-up menu in the Metadata tab choose Manage Views.

10 In the window that appears, scroll down and position your cursor over the word Location. Drag Location up until it's the second item below General. Click the OK button when you're done.

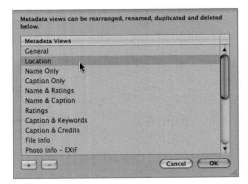

Now there's a view that displays information about when the photo was shot as well as when it was imported. A view can also be saved as a preset that can be applied to other images.

Creating and Applying Metadata Presets

Metadata presets can be big time-savers when you need to apply repetitive metadata across multiple images. Imagine always tagging the same images from a particular location or a particular client. Here's how you do it in Aperture.

1 Press W to cycle to the Projects tab. Select the **Lesson02** project.

2 Both the Browser and the Main Viewer should be displayed. If not, press V to cycle through your views until they are.

3 Press W to cycle to the Metadata tab. Choose General from the Metadata Views pop-up menu.

The Credit and the Copyright Notice fields weren't filled out during import, so we're going to enter the credit and copyright information. This will flag the field as modified. We can then save the modifications as a preset.

4 Enter *John Fleck* in the Credit field and © *John Fleck* in the Copyright Notice field.

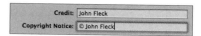

5 In the Browser, click the SingaporeSheets image to accept the new text.

NOTE ▶ If you had pressed Return prior to clicking out of the field box it would have created a new line inside the field.

6 From the Action pop-up menu choose Metadata Presets > Save as Preset... Name the new preset *Copyright Basic – Fleck* and click OK.

7 Choose Stacks > Open All Stacks. Press Command-A to select all.

The Main Viewer will display as many images as possible corresponding to the size of the display you're working on.

8 From the Action pop-up menu choose Batch Change or press Shift-Command-B.

The Batch Change window appears.

9 Choose Copyright Basic – Fleck from the Add Metadata From pop-up menu.

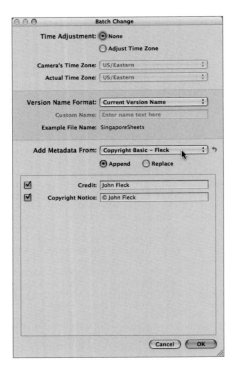

The filled-in Credit and Copyright Notice fields appear.

10 Click the Replace radio button.

Because we originally modified **SingaporeSheets**, if we chose Append it would create a second set of duplicated text in the two fields.

11 Click the OK button to apply.

Modifying One Field of Metadata Quickly

In some situations you may need to enter custom metadata for each image. This process can be tedious. Fortunately, Aperture provides a way to have the Metadata field you are working on stay active while you change images.

1 Select the **Singapore Sheets** image in the Browser. Click the Metadata Tab and select General from the shortcut menu.

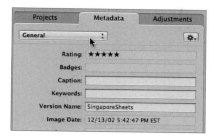

2 Type *Sheets on a clothesline in Singapore* in the Caption field.

3 Press Command-Right Arrow.

A new image is selected but the Caption field remains ready for you to type in.

4 Type *Lighthouse in the mist.*

5 Press Command-Right Arrow on the keyboard.

6 Type *Graphic Table Shadows.*

TIP ▶ Pressing Command plus any of the arrow keys will allow you to keep a field live while changing images.

Sorting and Filtering Your Project

You spent quite a bit of time in Lesson 2 rating your images. Although metadata can be informative on its own, it's the ability to sort and organize images based on that metadata that makes the time you spend applying it worthwhile.

Filtering in the Browser

The Browser filter field is a quick way of controlling which images you're viewing.

1 Press Shift-Command-A to deselect any images.

2 Press V to cycle to a Browser-only view.

3 Press I to close the Inspector.

4 All the stacks should be open. If not, choose Stacks > Open All Stacks.

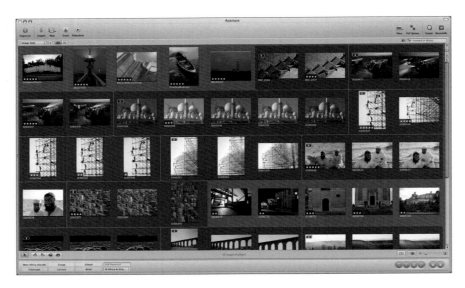

5 Click the small magnifying glass in the Browser search field to open the ratings pop-up menu.

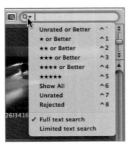

6 Choose the "*** or Better" option.

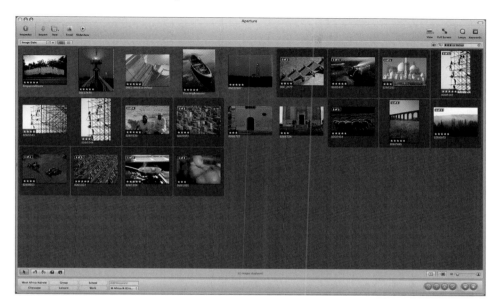

The number of images displayed is reduced. Note that some of the images have an indicator in the upper-left corner that reports how many images from a stack are displayed. The filter looks at all the images inside of a stack, whether stacks are opened or closed.

7 Click the small x on the right side of the Browser search field to clear the field.

8 Type *Singapore* in the Browser search field and press Return.

The **SingaporeSheets** image is displayed as the only result.

9 Click the small x on the right side of the Browser search field to clear the field.

10 Click the search field and press Option-H, and then press Return.

The images all disappear. The Browser search field searches for any character you enter. Entering Option-H inserted an almost invisible character.

The Browser search field doesn't automatically clear out even if you quit Aperture. Many a user has accidentally entered a character in the search field and panicked when their images disappeared.

11 Click the x in the Browser search field to clear out any characters.

The images return and all is well.

> **TIP** ▶ You can always tell that there's a character entered in the Browser search field if the small x on the right side appears.

Using the Query HUD

In the Browser Filter Query HUD you can enter much more detailed information for filtering your images.

1 Click the Query HUD button to the left of the Browser search field.

The Query HUD appears. Although the Query HUD window appears right below the Query HUD button, like all HUDs in Aperture, it's a free-floating window that you can drag to wherever you'd like on your screen.

2 Drag the Rating slider to three stars.

As before, only three-star images are shown. Now let's narrow it down.

3 Select the Calendar checkbox.

A calendar appears. Dates that are displayed in bold type indicate that images shot on that particular date are part of this project.

4 Click the double arrows above the center month to navigate to May 2007. Command-click to select May 15, 17, and 19.

The Browser now displays all four three-star or better images that were shot on May 15, 17, or 19.

5 Close the Query HUD by clicking the x in the upper-left corner. The Browser search field displays badges indicating the search criteria.

6 Click the x in the search field to clear out the filter criteria.

The cleared-out Browser search field defaults to "Unrated or Better." If you reject an image, it will disappear from the Browser view. You can always search for rejected images to retrieve the rejected images.

Working with Albums

Albums are sort mechanisms in Aperture. They allow you to manually sort images. They don't move or alter your images; they simply point to them. It's easiest to select the images you want to include in an album prior to creating the album.

1 Press W to cycle through the Inspector tabs to get to the Projects tab.

2 Press Shift-Command-A to deselect any images.

3 Click the disclosure triangle next to the Lesson02 project to display the World Light Table. Do not select the World Light Table at this time.

4 Select the first four images in the Browser: **SingaporeSheets**, **DSC07479**, **DSC0186811x14Final**, and **CourtingBoatcolor**.

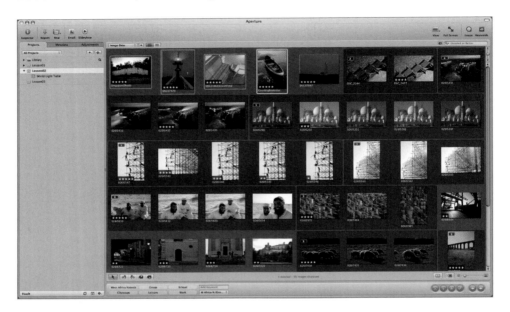

5 Choose Album from the New button menu in the toolbar or press Command-L.

The new album appears under the Lesson02 hierarchy and contains the four selected images.

6 Type *Approved* for the newly created album and press Return.

This album could be used to display images that have already been approved for posting.

7 Click the Lesson02 project in the Inspector.

8 Drag the lighthouse shot **DSC07087** onto the Processed album. An outline will appear around the Processed album. The image is added to the Approved album manually.

9 Click the Lesson02 project in the Inspector.

10 Select the first five images that are also in the Approved album.

11 Press Command-R to invert the selection.

This is a great shortcut if the image or images you don't want to select are in the minority.

12 Choose Album from the New button menu in the toolbar or press Command-L.

13 Type *Pending* for the newly created album. The selected images are now part of this album.

Working with Smart Albums

In the previous exercise you manually added images to a standard album. To make changes to a standard album, you have to manually add or remove images.

Smart Albums, like filtered Browsers, are updated dynamically according to metadata criteria that you define. When you change the criteria associated with a particular Smart Album, the contents of the Smart Album change automatically. Now we'll create a Smart Album that contains five-star images.

TIP ▶ Aperture comes with a selection of Smart Albums already set up in the library. For example, there are Smart Albums that gather all the images taken in the previous week, and all the images taken in the previous month. Click the Library disclosure triangle at the top of the Projects panel to see the preset Smart Albums that Aperture has created for you. Select any Smart Album to see its contents in the Browser.

Creating Smart Albums

1 Make sure the Lesson02 project is selected in the Projects panel and then choose File > New Smart > Album (Command-Shift-L) or click the New Smart Album button on the toolbar.

A new, untitled Smart Album appears along with a Query HUD (located next to the magnifying-glass icon) for setting the criteria for this Smart Album.

2 Rename the untitled Smart Album *Five Stars* and then press Return.

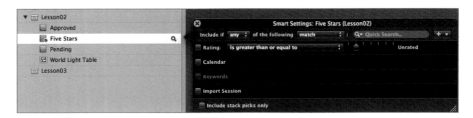

The Query HUD, as mentioned earlier, lets you specify your search criteria. The title of the Query HUD includes the name of the Smart Album along with the search source in parenthesis. Smart Albums can search projects, folders, or entire libraries.

3 Make sure the Rating checkbox is selected and that the Rating pop-up menu is set to "is greater than or equal to." Then drag the Rating slider all the way to the right to specify five-star images.

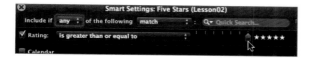

4 Click the circled X in the upper-left corner of the Smart Settings HUD to close it.

The images matching the search criteria appear in the Browser. You can work with these images in the same way as you can work with the images in any project or standard album. If you change the search criteria, Aperture will update the Smart Album so that it comprises all the images in the Travel folder that meet the new criteria.

5 Select the Lesson02 project and press Command-Shift-L to create a new Smart Album. Name the smart album *Three Stars*.

6 Drag the rating slider in the Smart Settings HUD to three stars.

7 Click the circled X in the upper-left corner of the Query HUD to close it.

The three-star images are displayed. This includes images that were the alternates in a stack. By default the Smart Album searches inside of stacks. Let's modify this Smart Album to sort through the Pick of a stack and ignore the alternates.

8 Click the small magnifying glass icon to the right of the Three Stars Smart Album to open the Smart Settings HUD.

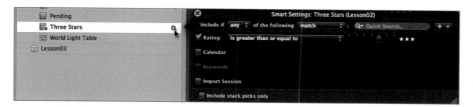

9 Position the cursor over the title bar of the Smart Settings HUD. Drag the Smart Settings HUD to the lower left so it's out of the way of the Browser images.

10 Select the "Include stack picks only" checkbox on the bottom of the Smart Settings HUD.

Selecting the "Include stack picks only" checkbox will filter out any images that are not the Pick of the stack prior to applying the filter criteria.

11 Click the circled X in the upper-left corner of the Smart Settings HUD to close it.

Creating Smart Albums from the Browser Filter

The Browser filter can be used to create either albums or Smart Albums. The advantage of this approach is that you're choosing to create an album or Smart Album after already viewing the results. You can also quickly create several albums or Smart Albums by changing criteria in the Browser's Filter HUD and creating a new album or Smart Album.

1 Select the Lesson03 project in the Projects inspector.

2 Make sure you're still viewing only the Browser. If necessary, cycle to the Browser-only view using the V shortcut key.

3 Click the Browser Filter button in the upper-right corner of the Browser. The Filter HUD appears.

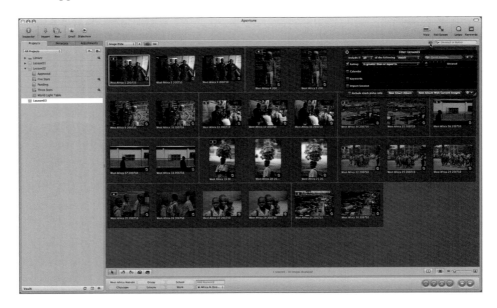

4 Select the Keywords checkbox in the Filter HUD.

A listing of keywords used in Lesson03 appears with corresponding checkboxes.

5 Select the checkbox next to Cityscape.

6 Click the New Smart Album button on the bottom of the Filter HUD.

A new Smart Album appears beneath the Lesson03 project in the Projects inspector.

7 Name the new Smart Album *Cityscape* and press Return.

8 Select the Lesson03 project once again.

The Filter HUD remains open awaiting your next creation.

9 Keywords and Cityscape should still be selected. Change the criteria for the top item to Include if "all" of the following "do not match" by selecting from the corresponding pull-down menus.

The image sort inverts the selection to not include images with the Cityscape keyword. Interesting, but we don't need an album with this criterion.

10 Reset the top line in the Filter HUD to Include if "all" of the following "match."

11 Change the menu next to Keyword to "do not include any of the following."

12 Set the Ratings slider to five star.

No images appear because you haven't rated any of the Lesson 03 images. You'll take care of that in the next exercise.

13 Click the New Smart Album button and name the Smart Album *Five Star No Cityscape* and press Return.

14 Close the Browser Filter HUD by clicking the x in the upper-left corner of the HUD.

> **TIP** ▶ The data you can base a search on is vast. It can include camera-specific information such as a camera's serial number or specific shooting characteristics such as focal length, f-stop, or any setting that is saved as part of the EXIF information. Additionally, you can search based on any image adjustments. As you work your way through the lessons in the book, try searching for images based on the image adjustments you're applying. Try also searching for images that have not been adjusted. This a great way to keep track of the images that need additional work.

Viewing and Organizing Multiple Projects

Many times, viewing one project element in Aperture is not enough. Aperture can display more than one element by splitting the Browser into multiple panes or tabs.

Using Folders

Folders are used to organize elements in the Projects inspector. Beyond simply organizing elements, selecting a folder will display the contents of any of the elements in that folder.

1 Select the Lesson02 project and then choose File > New Folder (Command-Shift-N).

2 Name the new folder *Albums* and press Return.

3 Drag the Approved album and then the Pending album onto the Albums folder.

An outline will appear around the Albums folder when an element is being dropped onto it.

4 Repeat step 3 with the Three Stars and Five Stars albums.

All four albums are now organized into a folder.

5 Select the library in the Projects tab.

6 Press Command-Shift-N to create a new folder.

7 Type *Travel* and press Return.

8 Drag the Lesson02 project and then the Lesson03 project onto the Travel folder.

The two projects are now organized into one tidy folder.

9 Select the Travel folder. All the images from both Lesson02 and Lesson03 are displayed.

NOTE ▶ Folders can be used to group any of the elements in the Projects panel with the exception of the library.

TIP ▶ Place multiple projects into folders based on location, client, or genre. You can view images from the individual projects by selecting the project, or view images from multiple projects together by selecting the folder.

Working with Browser Views

There are three main views in the Browser. The Filmstrip is a lean one-row view of your thumbnails. The grid view is a multiple row and column view that's similar to a contact sheet. The list view is a line-item display of your images that can be a powerful ally when sorting and viewing images by metadata.

1 Select Lesson02, which is now inside the Travel folder in the Projects tab.

2 Press the I shortcut to close the Inspector pane.

3 Cycle to a Browser-only view using the V key.

 This is the grid view. You've been working in this Browser view for most of this lesson.

 NOTE ▶ When you're in a Browser-only view, the Filmstrip option is not available.

4 Click the List View button on the upper-left corner of the Browser or press Control-L.

 A list of images appears in a form similar to a spreadsheet.

5 Drag the Thumbnail slider on the lower-right corner of the Browser all the way to the right.

6 Press Option-Apostrophe (') to open all stacks.

Although this is a list view, you can enlarge the thumbnails to be able to view them. A disclosure triangle indicates a stack. Clicking the disclosure triangle reveals the other images in a stack.

7 Close all stacks by pressing Option-Semicolon (;). Then click the Rating heading on the top of the list view.

The list view is now sorted by rating. You can click any heading in the list view to sort.

8 Drag the Ratings heading to position the Ratings column as the second item.

Any of the headings in list view can be repositioned by dragging.

9 Click the Grid View button or press Control-G to return to a grid view.

Aperture separately keeps track of what Browser view you're in for both the Browser-only view and the split Browser and Main Viewer view.

10 Cycle to a Browser and Main Viewer view by pressing the V shortcut key.

11 Make sure you're in the Filmstrip view. If necessary, click the Filmstrip button in the upper-left corner of the Browser or press Control-F.

12 Position your cursor over the line that separates the Main Viewer and the Browser. The cursor will change to a double arrow.

13 Drag upwards and release the mouse button when the line is one-third of the way up your screen.

The images scale as you drag the split line.

14 Press Control-G to switch to the grid view.

15 Drag the split view line upwards until it's positioned about one third of the way up the screen.

Additional rows of images appear. The list view can also be used in the Browser and Main Viewer display.

Working with Projects in Tabbed and Split Panes

Putting projects, folders, and albums in tabbed and split panes is a great way of accessing them quickly without having to select them in the Projects panel. Tabbed and split panes are also useful when you're working with more than one project at a time.

1 Make sure you're in a Main Viewer and Browser split. If necessary, cycle to this view using the V shortcut.

2 Press I to display the Inspector pane. Make sure the Projects tab is showing. If necessary cycle to the tab using the W shortcut key.

3 Click the Filmstrip button or press Control-F and drag the split between the Viewer and Browser as far down as you can.

4 Select the Approved album which is inside the Projects tab (Travel > Lesson02 > Albums).

5 Command-click the Pending album inside the Projects tab > Travel > Lesson02 > Albums.

The Pending album appears as a second tab in the Browser.

6 Click the Approved album tab in the Browser.

The Approved album becomes the active tab in the Browser. Only one Browser tab can be active at a time.

7 Command-click World Light Table in the Projects tab located in Travel > Lesson02.

The World Light Table appears in the Main Viewer with the corresponding tab in the Browser. Multiple project elements can be part of the tabbed Browser interface.

8 Command-click the Lesson03 project inside the Travel folder of the Projects tab.

NOTE ▸ Any Project element can become a tab in the Browser.

9 Click the small circled x in all the tabs in the Browser except Lesson03.

Organizing Images Using Split Panes

With split panes, we can select certain images to view in one pane, change ratings or other metadata, and view the results in another pane. Let's take a look at how this works.

1 Select the Lesson03 project in the Travel folder in the Projects tab. Click the small x in the Browser search field to reset the display criteria.

All the images in the Lesson03 project are displayed in the Browser.

2 Click the Grid View button in the Browser or press Control-G.

3 Adjust the thumbnail slider in the lower-right corner of the Browser until two rows of images are displayed in the Browser.

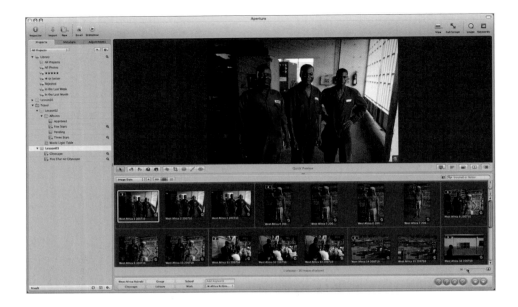

4 Option-click the Five Star No Cityscape Smart Album to open it in a tabbed pane in the Browser.

The contents of the Lesson03 project appear in the left pane of the Browser, and the empty contents of the Five Star No Cityscape Smart Album appear on the right.

5 Select the first three images in the Lesson03 tab beginning with **West Africa 1**.

6 Click the Primary Only button in the lower-right area of the Viewer. You only want to affect the primary selection.

7 Click the center image in the Viewer.

8 Press the 5 key to assign a five-star rating.

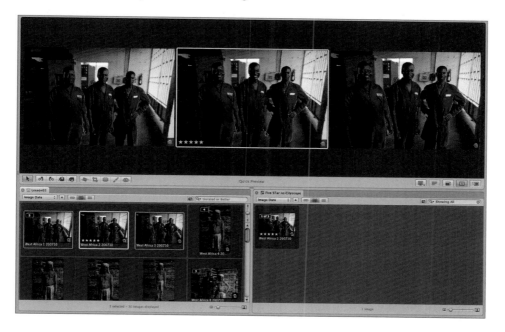

The image immediately appears on the right side under the Five Star No Cityscape browser.

9 Select the next set of images in the Lesson03 tab beginning with **West Africa 4**.

10 In order from left to right, rate the images 2 star, 3 star, 4 star, 5 star.

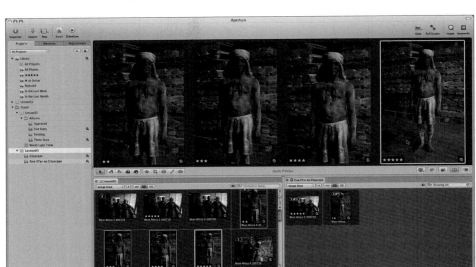

Only the last image appears in the Five Star No Cityscape tab. The combination of Browser tabs and panes can be quite powerful.

11 Close the second Split Pane by clicking the x in the Tab.

Copying and Moving Images between Projects

There may be times that you would like to have images moved or copied to other projects. Let's take some of the five-star images and copy them into a new project.

1 Adjust the interface so that only the Browser and Inspector are visible.

2 Select the Travel folder in the Project pane.

3 Press Command-N to create a new project.

4 Title the new project *Travel Favorites*.

5 Select the Travel folder.

6 Press Control-5 to select to filter the Browser to display only five-star images.

7 Click in the Browser, then press Command-A to select all the images.

8 Position the cursor over one of the images and click and drag onto the Travel Favorites project.

The Move Masters dialog appears.

9 Click the Move button.

The images are moved to the Travel Favorites project folder. References to the images are maintained in any Albums (not Smart Albums). The previously created five-star Smart Albums are now empty. We will leave them in place in case existing or future images are rated five stars.

Project Skimming and Favorites

The Projects tab can become loaded with elements very quickly. As the number of projects, albums, and other elements increases, finding and working on a specific project or element

can be challenging. Fortunately, you have the ability to skim through projects to determine which project you'd like to work on. You can also designate a project element as a favorite to effectively hide other project elements in the Projects tab.

Project Skimming

1 If necessary, click the Library disclosure triangle inside the Projects tab to open it.

2 Select All Projects.

A browser-like area appears, displaying thumbnails of your projects.

3 Adjust the thumbnail scale slider in the lower-right corner to increase the size of the project thumbnails.

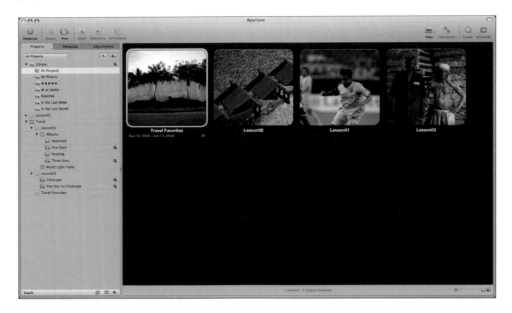

4 Position the cursor over the Lesson02 thumbnail.

5 Move the cursor left and right (skimming) within the frame of the thumbnail.

The images change as you move the cursor within the frame. This is called *skimming*. Imagine if this project were one of several hundred projects and we named the project generically. The name alone would not be much help. But skimming through a project would display the contents.

6 Skim through Lesson02 and stop when one of the shots of the domed building appears. Use the graphic below as a reference.

TIP You can change the order the images are skimmed to either Descending or Ascending by date by right-clicking any of the All Projects thumbnails.

7 Control-click the thumbnail and choose Make Key Photo from the shortcut menu.

8 Move the cursor away from the thumbnail.

The thumbnail updates to display the selected images as the "Key Photo" or representative photo of the project thumbnail.

9 Double-click the Lesson03 project thumbnail.

The view switches and Lesson03 is selected in the Projects pane.

10 Control-click the thumbnail of **West Africa 19** in the Browser. Choose Make Key Photo from the shortcut menu.

11 In the Projects tab, select Library > All Projects.

The Lesson03 thumbnail is now **West Africa 7**.

Favorites

Now let's choose Favorites.

1 Make sure the Projects tab is open. If necessary, press Control-P to open it.

2 Below the Projects tab, choose Recent Projects from the menu.

Recent projects will track the last 20 projects open. Because we have fewer than 20 projects, both options display an identical number of objects.

3 Switch the Projects sort menu back to All Projects.

4 Select the Lesson02 folder from the Projects tab.

5 Click the Action pop-up menu and choose Add to Favorites.

6 Choose Favorite Projects from the menu below the Projects tab. Lesson02 appears.

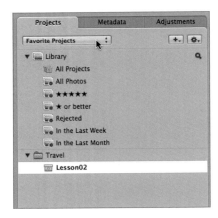

NOTE ▶ The Favorites option is project element-specific. If you want a folder, album, Light Table, or other element to appear in Favorites, you must select the item and choose Add to Favorite from the Action pop-up menu.

7 Switch the Projects sort menu back to All Projects.

Congratulations! You are now an expert at organizing your photos for sorting and viewing.

Lesson Review

1. How does Time Adjustment work?
2. How can keywording help you?
3. What are the different types of views available in the Browser?
4. What are the advantages of working with split panes?
5. What is project skimming?

Answers

1. Time Adjustment uses the camera time zone as a starting point and creates an adjusted time zone based on where a photo was shot.

2. Keywording can be used in addition to the information that's embedded in an image to differentiate between images. This will allow you to create useful searches that can quickly find images inside a project or an entire library.

3. The Browser can display three types of views: a Filmstrip view, a grid view, and a list view. When you're working in Browser-only mode, only the grid view and list view are available.

4. With split panes, you can select certain images to view in one pane, change ratings or other metadata, and view the results in another pane.

5. Project skimming is the ability to quickly view the contents of a project by positioning your cursor over a project thumbnail located in the All Projects item in the Projects tab, and then moving your cursor left and right within the frame of the thumbnail to skim through images.

Image Editing

4

Lesson Files	APTS_Aperture_book_files > Lessons > Lesson 04 > Kid_Photos
Time	This lesson takes approximately 60 minutes to complete.
Goals	Import photos from the iPhoto Browser
	Crop an image to size it
	Straighten an image to improve alignment
	Improve white balance in an image
	Remove sensor dust
	Remove red eye from a photo

Basic Edits

You've now learned powerful ways to import images and organize your library. The next step is to improve your selected images using Aperture's flexible editing toolset. The editing workflow can be divided into five areas of focus.

Basic Edits—Basic corrections include geometric tasks like straightening and cropping, and essential improvements like setting the white balance and removing red eye.

RAW-Specific Edits—RAW files can be adjusted precisely using RAW Fine Tuning, which offers the ability to control Sharpening, Noise Reduction, and Hue Boost.

Tonal Correction—Aperture gives precise control over an image's tonal properties with controls like Highlight Recovery, Levels, Highlights and Shadows, and Contrast.

Color Correction—Aperture lets you enhance the color in an image with control over Hue, Saturation, and Vibrancy as well as isolating and improving individual colors within a photo.

Enhancing Images—It's easy to remove distracting flaws in an image using the Retouch Brush and Spot & Patch tools. Vignettes can also be removed from an image or added for stylistic purposes.

As you narrow down your images and make selects, you'll often need to perform basic edits and corrections. In some cases, you'll want to quickly fix image problems before showing the photos to a client. In other cases, you may want to try straightening or cropping a version of an image to determine if it will work in a certain context. Learning how to perform basic edits in an efficient manner will greatly benefit you as a photographer.

Importing Images from iPhoto

Aperture offers an open library structure, which means you can store photos anywhere you want. Many Aperture users already have several images stored in their iPhoto libraries. You can have Aperture link to your iPhoto library or import the files into the Aperture library. In this lesson, you'll begin by adding a collection of photos to your iPhoto library, and then see how easy it is to access those images.

> **NOTE ▶** Although we are adding images to iPhoto, we're not suggesting that the iPhoto library is the ideal location for your images. Each user will need to determine how they want to organize their own image libraries. What's important is that the iPhoto libraries can be easily migrated and upgraded by bringing them into Aperture.

Adding Images to iPhoto

In this lesson, you'll work with several images that need basic corrections. You'll access images from iPhoto in order to illustrate the open library system. But to showcase this interaction, you'll need to add photos to iPhoto first.

1 Open the Lessons folder and navigate to Lesson 04. Open that folder and locate a folder of images called **Kid_Photos**.

2 Drag the folder of images onto the iPhoto icon in the Dock.

The images are added to your iPhoto library.

3 In iPhoto you can see the 20 images you just imported.

iPhoto creates a new Event based on the name of the photo.

4 Quit iPhoto and switch to Aperture.

Browsing Your iPhoto Library

Within Aperture you can use the iPhoto Browser to review iPhoto images as well as select specific images for import. This is an easy way to add images to your Aperture library without needing to import your entire iPhoto library. All of the organizational groupings you've used, including albums and Events, are visible within Aperture.

TIP ▶ If you ever want to import your entire iPhoto library into Aperture, you can choose File > Import > iPhoto Library.

1 Choose File > New Project and name the project *Lesson04*.

2 Choose File > Show iPhoto Browser (or press Command-Option-I).

3 In the iPhoto Browser, select the Kid _Photos Event.

 You can move your pointer over the Event to skim the photos and see the contents of the Event.

4 Drag the Kid_Photos Event onto the Lesson04 project in the Projects inspector.

5 When the images finish importing, click OK to close the Import Complete dialog.

6 Close the iPhoto Browser.

Cropping a Photo

Cropping an image allows you to change its composition. This can mean removing distracting elements, improving framing, or trimming the edges of the image to target a particular aspect ratio. Crops can be performed manually with the Crop tool or by using the Crop Adjustment controls.

The Crop tool allows for freehand control, which is desirable when you want to quickly frame an image. When combined with the Crop HUD, you can target a specific aspect ratio. If you need to size an image to exact dimensions (such as for printing), then you'll find Aperture's Crop controls useful.

Cropping Images with the Crop Tool

The Crop tool is an easy way to remove distracting objects from a photo. The Crop tool is nondestructive, so you can adjust the crop or revert to your original image at any time.

1 Select the Lesson04 project in the Projects inspector. If you can't see both the Viewer and Browser, press the V key to cycle views until both are visible. Be sure to exit Quick Preview mode by pressing the P key before continuing with the exercise.

2 Select the image **Kids 13** in the Browser.

The photo of the girl could be improved by removing the second girl (who is mostly obscured) from the shot.

3 Select the Crop Tool in the tool strip.

The Crop HUD appears.

4 In the Crop HUD, click the Common Sizes pop-up menu and choose 5 X 7.

The new target size is entered into the HUD.

NOTE ▸ If you ever need to, you can click the Switch Aspect Ratio button to switch the orientation of the Crop overlay to portrait or landscape (just click the double triangles between the Width and Height fields).

5 Hold down the Command key and drag with the Crop tool to drag a rectangle over the image.

Holding down the Command key adds a proportional grid to help with composition. Try to position the intersection of lines over the eyes to preserve the "rule of thirds."

6 When satisfied with the crop, press the Return key.

The image is cropped to the specified target size.

TIP After adding a crop to an image you can change its size and shape. One method is by dragging a resize handle; another is to adjust the crop in the Crop HUD or Adjustments inspector.

Cropping Images with the Crop Controls

It's important to remember that the Crop adjustments are very flexible because they work as adjustments. This means that you can modify a crop at any time.

1 Control-click **Kids 13** and choose Duplicate Version from the shortcut menu.

A new version of the image named Kids 13 – Version 2 is added to your project.

2 With Kids 13 – Version 2 selected choose the Crop tool from the tool strip.

The crop handles are displayed and the cropped portion of the image becomes available.

3 Press Control-A to open the Adjustments inspector, then locate the Crop adjustment.

4 Modify the crop values so that only the left edge is cropped.

We used the values shown in the image below (measured in pixels).

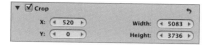

NOTE ▶ The Crop Adjustment measures the starting position of the crop using X and Y coordinates. Both the X and Y values are measured from the lower-left corner of the image. The shape of the crop is determined by the Height and Width sliders (which are also measured in pixels).

5 When satisfied with the crop, press Return.

Flipping an Image

When working with an image, you may want to flip it to create a reversed image. This might simply be for composition or layout purposes. You might also need to fix an image that is a reflection, or compensate for a scanned negative that was loaded backwards or upside-down. Fortunately, Aperture can easily flip images horizontally, vertically, or both ways.

1 Select the image **Kids 19** in the Browser.

The client would like the image flipped for composition purposes.

2 If the Flip controls are not shown in the Adjustments inspector, choose Flip from the Add Adjustments pop-up menu.

The image is flipped horizontally as soon as the adjustment is applied. If you want to modify the flip, you can click the type pop-up menu and choose Horizontal, Vertical, or Horizontal & Vertical.

TIP You can add the Flip controls (or any other Image Adjustment controls) to the Default Adjustment set. Just click the Preset Action pop-up menu (shaped like a gear) and choose Add to Default Set. Similarly, you can remove an adjustment from the default set by clicking the Preset Action pop-up menu and choosing Remove from Default Set.

Straightening a Photo

Getting a perfectly level image can often be difficult. A tripod with a bubble level can help, but sometimes, "getting the shot" is more important than perfection. What generally happens in the post-production stages is that an adjustment is made to level the horizon in images that need straightening. Here's how you can make that adjustment in Aperture.

1 Select the image **Kids 15** in the Browser.

2 Click the Straighten tool in the tool strip (or press G to select it with your keyboard).

3 Click the image to rotate it either clockwise or counterclockwise.

As you rotate an image, a yellow grid overlay appears. This can help you straighten the horizon in the photo. As you rotate, the image is cropped to prevent gaps from appearing in the corners.

For this image, the photo needs to be rotated clockwise until the perpendicular edges of the dresser appear straight. We used an angle of approximately -1.4°.

4 Refine a Straighten adjustment by controlling it numerically in the Adjustments inspector.

> **TIP** ▶ The Straighten adjustment is somewhat processor-intensive. If you're experiencing performance issues while making several adjustments, you can temporarily disable it by deselecting it in the Adjustments inspector. You can then re-enable it after all the adjustments are made.

5 Click the Lift button in the tool strip to lift the image adjustment.

The Lift & Stamp HUD opens to show which properties have been lifted.

6 In the Lift & Stamp HUD, deselect the checkbox next to IPTC (since you don't need to modify the metadata for the image).

7 In the Browser, drag to select the images **Kids 16** and **Kids 17**.

8 Click the Stamp Selected Images button in the Lift & Stamp HUD.

The Straighten adjustment is applied to the two images shot under similar conditions.

Adjusting White Balance

A very common adjustment that you'll perform is a white balance adjustment. By modifying the white balance you can remove unwanted color cast from an image. Using the

White Balance eyedropper, you can usually adjust the color temperature and tint for an image. A white balance adjustment is generally made before all other color and tone adjustments, because it achieves a baseline so that the image can be further refined.

1 In the Browser, select the image **Kids 4**.

This is the first of three images shot under similar lighting.

2 In the White Balance area of the Adjustments inspector, select the White Balance eyedropper.

The pointer changes to the Loupe to show a magnified view of the target area.

3 Position the target over the white in the shirt.

TIP ▶ Be careful to position the target over an area that's supposed to be white.

4 Click to set the white balance in the image.

The white balance of the image is adjusted by shifting the color tonality of the image cooler. Because the next two images were photographed under similar conditions, we can reuse the white balance adjustment.

NOTE ▶ If the eyedropper doesn't achieve the perfect balance, you can always refine it with manual adjustment controls.

5 Select the Lift tool in the tool strip to lift the image adjustment.

The Lift & Stamp HUD opens to show which properties have been lifted.

6 In the Lift & Stamp HUD, make sure the checkbox next to IPTC is deselected.

7 In the Browser, drag to select the images **Kids 5** and **Kids 6**.

8 Click the Stamp Selected Images button in the Lift & Stamp HUD.

The white balance adjustment is applied to the two images shot under similar conditions.

Removing Sensor Dust

When you change lenses on an SLR camera, it's easy to get sensor dust on an image. Unfortunately, these little bits of dust often appear as unattractive blobs on your photos. Aperture offers several ways to remove these, as sensor dust is a problem that can plague even the most professional photographers.

> **MORE INFO** ▶ Although we touch on the topic of sensor dust here, you'll see greater coverage of Aperture's repair tools in Lesson 9.

1 In the Browser, select the image **Kids 7**.

2 Look carefully in the upper-right corner for a black fleck, which indicates sensor dust.

3 Press Z to zoom the image and view it at 100%. Position the image so you can clearly see the sensor dust.

4 Select the Retouch tool in the tool strip.

The pointer changes to a target, and the Retouch HUD appears so you can adjust the Retouch tool.

5 In the Retouch HUD, select the Repair button.

6 Set the Radius to 50 and the Softness to 0.65.

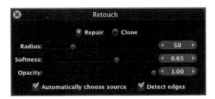

7 Brush over the sensor dust using one continuous stroke.

8 Repeat step 7 until the imperfection and any noticeable edges disappear.

9 Click the Lift button in the tool strip to lift the image adjustment.

The Lift & Stamp HUD opens to show which properties have been lifted.

10 In the Lift & Stamp HUD, make sure the checkbox next to IPTC is deselected.

11 In the Browser, drag to select the images **Kids 8** and **Kids 9**.

12 Press Z to fit the images in the Viewer.

13 Click the Stamp Selected Images button in the Lift & Stamp HUD.

The Repair adjustment is applied to the two images shot under similar conditions.

NOTE ▶ Be sure to view the images individually so you can better see the repair. The images **Kids 7** and **Kids 8** were easily repaired by letting the Retouch brush automatically pick a source. The more complex shot of **Kids 9** (with the patterned headband) needs greater control for harnessing cloning and manually setting the source point. We'll cover the Repair tools in greater detail in Lesson 9.

Removing Red Eye

Red eye often occurs in images when using a flash in lower-light conditions. Although there are several adjustments that can be made during the shooting stage to eliminate or reduce red eye, it will still occur in certain situations. Fortunately, Aperture makes red eye removal easy.

1 In the Browser, select the image **Kids 1**.

2 Press Z to view the image at 100%.

3 Hold down the spacebar, then drag to pan the image so you can see both eyes.

4 Select the Red Eye tool in the tool strip.

The pointer changes to a target, and the Red Eye HUD opens to help you control the Red Eye adjustment.

TIP ▸ Aperture fixes red eye by desaturating the red pixels within a target area. It's a very good idea to adjust the radius of the target overlay to the size of the eye it covers. You can adjust the size of a Red Eye target overlay before or after adding it to an image. Try to avoid getting skin inside the target area.

5 In the Red Eye HUD, set the radius to 35.

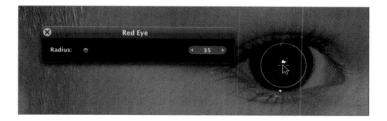

6 Click the eye on the left with the Red Eye tool to remove the red eye.

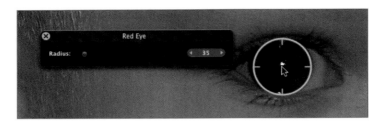

7 Click the right eye with the Red Eye tool to remove the red eye.

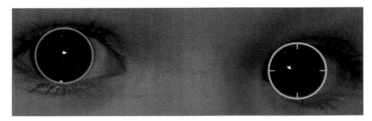

The Repaired Image

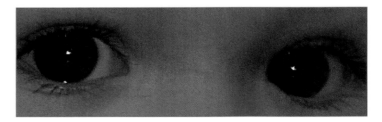

The Original Image

8 Repair the images **Kids 2** and **Kids 3** using the same techniques.

TIP ▶ You can adjust the amount of red eye affected with the Sensitivity slider in the Red Eye Correction controls in the Adjustments inspector.

NOTE ▶ It's very difficult to use the Lift & Stamp tool with red eye adjustments because the face is likely to move from shot to shot.

Lesson Review

1. How do you import your iPhoto library into Aperture?

2. What are the two ways to crop an image in Aperture?

3. True or false: White balance adjustments should only be made after other color correction adjustments are complete.

4. How big should you make the target overlay when correcting red eye in Aperture?

Answers

1. Choose File > Import > iPhoto Library.

2. Crops can be performed manually with the Crop tool or by using the Crop Adjustment controls.

3. False. A white balance adjustment is generally made before all other color and tone adjustments, because it achieves a baseline so that the image can be further refined.

4. You should adjust the radius of the target overlay to the size of the eye it covers.

5

Lesson Files APTS_Aperture_book_files > Lessons > Lesson 05 > Lesson05.approject

Time This lesson takes approximately 90 minutes to complete.

Goals Configure Aperture to work with multiple displays

Specify a RAW decoding method to use

Refine the RAW decoding process using Fine Tuning

White balance a RAW file

Detect and adjust hot and cold areas in an image

Working with RAW Images

When working with RAW files, it's often the little things that make a big difference. RAW files contain a lot of information; how that information is interpreted can mean the difference between a good image and a great one. For greater flexibility, you can modify how Aperture decodes RAW files using the RAW Fine Tuning area of the Adjustments inspector or the Adjustments pane of the Inspector HUD.

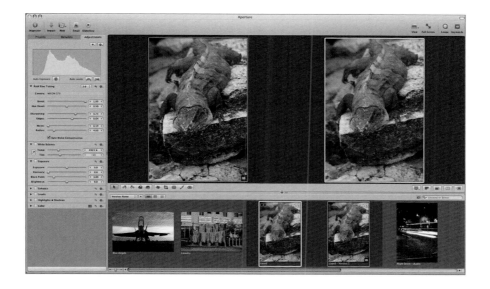

Preparing the Project

For this lesson you'll need to import several images to explore Aperture's ability to process RAW files. To begin, we'll import images from the APTS DVD into a new a project.

1 Activate the Projects inspector.

2 Choose File > Import > Projects, navigate to the **APTS_Aperture_book_files > Lessons > Lesson 05 > Lesson05.approject**.

3 Click the Import button to load all of the images.

Aperture adds a project with 7 images to the Projects inspector.

4 Cycle the Viewer and Browser by pressing the V key until both windows are visible.

Using Multiple Displays

For the ultimate image-editing and onscreen proofing experience (and to really impress your clients), you can use a system with multiple displays. The Mac OS has long supported more than one display, allowing you to create a large desktop that spans two screens. Aperture improves on this simple "extended desktop" capability by letting you specify what the second screen should be used for. For example, you can have your primary display show the normal Aperture interface, while your secondary display shows a full-screen view of the currently selected image.

> **NOTE ▸** Even if the computer you're currently using is not using multiple displays, keep reading. You may find yourself working on a two-screen system, and knowing how to harness both screens will boost your productivity.

Setting Up a System with Two Displays

The hardware requirements for hooking up a second display vary by system. For example, hooking up a second display to a MacBook Pro is relatively easy. Connecting a second

display to a Mac Pro requires that your computer have a graphics card capable of driving two displays.

> **NOTE ▸** The process of hooking up the second display will vary based on your hardware configuration. Be sure to see the documentation that came with your computer or graphics card for more information.

1 Turn off the computer.

2 Connect a display cable from the second display to an available display port on the computer or graphics card. Make sure the cables are firmly connected.

3 Turn on the displays if needed (Apple Cinema Displays will power on automatically).

4 Start up the computer.

> **MORE INFO ▸** The Aperture User Guide has additional information on hooking up multiple displays.

Configuring OS X for Multiple Displays

Once your computer is properly connected to two displays, you can configure them for maximum performance. By adjusting the System Preferences you can configure the monitor to show a continuous desktop across both screens. This mode is called extended desktop mode and is ideal for working in Aperture.

> **NOTE ▸** In a dual-display configuration, Aperture controls the second display, so you must keep it in the extended desktop mode. Do not switch your monitors to mirroring mode or Aperture may not work properly.

1 Choose Apple menu > System Preferences.

2 Click Displays.

3 Click Arrangement.

NOTE ▶ If the Arrangement button is not visible, click the Detect Displays button. If the Arrangement button still doesn't appear, check that the second display is properly connected to your computer.

4 Deselect the Mirror Displays checkbox.

Once the second display is detected, the display arrangement may be out of order. You'll need to adjust the displays so that the monitors' physical arrangement is recognized by the computer.

5 Drag the blue rectangles representing the displays to match the position of the displays on your desk.

The screens update and refresh to accommodate the new arrangement.

6 Drag the white rectangle to move the menu bar to the display on the left.

MORE INFO ▶ Be sure to color-calibrate your displays to match the hardware pro-files for each manufacturer. For more information about color-calibrating displays, see Appendix B, "Calibrating Your Aperture System."

Configuring Aperture for Multiple Displays

Once the displays are attached, you're ready to configure Aperture for multi-screen view-ing. When two displays are connected to your Mac, Aperture considers the main display—the one with the menu bar—to be the *primary Viewer.* The other display is the *secondary Viewer.* By default, the primary Viewer displays the Aperture application.

Let's specify the function of the secondary Viewer.

1 From the control bar, click to open the Viewer Mode pop-up menu.

If you have two displays connected, then you'll see separate sections for each display.

2 Choose Mirror from the Secondary Viewer Mode pop-up menu.

3 In the Browser, select any three images. You should see all three images appear on both displays. The second display is showing an exact mirror of the Viewer of the first display. Obviously, the difference is that the second display shows the selection full-screen, with no interface elements.

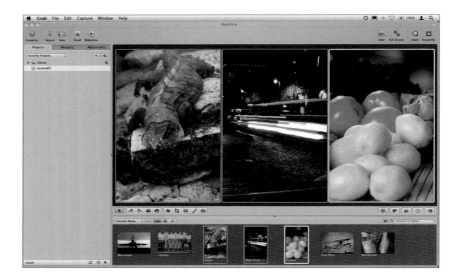

4 Choose Alternate from the Viewer Mode pop-up menu.

Your primary Viewer should still show all three selected images, but the secondary Viewer should change to show only the primary selection.

5 Use the Left and Right Arrow keys to navigate through the images in the Browser. The second display will update to show only the current primary selection.

6 Choose Span from the Viewer Mode pop-up menu.

Some of your selected images should move to the second display, while the rest of the images in the selection remain on the main display. Span mode spreads the selection across both displays, so your images can be viewed at a larger size. How Aperture chooses to divide them up will depend on the size of your Viewer and the size of your displays.

TIP ▶ If you want to use your second display for something other than Aperture, you can choose Desktop from the Viewer Mode pop-up menu. This reveals your Mac desktop and frees up the display to show the Finder or another application. If you want to completely eliminate the use of the second display, choose Blank from the Viewer Mode pop-up menu.

NOTE ▶ Aperture will keep the toolbar in easy reach when working with multiple displays. When your second display is active using either the Mirror, Alternate, or Span setting, the toolbar appears on the second display. If you put the main display in Full Screen view, the toolbar switches to the main display.

Working with the RAW Fine Tuning Controls

Aperture is loaded with profiles for many different cameras and RAW formats. Each RAW type supported by Aperture has preset calibration data that Aperture uses to produce the best decode in most situations. You'll find that some images can benefit from a custom decode or some fine-tuning. Using the RAW Fine Tuning controls lets you define settings on an image-by-image basis. Additionally, you can create default settings to use with a specific camera.

NOTE ▶ Depending on the type of RAW file you're working with, some controls may be dimmed. This indicates that either the RAW decode method or camera model are not fully supported.

Choosing a RAW Decode Method

When you edit a RAW file with Aperture, the file must be decoded. In order to do this, Aperture uses a RAW decode engine. Aperture 2 provides an even higher-quality decode engine to help you produce superior images. The decode engine supports noise reduction, enhanced detail, color handling, and highlight recovery.

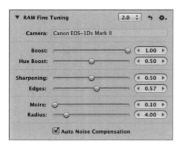

NOTE ▶ Aperture features native support for more than 100 RAW image formats from leading camera manufacturers. These include .ARW, .CR2, .CRW, .MOS, .NEF, .RAF, .RAW, .SRW, .TIF, .OLY, FFF, 3FR, and .DNG.

NOTE ▶ If you're working with newly imported images, Aperture automatically uses the newer 2.0 RAW decode method. The newer decode engine offers more control and greater color fidelity. If, for some reason, you don't want to use the new decoding engine, you can choose the 1.0 or 1.1 decode methods.

Using Existing Aperture Libraries

If you've upgraded Aperture from an earlier version, then your RAW files are using an older RAW decoder. Aperture 2 uses a decode engine with more controls. You can selectively choose to migrate your images to the newer decode engine.

1 In the Viewer, select the image **Produce**.

2 Locate the RAW Fine Tuning controls in the Adjustments inspector.

3 Click the RAW Decode Version pop-up menu and choose the 2.0 decoding method.

Working with DNG Files

If the RAW files you want to import are not recognized by Aperture, you can use the Digital Negative (DNG) format. Originally developed by Adobe, the DNG format functions as a universal format. Adobe offers the Adobe DNG Converter as a free download. This software can convert most RAW files (even those not supported by Aperture) into DNG files. You can download the DNG converter from http://www.adobe.com/products/dng/. Aperture uses the camera information stored in the DNG file to decode the image.

To adjust the RAW Fine Tuning parameters of a DNG file, do the following:

1 In the Viewer, select the image **Night Street - Austin**.

This is a DNG file.

2 Look at the RAW Decode Version pop-up menu.

Because the photo is not directly supported by Aperture, the RAW Decode Version pop-up menu displays "2.0 DNG."

3 Adjust the RAW Fine Tuning settings as needed.

NOTE ▸ If you're using DNG files generated with the Adobe DNG Converter, you can't use the "Convert to Linear Image" option in the Adobe DNG Converter application.

Adjusting Boost and Hue Boost

Now let's look at two other adjustment controls in the RAW Fine Tuning controls group: Boost and Hue Boost. As mentioned earlier, Aperture includes a set of camera profiles for all supported cameras. These profiles give Aperture specific details about each camera's imaging characteristics, and are used to determine what color and contrast adjustments should be automatically applied to the RAW file. These adjustments are done to apply the optimal decode based on the manufacturer of the camera.

The Boost slider lets you control the degree to which this default adjustment is applied to your image. By default, the Boost slider is set at full strength, so your image appears with the full level of correction. As you drag the slider to the left, the correction is reduced. The Boost slider is handy for times when you feel your images have too much contrast or are a little too saturated.

Working in conjunction with Boost is the Hue Boost control. The Hue Boost control is used to maintain the hues in the image as contrast is increased with Boost. For example, if an image has both the Boost and Hue Boost controls set to 1.00, the colors will be pinned to their pure color values. This works very well for nature shots but can create oversaturated skin tones.

1 In the Viewer, select the image **Produce**.

2 Press F to enter Full Screen mode.

3 Press H to open the Inspector HUD.

 We need to perform an Exposure adjustment to set the highlights in the image properly.

4 In the Adjustments pane of the Inspector HUD, click the Auto Exposure button to set the Exposure for the RAW image.

5 In the RAW Fine Tuning controls group, drag the Boost slider to 0.75.

NOTE ▶ A value of 0.00 applies no contrast adjustment to the RAW file during decode. A value greater than 0.00 increases the contrast adjustment to the RAW file. Using a value of 1.00 applies the full Apple-recommended contrast adjustment for the specified camera model. Depending on the image, you may need to lower Boost.

6 In the RAW Fine Tuning controls group, drag the Hue Boost slider to 0.65.

Using a value of 0.00 preserves the original hues in the image in relation to the Boost adjustment. A value greater than 0.00 increases the hue adjustment during the RAW decode.

The contrast in the image is slightly reduced, but the colors are enriched.

Your image should appear slightly darker and you'll probably see some change in color in the lemons. As the contrast in the image is reduced, the shadows will brighten up a little bit. Overall, the image will appear a little more flat. In many cases, a flatter image will be more pleasing than an image with harsh contrast.

Before After

Sharpening and Noise Reduction for RAW Images

If you're working with RAW images, then you have an extra set of sharpening and noise-reduction controls at your disposal. When you have a RAW image selected, the Adjustments HUD offers extra controls in the RAW Fine Tuning group.

Sharpening RAW Images

Aperture tries to automatically sharpen your images based upon the model of camera used. Aperture will detect the type of camera that was used to shoot the image and will show the camera's name in the Camera field. Apple has profiled all cameras supported by Aperture and created RAW-conversion parameters for each camera. The Settings pop-up menu defaults to Apple, indicating that the Apple-defined RAW-conversion parameters are being used.

1 Move your pointer to the bottom of the screen until the Filmstrip appears.

2 Select the image **Prop Plane**.

3 Choose View > Show Loupe, or press the Accent Grave (`) key.

4 Position the Loupe to show the numbers on the tail of the plane.

5 Choose the 200% magnification level from the Loupe pop-up menu.

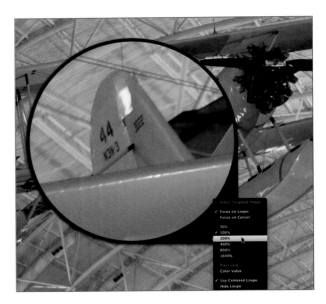

As with any other sharpening tool, your goal with the Fine Tuning controls is to improve the sharpening in your image without accentuating the noise. This image has very soft edges, so we'll start with the Edges slider, which sharpens the edges in your image.

6 Drag the Edges slider to the right to about 1.00.

The default value for the Edges slider is determined by the camera profile. Drag the Edges slider to the right to intensify the sharpening that occurs at "hard" edges of the image. This will increase sharpening in areas with significant color changes during the RAW decode process.

7 Move the Sharpening slider to about 1.00. Your image should appear sharper.

The default value for the Sharpening slider is determined by the camera profile. Drag the Sharpening slider to the right to increase the strength of the sharpening effect applied during the RAW decoding process.

The RAW Fine Tuning Sharpen controls produce very subtle results. You can further sharpen your images with Aperture's additional controls.

Before After

8 Click the Add Adjustments pop-up menu and choose Edge Sharpen.

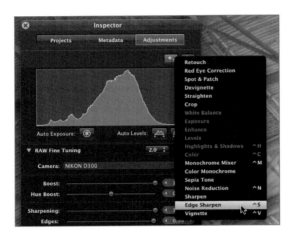

9 Adjust the Intensity and Edges sliders to your taste, until you are satisfied with the sharpening.

The Sharpening component of the RAW Fine Tuning adjustment is a useful way to decode the file. If the image is still sharp, you can use the Edge Sharpen adjustment for further refinement.

For this graphic we used an Intensity of 0.77 and Edges of 0.66. We'll cover the Edge Sharpen controls in greater detail in Lesson 8.

Noise Reduction for RAW Images

As you sharpen an image, it's important to look for noise. Aperture will attempt to eliminate noise when it decodes the RAW file. However, the addition of the Edge Sharpen adjustment requires additional noise reduction.

1 Deselect the Auto Noise Compensation checkbox in the RAW Fine Tuning adjustment group.

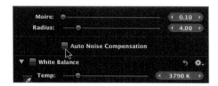

This checkbox is used to turn on additional adjustments, such as noise reduction and stuck pixel removal, that are automatically applied to the image during decode.

2 Position the Loupe over the dark areas of the plane's engine. Closely examine the area for noise.

3 Select the Auto Noise Compensation checkbox.

You should see a lot of bright noisy pixels disappear, and the grainy patterns in the shadows become less obvious. If you'd like to further reduce noise, you can make additional adjustments.

4 Click the Add Adjustments pop-up menu and choose Noise Reduction.

5 Adjust the Radius and Edge Details sliders to your taste, until you're satisfied with the noise reduction.

For this graphic we used a Radius of 0.70 and Edge Detail of 1.70. We'll cover the Noise Reduction effect in greater detail in Lesson 8.

As with all sharpening and noise-reduction tools, you'll usually perform a balancing act with these sliders, as you try to sharpen your image without making the noise more visible. On some RAW images, you'll probably find that you can achieve all of the sharpening and noise reduction that you need with the Fine Tuning sliders. On others, you might need to also apply the normal sharpening and noise-reduction adjustments.

Removing Moire from RAW Images

You can often find color artifacts that appear at the edges of your image. This is caused by the noise created by the sensors used in digital cameras, and may occur if an image has a linear pattern (such as a brick wall or a wooden fence). Additionally, cameras that use the common Bayer filter can produce color aberrations in monochromatic areas.

> **NOTE ▶** The Bayer pattern color filter array is very common in digital cameras. This filter uses a specific arrangement of red, green, and blue lenses attached to the surface of a digital image sensor. The filter uses approximately twice as many green lenses as blue and red. This accurately simulates how the human eye perceives color.

To counter this effect, Aperture uses the Moire and Radius sliders. These commands can help reduce color fringing in high-contrast edges and the moire pattern artifacts. The Moire controls specifically correct aliasing issues that can appear during the RAW decode process. Additionally, the Moire parameter modifies the amount of signal used in the adjustment. The Radius parameter adjusts the visual threshold at which the adjustment is applied.

1 Move your pointer to the bottom of the screen until the Filmstrip appears.

2 Select the image **Woodpecker**.

3 Position the Loupe to show the shoulders of the bird.

4 Deselect the checkbox next to Auto Noise Compensation in the RAW Fine Tuning controls.

This disables Aperture's automatic noise reduction, which will make it easier to use the Moire controls.

5 Choose the 400% magnification level from the Loupe pop-up menu. Size the Loupe smaller by dragging its corner.

If you look closely, you can see color fringing and noise.

6 Drag the Moire slider all the way to the right until the slider reads 1.00.

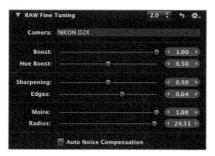

NOTE ▶ Like the other controls in RAW Fine Tuning, the image must decode when you release the slider. As you make adjustments, you'll need to release the slider and let the image update as it decodes.

7 Drag the Radius slider all the way to the right to increase the area to which the Moire adjustment is applied.

By adjusting the Moire slider and increasing the Radius, the amount of colored noise has been reduced in the image.

Saving RAW Fine-Tuning Presets

You'll often find that images from your camera consistently need to be fine-tuned in the same ways. To speed up the fine-tuning process, you can save presets for your RAW fine-tuning adjustments.

The "Save as Preset" command lets you save the current settings as a preset. The command appears in the RAW Fine Tuning Action pop-up menu just below the Apple – Camera Default preset.

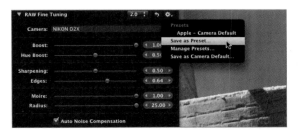

You might find that you consistently use one preset for daylight images, and another for tungsten images. Or, you might develop a preset that's particularly suited to the noise and sharpness issues that arise when shooting in low light.

If you find that *all* of your images need a particular fine-tuning adjustment, then you might want to save your settings as the camera default.

1 Choose Save as Camera Default. The RAW Fine Tuning Adjustment Presets window opens and prompts you for a name.

2 Give the camera preset a descriptive name and click OK.

Aperture will use your defined setting on *any* RAW file produced by your camera model.

TIP If you change your mind and want to use the Apple-recommended camera default settings you can restore them. In the RAW Fine Tuning area choose Apple – Camera Default from the Preset Action pop-up menu.

Adjusting White Balance for RAW Images

Light has inherent color qualities. These qualities are measured using a temperature scale. When you change the white balance setting in your camera, you're simply letting your camera know a little more about the color of the light under which you're shooting. The information is used by your camera to calibrate its color calculations so that they'll be more accurate.

When you open a RAW file in Aperture, the first thing the application does is calculate the color of every pixel in your image. It uses the temperature and tint settings that you (or your camera) specified as image metadata to calibrate its settings for the color of the light you were shooting under. When you change these settings, you're doing nothing more than changing the calibration reference that Aperture uses for its calculations.

As you learned in Lesson 4, there are lots of environmental and technical factors that can get in the way of a perfect white balance. In our last lesson we manually adjusted the White Balance controls for an image. This adjustment was applied to a JPEG image. Although the process of applying a White Balance adjustment to a RAW image is similar, the command behaves a bit differently.

MORE INFO ▶ The idea behind white balance correction is that because white light contains all the other colors, if you properly represent white in your image, you'll get every other color correct.

1 Move your pointer to the bottom of the screen until the Filmstrip appears.

2 Select the image **Laundry**.

3 Click the Eyedropper in the White Balance controls.

4 Locate an area in the image that should be white.

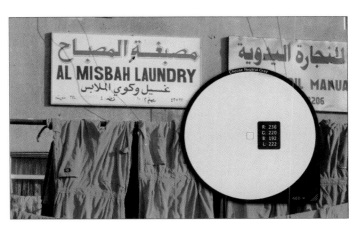

5 Click to set the white balance using the reference point.

The White Balance controls are very close to correct now, but the image is still a little too cool.

6 In the White Balance controls, drag the Temp slider to the right to about 5000 K. This helps the image a lot, and the color seems to be properly balanced.

NOTE ▶ In a non-RAW file, the color of every pixel is already set. The white balance calculation was made by your camera when you took the shot, and can no longer be altered. In Aperture, therefore, when you adjust the Temp or Tint sliders while editing a non-RAW file, the application has to work with existing color information and adjust existing pixel colors. When working with RAW files, the white balance adjustment is much more precise. It allows you the same level of control as you would have had if you had properly set the camera when shooting. Simply put, the White Balance controls are not nearly as effective on a non-RAW file as they are on a RAW file.

Recovering Hot and Cold Areas in RAW Images

One of the primary benefits of RAW images is their support for a wide range of color information. However, this can often produce areas that are too bright where the color information is beyond the limits of the working space Aperture uses to process the image. You will most likely see overexposure in areas like sky or direct sunlight. Additionally, black areas can become clipped, and the details can be lost.

The "hot" areas of the image are shown in red, which indicates overexposed areas. The "cold" areas are shown in blue, which indicates a lack of detail.

Aperture makes it easy to see these out-of-range areas. Overly bright areas are referred to as "hot," and clipped shadows are called "cold." By enabling the Highlight Hot & Cold Areas command, you can clearly see the affected pixels. This command is not exclusive to RAW images, but it is most important to a RAW workflow.

1 Move your pointer to the bottom of the screen until the Filmstrip appears.

2 Select the image **Blue Angels**.

Because this image was shot at sunset, it has very intense highlights in the sky as well as several areas of concentrated shadows.

3 Press Shift-Option-H to invoke the Highlight Hot & Cold Areas command.

> **TIP** If you're not in Full Screen mode you can choose View > Highlight Hot & Cold Areas.

4 Examine the image closely.

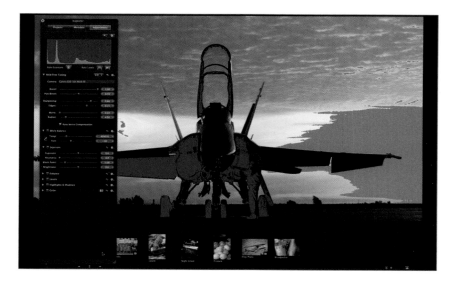

Aperture uses color to represent the hot and cold areas. Red indicates areas that are too high and outside of the range of the working space. The shadowy areas that are clipped are colored blue. Let's repair the highlights first.

5 In the Highlights & Shadows controls, slowly drag the Highlights adjustment to the right.

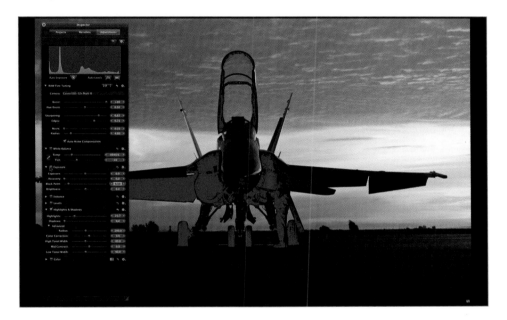

When the red areas disappear, the clipped highlights are repaired. The Highlights adjustment is used to adjust the brightest areas in an image without affecting the midtones and shadows.

Now that the bright areas are repaired, we need to adjust the "cold" pixels. While the Highlights & Shadows adjustment can be used to modify the shadowy areas, it will affect too great an area. Instead, we'll use the Exposure controls.

6 In the Exposure controls, slowly drag the Black Point adjustment to the left.

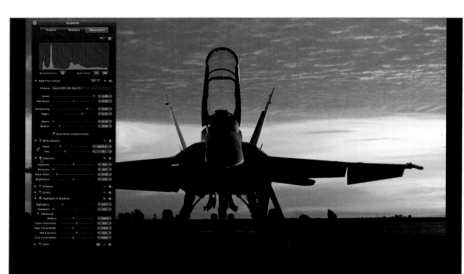

When the blue areas disappear, the clipped shadows are repaired. Dragging to the left recovered additional details in the shadows. We'll cover the Exposure and Highlights & Shadows controls in greater detail in Lesson 8.

7 Press F to exit Full Screen mode.

Lesson Review

1. How do you spread selected images across multiple displays in Aperture?

2. What is the benefit of working with the RAW Fine Tuning controls?

3. What is the function of Aperture's Moire controls?

4. If you find that all RAW images from the same camera need the same adjustments, how can you apply the adjustments you made to a single image to all RAW images from that camera?

5. How does Aperture identify out-of-range color areas in RAW images?

Answers

1. Choose Span from the Viewer Mode pop-up menu.

2. Using the RAW Fine Tuning controls overrides the camera preset which lets you define settings on an image-by-image basis.

3. The Moire controls specifically correct aliasing issues that can appear during the RAW decode process.

4. When you've completed your adjustments, choose Save As Camera Default.

5. It identifies overly bright areas as "hot" and represents them in red, and it identifies clipped shadows as "cold," and represents them in blue.

6

Lesson Files APTS_Aperture_book_files > Lessons > Lesson 06

Time This lesson takes approximately 60 minutes to complete.

Goals Use the Exposure controls to improve an image

Create a courtesy book for review images

Create contact sheets for web and print use

Send review materials to clients via email

Correcting Tone

In traditional film-based photography, image color and contrast were controlled through specialized processing and the use of filters. In the digital world, you can make the same adjustments with software. Aperture offers powerful controls that allow you to modify the exposure of an image, and offers highlight recovery, black point adjustment, and brightness controls.

An adjustment can be a way of making the image true to the photographer's vision of the shot. Using RAW file types will ensure the greatest latitude in making adjustments after the shoot, but Aperture offers flexibility for all digital files.

In this lesson, you'll work on correcting and improving tone in several images. Although tone and color adjustments often go hand in hand, we find that most often it's tone that is adjusted first. Getting the image properly exposed will often result in changes to color and saturation. For this reason, we find it most useful to get an image properly exposed, and then make any necessary color adjustments to the image.

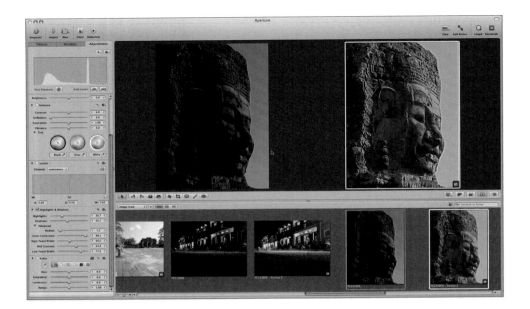

Preparing the Project

For this lesson you'll need to import several images to explore Aperture's ability to adjust tone. To start off, we'll import images from the APTS DVD into a new project. When we import, we'll also adjust the Time Zone of the images.

1 Select the Projects inspector.

2 Press Command-N to create a New Project.

A new untitled project is added.

3 Name the project *Lesson06*.

4 With the project selected, choose File > Import > Images, and navigate to **APTS_Aperture_book_files > Lessons > Lesson 06**.

5 Select the Adjust Time Zone radio button in the Import area.

6 In the Camera Time Zone pop-up menu, set the Camera Time Zone to US > US/Pacific.

While the camera's owner had the camera set to local time in San Francisco, California, the photos were shot in Thailand. Aperture lets you adjust the Time Zone so the photograph's time matches actual time of day for the location.

7 Choose GMT > GMT/GMT+7 from the Actual Time Zone pop-up menu.

8 From the Version Name pop-up menu, choose Master Filename.

9 Click the Import All button to load all of the images.

Aperture adds 22 images to the Lesson06 project.

10 Click OK when the import completes.

11 In the Browser, click the Filmstrip button and choose Version Name from the Sorting pop-up menu.

The files are now sorted alphabetically by version name.

Analyzing Image Information with the Histogram

Histogram analysis is a tool found in many imaging applications and camera LCD read-outs. A histogram is a graph that plots the brightness values of an image from the blackest to the whitest. By looking at a histogram, you can tell such things as where the pixels are concentrated in an image (in the shadows, midtones, or highlights), whether the overall tonal range is smooth, and whether the shadows or highlights are clipped. Knowing how to read a histogram is critical to making informed decisions about an image at every stage of production, from capture to output.

In Aperture you can view five types of information in a histogram: luminance, combined RGB channel data, and separate red, green, and blue channel information. The histogram is an important resource, and we can use it to help us make some additional image adjustments.

1 In the Browser, select image **IMG_5218**.

This image, shot with natural light, is still relatively dark. Because most of the image's pixel values are dark or in the middle area, they're concentrated on the left side and center of the luminance (default) histogram at the top of the Adjustments inspector.

2 Choose Histogram Options > RGB from the Adjustments Action pop-up menu.

The histogram is updated to show the RGB image data so that you can see not only the three individual color channels, but also where their channel information overlaps. To turn the overlay off, choose View > Highlight Hot & Cold Areas. You should see just the image now.

Let's apply an adjustment to the exposure of the image, and then see how the histogram reflects that change.

3 Drag the Exposure slider slowly to the right.

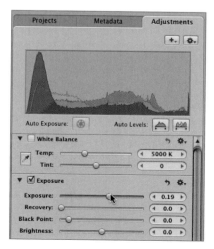

Aperture brightens the image, and the values in the histogram shift to the right, toward highlights. Notice how the blue channel shows the greatest change as the shadowy areas are brightened.

4 Using the Adjustments Action pop-up menu, choose Histogram Options > Luminance. This will allow you to focus on the luminance values of the images.

The Exposure Controls

Controlling the light in your photos is often challenging. Whether you're shooting indoors or outdoors, it's often difficult to have absolute control over the amount and quality of light available. Photographers do their best to adapt, using flashes and reflectors to point and shape the light, but invariably, exposure ends up short of perfect. Aperture offers flexible Exposure adjustment controls, which allow you to set the exposure, black point, and brightness values in your images.

Adjusting Exposure in an Image

Whether an image is under- or overexposed, Aperture can often correct it using the Exposure parameter. How much you can adjust the image will depend upon the format and bit-depth of the file. For example, an 8-bit JPEG file has significantly less information to work with than a 12-bit camera RAW file.

TIP For best results, try to shoot your images within 1.5 stops of a balanced exposure.

1 Select image **PC213860**.

Using the histograms is a good way to evaluate exposure. In this image, a series of peaks in the darker side of the histogram indicates an underexposed image that consists mainly of dark pixels.

2 In the Exposure area of the Adjustments inspector, drag the exposure slider to the right to increase the exposure of the image.

> **NOTE** ▶ A negative Exposure value means the exposure has decreased, which darkens the image. A positive value means the exposure has increased. The exposure of the image updates as you change the parameter value.

For this image, a value of 1.10 works well. If necessary, double-click the number in the Exposure value slider, then enter a precise value from -9.99 to 9.99 stops, and press Return.

Identifying Color Clipping

As you identify the Exposure controls for an image, it's possible to get clipping in your color channels. Clipping indicates that an area has become too bright and that detail in the color area has been lost. Aperture can identify clipping in individual channels or a combination of channels. Aperture uses color overlays to indicate where clipping has occurred.

1 Select image **PC173531**.

The image is fairly bright, but let's overexpose it to illustrate clipping.

2 Press the Command key, then slowly drag the Exposure slider to the right.

Although at first the image is black, you'll see color overlays used to indicate clipping. Take notice of where clipping occurs. You'll first see it in the sky area, then on the water's surface.

MORE INFO ▶ Aperture can identify color clipping for several of the Exposure and Levels controls when you drag the slider while holding down the Command key.

Exposure Controls:

The chart below indicates clipping when dragging a slider with the Command key held down.

Exposure slider—Shows highlight clipping.

Recovery slider—Shows highlight clipping.

Black Point slider (Exposure controls)—Shows shadow clipping.

Black Levels slider (Levels controls)—Shows highlight clipping.

White Levels slider (Levels controls)—Shows highlight clipping.

Colors Indicating Clipping by Channel

	Red	**Green**	**Blue**	**Yellow**	**Pink**	**Cyan**	**White**	**Black**
Exposure	Red	Green	Blue	Red & Green	Red & Blue	Blue & Green	All	None
Recovery	Red	Green	Blue	Red & Green	Red & Blue	Blue & Green	All	None
Black Point	Red	Green	Blue	Red & Green	Red & Blue	Blue & Green	None	All
Black Levels slider	Red	Green	Blue	Red & Green	Red & Blue	Blue & Green	None	All
White Levels slider	Red	Green	Blue	Red & Green	Red & Blue	Blue & Green	All	None

3 Look at the histogram for the adjusted image.

The large series of spikes at the right edge of the image indicates an overexposed image because many of the pixels in the image are too bright.

Using the Auto Exposure Button

One benefit of working with RAW images is that you can use the Auto Exposure button. This adjustment will attempt to choose the best exposure for your image automatically based on Aperture's analysis.

1 Click the Auto Exposure button.

Aperture automatically adjusts the exposure of the selected RAW file.

NOTE ▶ Auto Exposure is available only for RAW image files. You must also be using the newer RAW decoding 2.0. If you're using versions 1.0 and 1.1 for RAW decoding—for example, if you have an older image in the library—you'll need to change the Decode method. To do so, you'll work with the RAW Fine Tuning Controls as you did in Lesson 5. For a list of supported RAW file types, go to the Apple website at http://www.apple.com/aperture/raw.

2 Look at the histogram for the adjusted image.

Aperture did a good job of improving exposure while avoiding clipping or overexposed areas. Most importantly, you'll see that there's no overexposure in the bright areas of the sky or surface of the lake.

TIP ▶ You can use the Auto Exposure button to get the adjustment close, and then fine-tune the image's exposure setting using the Exposure controls.

Recovering Highlights in an Image

When working with images, particularly RAW files, you'll find that the computer can't display all of the image's information. The raw sensor in the camera can capture more detail than a computer can display. One area in which this is particularly true is highlight detail. To address this issue, Aperture offers the Recovery parameter controls to give you access to the headroom.

It's important to note that how much of an improvement occurs depends largely on the camera you used to shoot the image. Because digital image sensors vary between camera models, the amount of highlight headroom varies. In many cases, you can recover details that appear blown out in the most extreme highlight areas of the image.

NOTE ▶ The Recovery slider is not available for RAW decoding versions 1.0 and 1.1. If working with older RAW files in your library, you'll need to migrate the image to RAW version 2.0.

1 Select image **PC203738**.

2 Enter a value of *.020* for the Exposure parameter to set the exposure for the image.

The image looks good, but let's recover some of the brighter areas in the sky and reflections.

3 Hold down the Command key and start to slowly drag the Recovery slider to the right.

The white areas indicate clipping in all the color channels and blue indicates clipping in only the blue channel. Clipping results in a loss of detail (especially when printing the image).

4 With the Command key still depressed, drag the slider to the right until the clipping warnings disappear (the screen will turn black). We used a value of 0.60 to produce the image below.

The highlights in the image have been recovered, which helps ensure that they will show detail when printed or displayed.

Adjusting the Image's Black Points

As you work with images, you'll find that the shadows play a very important role in the impact of the photo. Getting shadow detail right can help create balance between objects in the photo and can affect the perception of the photo.

Aperture offers the Black Point parameter controls to increase the threshold of shadow details in the image. Additionally, the Black Point controls can be used to crush the blacks when necessary to create stronger blacks. Let's continue to improve the last image we were working on.

> **NOTE ▶** The Black Point slider is not available for RAW decoding versions 1.0 and 1.1. If working with older RAW files in your library, you'll need to migrate the image to Aperture 2.0.

1 In the Exposure area of the Adjustments inspector, drag the Black Point slider to the right.

The black point adjusts as you drag and the image updates to reflect the changes on screen.

2 Hold down the Command key and drag the slider back to the left.

The black areas indicate clipping in all the color channels and the other colors indicate clipping on a per-channel basis. Clipping results in a loss of detail (especially when printing the image).

3 Set the Black Point slider to a value of approximately 17.00.

MORE INFO ▶ Decreasing the Black Point value increases the amount of detail in the shadows. Increasing the value decreases the amount of detail in the shadow areas of the image, effectively crushing the blacks by moving pure black above the current black point. It's generally acceptable to have some crushing of blacks as you adjust the image to create the right tonal value for shadows. In the case of this image, it's appropriate to have clipping in the darkest shadows.

Adjusting the Brightness of an Image

Aperture offers the Brightness parameter when you want to lighten or darken an image. The Brightness parameter is a simple control and works well for making quick changes. When using the Brightness parameter, the midtones of the image will show the greatest change.

1 Select image **PC250017**.

The image is very dark. When the photo was shot, it would have been better to use a significantly longer exposure.

2 In the Exposure area of the Adjustments inspector, drag the Brightness slider slowly to the right.

The slider has a maximum value of 0.50, but this is not the limit of the adjustment.

3 Click the right arrow of the Brightness value slider five times to change the brightness of the image to 0.75.

The image is significantly brighter and the histogram shows the image's pixels are more evenly distributed across the luminance. We will further enhance this image later in the lesson.

TIP ▶ For more precise control over tonal range, consider using the Levels adjustment.

Enhancing an Image with Contrast and Definition

The Enhance group of controls gives you the ability to improve both contrast and saturation within an image. Additionally, Aperture offers Definition and Vibrancy, which can be used to make selective adjustments based on image analysis. In this exercise we'll utilize the tonal controls, which affect image tone and are part of the Enhance group. The remainder of the Enhance controls will be covered in depth in the next exercise.

Adjusting Contrast in an Image

Aperture offers precise control over the difference between the darkest and brightest areas of an image with the contrast adjustment. If an image's histogram shows a concentration of considerable midtone tonality, it's considered to have minimal contrast. You can increase the contrast of an image to add depth, but it usually comes at the expense of detail in the midtones. It's therefore important to balance the use of contrast in an image.

1 Select image **PC250019**.

The image lacks a lot of information in the high end (white area) of the histogram, and is slightly deficient in the shadow areas as well.

2 In the Enhance area of the Adjustments inspector, drag the Contrast slider slowly to the right.

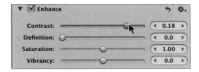

A value less than 0.0 decreases contrast in an image. A value greater than 0.0 increases the contrast in an image. The contrast updates as you change the parameter value.

The image looks better, but we can still improve it by using additional controls found in the Enhance group.

NOTE ▸ If an image has particular issues with the highest or darkest ends of the histogram, use the Highlights & Shadows controls to address these issues. You'll learn about these controls in depth later in the lesson.

Adjusting Definition in an Image

Although Contrast is a useful control, it can sometimes affect certain areas too strongly. To add a little clarity to an image, you can use the Definition parameter controls. With Definition, Aperture can localize the contrast improvement to the areas it needs the most. This is an effective way to improve problem areas without affecting the image's global contrast.

Let's continue working with the current image.

1 In the Enhance area of the Adjustments inspector, drag the Contrast slider slowly to the left to reduce the amount of contrast applied globally (a value of 0.15 works well).

Let's make it easier to see the image by using the Loupe.

2 Choose View > Show Loupe, or press the Accent Grave (`) key.

3 Position the Loupe so it's focused on the area above the door.

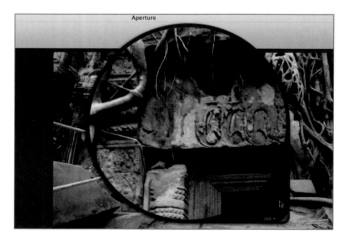

4 In the Enhance area of the Adjustments inspector, drag the Definition slider slowly to the right (a value of 0.65 works well).

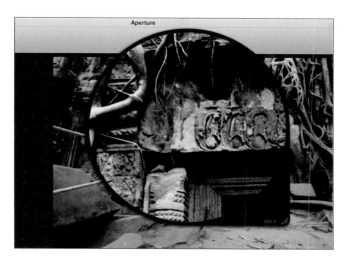

The image has better contrast in key areas of detail, while flatter areas are left alone.

Let's finish the image by using another Enhance control, this time to adjust Saturation.

5 In the Enhance area of the Adjustments inspector, drag the Saturation slider slowly to the right (a value of 1.25 works well).

The image now shows significant improvement in the areas of contrast, definition, and saturation. We'll explore the remaining Enhance controls in the next lesson.

Adjusting the Levels of an Image

Among the most common controls used by digital photographers are the Levels adjustment controls. These can be used when you want to manually set the tonal values of the shadows, midtones, and highlights for an image. By default, Aperture uses a value of 0 as pure black and 1 as pure white. By constraining the white and black point values evenly, Aperture can redistribute the tonal range of the pixels between black and white.

When you make a Levels adjustment, the pixels are reapportioned, which means the luminance values increase the tonal range and contrast in the image. However, just like the Exposure adjustments, if you adjust too far into either the black or white tonal values, clipping can occur, resulting in lost image detail.

Adjusting Luminance Levels for an Image

The easiest way to make Levels adjustments is to apply them globally across all three color channels. If you want to adjust the overall tonality of an image, make sure the histogram shows luminance. In this way, it displays the cumulative brightness values for all three color channels for each pixel.

> **MORE INFO** ▶ You can also adjust Levels for each individual channel. This is a useful way to remove the colorcast in an image as it balances the color in the image. We'll explore this technique in our next exercise.

1 Select image **PC153351**.

Let's start by adjusting the overall luminance of the image in order to darken the shadows. We can achieve this by using the Levels controls in the Adjustments HUD.

2 In the Levels area of the Adjustments inspector, click the disclosure triangle next to Levels to reveal the Levels controls if they're not already visible.

3 By default, the Levels histogram is off. Select the Levels checkbox to turn it on.

4 Drag the Black Levels and White Levels sliders to where they touch the outside of the histogram graph.

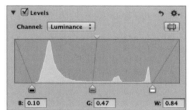

Moving the Black and White Levels sliders performs a dramatic adjustment to the image. The tonal values for shadows and highlights are updated (as is the histogram), resulting in more defined blacks and highlight values as well as increased overall contrast.

Now that the high and low ends have been adjusted, we need to adjust the midtone levels in the image.

5 Drag the Gray Levels slider until the brightness values for the midtones are correct.

By default, the gray point is set to 0.50. You can use any value between 0.02 and 0.98 until the brightness values in the image's midtones are correct.

Using Quarter-Tone Controls

If you need even greater control over tonal values, Aperture offers Quarter-Tone controls. These allow you to adjust the values between the midtones and shadows as well as the midtones and highlights. For example, if want to add contrast to the midtone values independently of the black and white point settings, the Quarter-Tone Levels sliders work well.

NOTE ▶ Unlike the Black Levels and White Levels sliders, Quarter-Tone Levels sliders independently affect only the tonal range of the pixels they represent. This offers precise control on the pixels that fall between shadows and midtones or midtones and highlights.

1 Click the Quarter-Tone Controls button to activate the Levels Quarter-Tone controls. The Levels histogram updates with new controls for adjusting four discrete tonal ranges of the image, from black to white, allowing you to make finer adjustments.

When using the Quarter-Tone sliders you can drag both the top and bottom control points.

2 Drag the Shadow Brightness Levels and Highlight Brightness Levels sliders until the shadows and highlights in the image are improved. You can use the figure below for guidance.

TIP For even greater control over how the Levels adjustment affects the image, adjust the input points at the top of the histogram.

Using the Auto Levels Button

You can use the Auto Levels button to have Aperture attempt to automatically choose the best levels for your image based on Aperture's analysis.

1 Select image **PC193729**.

2 Click the Auto Levels button.

Aperture automatically adjusts the levels of the selected file.

3 Look at the histogram for the adjusted image.

Aperture did a good job of improving levels while avoiding clipping or overexposed areas. Most importantly, you'll see that there is no overexposure in the bright areas on the surface of the lake.

TIP ▶ You can use the Auto Levels button to get the adjustment close, and then fine-tune the image's exposure setting using the Levels controls.

Improving Highlights & Shadows

Compared to your camera, the human eye can perceive a substantially larger range of brightness, from near-darkness to the brightest light. Whereas your eye can see a range of roughly 18 to 20 stops of light, even the most sophisticated digital (or film) camera can only capture about 8 to 10 stops.

NOTE ▶ In photography, each doubling of available light is measured as a single stop. Because your camera sees a narrower range of brightness levels than your eyes do, you usually have to choose between trying to capture detail in the shadows or the highlights of your image.

Controlling Highlights & Shadows

Aperture offers the flexible Highlights & Shadows adjustment controls to correct the exposure in images shot in complex lighting conditions. These controls allow you to adjust the shadows or highlights independently of each other. This is very helpful when fixing images with mixed lighting, areas with intense shadows, or areas that include snow and clouds.

Let's try to improve an image we worked with earlier.

1 Select image **PC250017**.

This image was previously adjusted using a Brightness adjustment. Although the adjustment improved the shadowy areas, it caused the sky to blow out, essentially losing important details.

2 Remove all adjustments from the image by choosing Images > Remove Adjustments.

The image is now restored to its original state.

The Highlights & Shadows controls are very simple. If you drag the Highlights slider to the right, the bright areas of your image will get darker. If you drag the Shadows slider to the right, the dark areas of your image will get brighter.

Because a bigger part of this image is shadowed, let's begin by lightening the shadows.

3 In the Highlights & Shadows controls, drag the Shadows slider to the right until the value field reads approximately 60.

4 Drag the Highlights adjustment slider to the right until the value field reads approximately 30.

Notice that the bright parts of the image darken. Although you can set this control to your own taste, be careful not to overdo it, or the image will get a little dull.

The image already looks much better, with more equal tones, but without an overall loss of contrast. The Highlights & Shadows controls do more than simply brighten or darken the specified range of tones in an image. When you adjust either control, Aperture analyzes your image to more intelligently determine which tones should be adjusted and by how much. For each pixel it analyzes, the Highlights & Shadows control considers the tones of adjacent pixels to calculate how much that one pixel should be brightened or darkened.

Now, let's fine-tune our adjustments.

5 Press M to view your original master image.

> **NOTE ▶** As you may recall, pressing M toggles between your current edited version and your original master image, which provides a simple way to quickly see the effects of your edit.

6 Press M again to return to your edited version.

Now let's add a final bit of punch to the image.

7 In the Highlights & Shadows adjustment, click the disclosure triangle to reveal advanced controls.

8 Drag the Color Correction slider to 30.0.

9 Click the Auto Exposure button to finish the image.

Using the Highlights & Shadows Controls as a Fill Flash

Although the Highlights control is useful, you'll probably find that you mostly use it for brightening up dark shadows. As you play with this adjustment, you'll find that you can dramatically brighten areas that were almost completely dark. But the Highlights & Shadows controls can also be used for more everyday tasks, such as simulating a fill flash.

1 Select image **PC234000**.

The shadow on the left side of the statue is too dark. This is because the camera was set to meter for the bright sky, leaving too much darkness in the shadows.

2 In the Highlights & Shadows controls, drag the Shadows slider to the right until the value field reads approximately 40.

The shadow on the statue's face brightens significantly. Overall, though, the contrast and dark tones remain the same.

The Highlights & Shadows adjustment includes advanced parameters for improving the image.

3 Adjust the Radius parameter by dragging its slider to the right (a value of 300.0 works well).

Drag to the right to increase the radius of the area Aperture uses to assess whether a pixel requires a highlights or shadows adjustment. Drag the slider back to the left to reduce the radius of the assessment area.

4 Adjust the Color Correction parameter by dragging its slider to the right (a value of 50.0 works well).

NOTE ▶ The Highlights & Shadows controls can solve innumerable contrast and shadow problems, but they're extremely processor-intensive. You'll get better performance if you perform all of your other adjustments first.

Lesson Review

1. What types of information are shown in an Aperture histogram?
2. What's indicated by clipping in your color channels?
3. What functions are served by Aperture's Black Point controls?
4. How do adjusting the Highlights & Shadows controls affect an image?
5. True or false: It's best to make adjustments to your image using the Highlights & Shadows controls before performing other adjustments on your image.

Answers

1. Aperture histograms show luminance, combined RGB channel data, and separate red, green, and blue channel information.
2. Clipping indicates that an area has become too bright and that detail in the color area has been lost.
3. The Black Point parameter controls can be used to increase the threshold of shadow details in the image, and to crush the blacks when necessary to create stronger blacks.
4. If you drag the Highlights slider to the right, the bright areas of your image will get darker. If you drag the Shadows slider to the right, the dark areas of your image will get brighter.
5. False. Because the Highlights & Shadows controls are extremely processor-intensive, you'll get better performance if you perform all of your other adjustments first.

7

Lesson 7
Correcting Color

The goal of every photographer is to capture great images while shooting. Unfortunately, lots of factors can get in the way of the perfect image. No matter how skilled a photographer you are, the editing phase is what frequently makes the difference between a great image and one that's merely usable.

Sometimes you'll use your editing tools to correct problems, but your editing and adjustment tools are also the key to fine-tuning your image. With them, you'll turn the raw shot into the finished image that you saw in your mind's eye when you captured it.

In this lesson, we'll focus on fixing and improving the colors in several images.

Aperture gives you precise control over colors in your images.

Preparing the Project

For this lesson you'll need to import several images to explore Aperture's ability to adjust color. To start off this lesson, we'll import images from the APTS DVD into a new a project.

1 Activate the Projects inspector.

2 Press Command-N to create a new project.

A new Untitled Project is added.

3 Name the project *Lesson07*.

4 With the project selected, choose File > Import > Images, and navigate to **APTS_Aperture_book_files > Lessons > Lesson 07**.

5 Click the Import All button to load all of the images.

Aperture adds 14 images to the Lesson07 project. When the import finishes, click OK to close the Import Complete dialog.

For the exercises in this lesson, we'll be referencing many of the images in this project by their version name. Therefore, you'll want to be sure your Browser is configured to show version names.

6 Choose View > Metadata > Customize or press Command-J to open the Metadata Preferences window.

7 Make sure the Browser checkbox is selected, and then select the Set 2 radio button to activate the Set 2 option. Also make sure the Grid View – Expanded choice is selected from the pop-up menu next to Set 2.

8 Close the Metadata preferences window.

Working in Full Screen View

For this lesson, we'll make our adjustments using Full Screen view. Because the images will be displayed at a large size against a black background, it will be easy to make qualitative adjustments to the images.

To switch to Full Screen view, *do one of the following*:

▶ Choose View > Full Screen.

▶ Press the F key.

▶ Click the Full Screen button in the toolbar.

To switch back to the Aperture main window, *do one of the following*:

▶ Click the Exit Full Screen button in the toolbar.

▶ Press the F key.

▶ Press the Escape key.

> **NOTE** ▶ In Full Screen view, you have access to all the tools you need to perform adjustments to your images.

To show the Inspector HUD while in Full Screen view:

▶ Press the H key.

To access a tool in Full Screen view:

▶ Move your pointer to the top of the screen, and in the Full Screen view toolbar that appears, select a tool.

> **TIP** ▶ By default, the toolbar is not shown in Full Screen view until the pointer is moved to the top of the screen. To set the toolbar to remain on the screen, move the pointer to the top of the screen in Full Screen view, then click the Always Show Toolbar button in the toolbar.

About Making Color Adjustments

The perception of color is very subjective and can vary from person to person. It's often difficult to make objective changes accurately because the human brain skews perception to make colors appear as natural as possible. Because of this compensation factor, you'll want to optimize your work environment to have the least impact on your perception of color.

▶ Set your computer's display to its highest-resolution setting. The increased resolution will give you the best view of your image. The highest setting generally displays the native resolution, which means you'll be working at the optimal resolution for clarity.

▶ Make sure your computer displays are set to their maximum brightness.

▶ Reduce the amount of ambient light in the room where you're working. This will help prevent the light from skewing your perception.

▶ If possible, paint the walls a neutral gray in the room where you perform detailed adjustments.

▶ Keep bright-colored objects to a minimum in the room to avoid skewing your perception.

▶ Make sure you're employing good color management practices. Be sure to calibrate your printers and displays. For more information, see Calibrating Your Aperture System, which is Appendix B in the Aperture User Manual.

Using the White Balance Controls

Even though many cameras offer Auto White Balance controls, there are several reasons to adjust the white balance in post production. If your camera was improperly set for the shot or you took it in a mixed lighting environment, then you can use Aperture's White Balance control to correct for any issues that arose as a result.

Using the White Balance Eyedropper

The flexible White Balance adjustment lets you control the color temperature and color tint of an image. The fastest way to correct the white balance of an image is to use the White Balance eyedropper. As long as the image has pixels that are supposed to be white, you can automatically change the color temperature and tint with the White Balance eyedropper.

1 Select image **DSC_540**.

This photo is improperly white balanced.

2 Press F to enter Full Screen view.

3 Press H to open the Inspector HUD, then click the Adjustments button.

4 In the White Balance area of the Adjustments pane of the Inspector HUD, select the White Balance eyedropper.

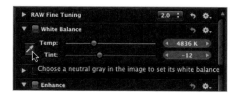

The pointer changes to the Loupe, which shows a magnified view of the target area.

NOTE ▸ The Loupe is set to magnify the image to 100% (full size). You can change the magnification of the Loupe by pressing Command–Shift–Plus Sign (+). You also may need to reposition the Loupe to make it easier to select your white point.

Aperture prompts you to click an area that is neutral gray.

5 Click the sign that says Sweet Onion.

The white balance of the image is adjusted to compensate for the lighting in the scene. The color tint of the image is shifted cooler.

The image is now properly balanced, but a little dark. Let's revisit the tonal adjustments we made in Lesson 6. Because the image we're working on is a RAW file, we can use the Exposure controls to fix it.

6 Click the Auto Exposure button in the Adjustments inspector.

Aperture adjusts the exposure automatically in the RAW image.

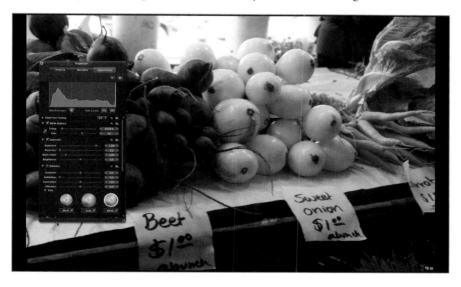

Using the Temp Controls

Although the White Balance eyedropper will successfully remove color cast from most images, it may not succeed in removing all of it. In that case you can use the Temp and Tint adjustment controls for fine-tuning an image.

NOTE ▶ The temperature of light is measured in units called kelvin (K). The reason to adjust the color temperature in an image is to make the photo look as natural as possible.

1 Move your pointer to the bottom of the screen until the Filmstrip appears.

2 Select the image **DSC_0132**.

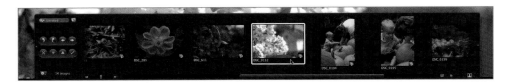

3 In the White Balance area of the Adjustments pane of the Inspector HUD, drag the Temp slider slowly to the left.

The image cools down and turns a blue tint.

4 Drag the Temp slider to the right until the image is warmer.

We used a value of 5150 K.

TIP If you need to reset a slider, simply double-click it.

Fixing Color with the Auto Levels Separate Button

Aperture offers several automatic adjustment controls that attempt to fix problems with a single click. These controls analyze an image, then apply an adjustment based on that analysis. Many users choose to use a one-click method as their basic quick correction, then refine the adjustment using manual controls.

While most of the automatic adjustments work for exposure, it's possible to use them to fix some color issues as well. By using the Auto Levels Separate button, Aperture can analyze the image and automatically adjust the levels for each individual color channel.

1 Move the pointer to the Filmstrip and select the image **DSC_626**.

The image is a bit red and dark because it was shot under a translucent red canopy.

2 In the Adjustments pane of the Inspector HUD, click the Auto Levels Separate button.

Aperture performs an analysis and then applies a Levels adjustment for each channel in the image. Because the Red, Green, and Blue channels are calculated independently, both exposure and color cast are improved.

NOTE ▶ The Auto Levels Separate button fixes an image based on an analysis of each channel's luminance values. Because the operation is performed on a per-channel basis, some color cast issues can be improved.

Working with the Enhance Controls to Control Color

As you work with images, you may discover that they lack the intensity of color that you desire. In many cases the image will be a bit washed out, while in other instances you may want to reduce the saturation to make the image less intense. Aperture offers two powerful controls for adjusting the intensity of color, the Saturation and the Vibrancy controls. Additionally, the Tint controls make it possible to remove color cast from shadows, highlights, and midtones.

Controlling Saturation in an Image

The Saturation controls allow you to either boost the colors in an image or to desaturate the image. These changes are most often made subjectively, to give the image a desired appearance.

1 Move the pointer to the Filmstrip and select the image **DSC_0199**.

The image has good exposure and contrast as shot, but could use a slight boost.

2 In the Enhance area of the Adjustments pane of the Inspector HUD, drag the
Saturation slider to the right.

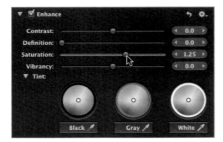

In this image, a value of 1.25 works well.

NOTE ▶ Although the slider only goes to a value of 2.0, you can double-click the number in the Saturation value slider, then enter a value from 0.00 to 4.00 and press Return. Remember, a value of 4.00 will increase the saturation by 400%. You can also mouse-over a number value, then drag to change its value.

Aperture will update the saturation of the image as you change the Saturation parameter value.

TIP ▶ Be careful not to oversaturate your images. Although boosting the saturation will make colors appear more pure or intense, you shouldn't overdo it. As saturation increases, the subtleties in shades of colors disappear. This can result in a reduction of detail in the image. Be sure to pay attention as you increase the saturation of an image to avoid a loss of quality.

Controlling Vibrancy in an Image

Oftentimes an image can benefit from a selective saturation boost. That is to say, one area would benefit from a color boost, but other areas would lose detail or become oversaturated. For these situations, Aperture offers the Vibrancy parameter, which applies saturation to an image in a nonlinear fashion.

Essentially, what happens is that already saturated colors are left alone while less saturated colors are boosted. This works well for boosting colors in skies or for making adjustments to an image without affecting skin tones.

1 Move the pointer to the Filmstrip and select the image **DSC_0195**.

The image could use a slight boost of color to bring out the blue shirt and red wagon.

2 In the Enhance area of the Adjustments pane of the Inspector HUD, drag the Vibrancy parameter all the way to the right.

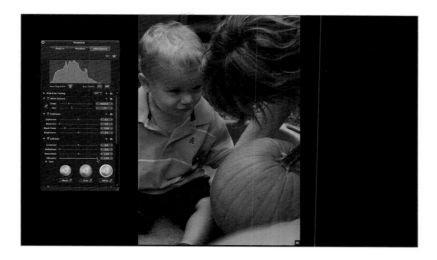

NOTE ▶ Using a value below 0.0 decreases the color saturation in the image (a value of -1.00 strips all color from the image, making it grayscale except for skin tones). A value of 1.00 is the maximum boost you can make with the Vibrancy slider. If you need more color, you'll need to use the Saturation slider.

Although the color has been improved, some of the detail in the pumpkin has been lost. Remember from our last lesson that the Definition adjustment can be used to add local contrast to only the areas that will benefit the most.

3 Drag the Definition slider to the right to add contrast to the image selectively.

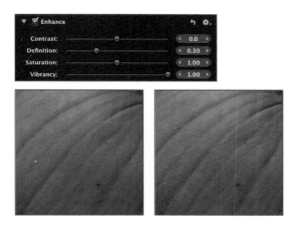

The Definition parameter has added contrast into the needed areas.

The Vibrancy slider doesn't just work on skin tones; in fact, it's an excellent adjustment for punching up horizon shots. Let's try the Vibrancy adjustment on a sunset image to see the results.

4　Move the pointer to the Filmstrip and select the image **DSC_415**.

For comparison's sake, let's first try adjusting the saturation.

5　Drag the Saturation slider all the way to the right.

The image has become oversaturated, with the oranges in the sunset sky looking particularly unattractive.

6　Double-click the Saturation slider to reset the Saturation adjustment.

7　Drag the Vibrancy slider all the way to the right to selectively increase saturation in the sky.

The sky is better saturated without the artificial look of oversaturated reds and oranges. The image is close to having the look we want, but would benefit from a little more saturation.

TIP It's a good idea to adjust Vibrancy before Saturation to improve the areas that need the most attention.

8 Drag the Saturation slider slowly to the right until the saturation looks rich, but natural.

A value of 1.30 works well for improving the saturation of this image.

Adjusting Tint with the Tint Controls

Aperture offers additional controls for manually adjusting the tint of an image with the Tint parameter controls. The Tint controls are useful for fine-tuning the white balance in an image. They can be used in conjunction with the White Balance adjustment or on their own.

You should use the Black Tint, Gray Tint, and White Tint color wheels when you need to selectively remove color casts from the shadows, midtones, and highlights in an image. These color casts occur most often when shooting in mixed-light situations (such as when both natural and electrical light are present or when shooting in the shadows). The mixture of multiple light sources can create color variance in a specific tonal range of an image.

Although the execution of the Tint Controls is similar to the White Balance adjustment, there is one essential difference. When using the White Balance controls, all tonal values in the image are adjusted uniformly. When you use the Tint Controls, however, you can selectively neutralize color casts that affect only the shadows, midtones, or highlights.

1 Move the pointer to the Filmstrip and select the image **DSC_753**.

2 If it's closed, click the Tint disclosure triangle in the Enhance area of the Inspector HUD Adjustments pane to reveal the Tint color wheels.

3 Click to select the Black Tint eyedropper.

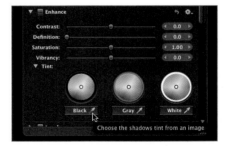

The pointer changes to the Loupe to show a magnified view of the target area.

4 Move the target area so it's positioned over the darkest pixels in the image.

It's important to ensure that there are no bright pixels in the target area of the Loupe or the adjustment will be skewed and produce unintended results.

5 Click the Loupe pop-up menu and choose a magnification of 800%.

6 Click in a dark shadowy area to sample the blacks (making sure that no light pixels are inside the Loupe).

Now that the shadows have had their color casts removed, let's adjust the highlights.

7 Select the Gray Tint eyedropper.

The Loupe appears so you can position the target area.

8 Select an area that is a midrange color (look for an area that's as close as possible to medium gray).

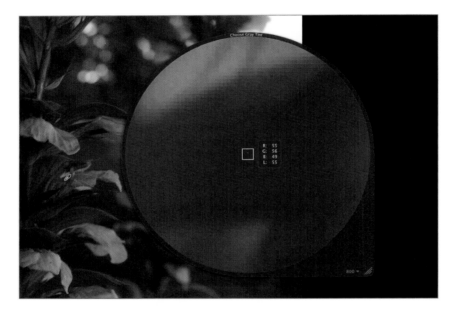

9 Click to remove color cast from the midtones.

10 Select the White Tint eyedropper.

The Loupe appears so you can position the target area.

11 Select an area that is clearly a highlight.

12 Click the target area to remove color cast from the highlights.

NOTE ▶ You can manually remove a color cast in a tonal range by dragging the point in the color wheel. The eyedroppers are the easiest way to use the tool, but may not work in all images if clear black, gray, and white points aren't available.

The image is still a little dark.

13 Click the Auto Exposure button to properly expose the image.

The image on the left is the original. The image on the right has used the Tint and Exposure controls to improve the image.

Selectively Improving Color with the Color Controls

Earlier in this lesson you used the Vibrancy slider to selectively adjust the saturation in an image. Although this control is very useful, Aperture gives you even greater independent controls to selectively adjust the red, green, blue, cyan, magenta, and yellow colors in an image. To access these powerful options, you'll use the Color controls in the Adjustments inspector. Each color offers precise adjustments with Hue, Saturation, and Luminance controls.

Working with the Color Controls

The easiest way to work with the Color controls is to adjust the hue, saturation, and brightness of specific, preset color ranges. Using the Color controls, we'll enhance a multi-colored image.

The first step when using the Color controls is to identify the color values that have the most influence on the colors you want to change. Aperture works in the RGB spectrum, so when you decrease blue, you're adding yellow; when you decrease magenta, you're adding green. If you look at the Tint color wheels, you can see the relationship between colors.

You don't need to use all of the Color controls to improve an image.

1 Move the pointer to the Filmstrip and select the image DSC_671.

 This image contains several bright colors that we can enhance. Let's work first with the reds.

2 Click the disclosure triangle Color adjustment to show all of its controls, then click the Red hue button.

3 Drag the Hue slider to the left to change the reds to a deeper, purplish red.

4 Drag the Saturation slider to the right to create a more saturated red.

5 Drag the Luminance slider to the left to darken the red areas significantly.

6 Drag the Range slider to the left to limit the chromatic range of the adjustment. A smaller value will ensure that only the reds are being affected.

The reds in the image have been improved. Now let's adjust the other colors.

The original image on the left doesn't show as rich a red as the modified image on the right.

7 To see all of the controls in the Color area, click the Expanded View button.

Working in expanded view lets you see all of the controls for each hue in the Colors adjustment. This eliminates the need to click a hue swatch to switch which hue is affected by the adjustment.

NOTE ▶ If space is a concern, you can stay in Compact View and click a Hue button to switch the colors you're affecting.

8 Adjust the following colors while trying to achieve specific results.

Yellows—Warm the yellows by moving the Hue slider to the left. Increase saturation and decrease luminance until a deeper yellow is attained.

Green—Cool the greens by moving the Hue slider to the right. Increase saturation and decrease luminance until a deeper emerald green is attained.

Cyan—The tent has a cyan cast to it from an improper white balance. Leave the Hue slider alone, but drag the Saturation slider to the left until the color cast is gone in the tent. Lower the Luminance slider a small amount to compensate for the bright white canopy.

9 Click the disclosure triangle next to the Colors adjustment to make more room in the Inspector HUD.

The Color controls group is a simple but powerful tool that you'll probably use very frequently. With a little practice, you'll quickly learn how to identify and isolate the particular color swatch and range that you need to select to make your adjustments.

Applying Color Adjustments to Multiple Images

In order to save time, Aperture makes it easy to apply an adjustment to a range of images. The first step is to apply the adjustment to one image, then lift the adjustments and stamp them onto similar images. In this lesson, you just fixed a photograph of peppers. Let's reuse the Colors adjustment and apply it to three similar photos.

1 With the current image still selected, move the pointer to the top of the screen to reveal the toolbar.

2 Select the Lift tool.

The Lift & Stamp HUD appears on screen. It shows all of the adjustments made to the image as well as IPTC metadata and keywords (if present). In an earlier lesson you used the Lift & Stamp tools to copy metadata from one image to another. You can also use Lift & Stamp for image adjustments

NOTE ▶ You many need to deselect the IPTC and Keywords checkboxes to prevent Aperture from copying IPTC metadata and keywords from the selected image. Although the Lift and Stamp tools can be useful for managing metadata, we aren't performing those types of tasks at this time.

3 Move your pointer to the bottom of the screen until the Filmstrip appears.

4 Click to select image **DSC_675**; then hold down the Shift key and click to select image **DSC_683**.

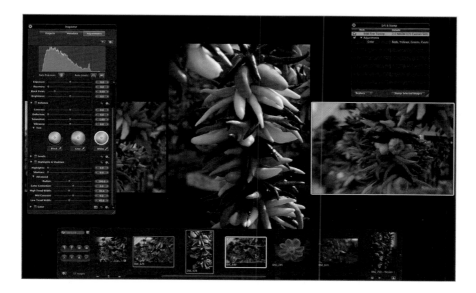

You've now selected three similar images. The Full Screen view adapts to show all three at one time.

5 In the Lift & Stamp HUD, click the Stamp Selected Images button to apply the specified adjustments to the new images.

6 Press H to hide the Inspector HUD so you can better view the modified images.

Customizing the Color Controls

One of Aperture's greatest strengths is its flexible but easy-to-use adjustments. Up to this point you've used the Color controls to adjust preset colors. But what happens if you need to adjust the hue, saturation, and luminance of a color that doesn't appear in the Color controls? Don't worry; you can use the Color eyedropper to identify a hue in the image that needs adjusting.

NOTE ▶ Although controlling hue, saturation, and luminance on a per-color basis may seem challenging at first, it's well worth the effort. Keep in mind that you can use the Range control to fine-tune color adjustments.

1 Move the pointer to the Filmstrip and select the image **DSC_285**.

2 Close the Lift & Stamp HUD by clicking the X in its top corner.

3 Open the Inspector HUD by pressing H.

For this image, we'll adjust the purple in the flower to an entirely new color.

4 Click the color button that most closely matches the flower. In this case, it's the Magenta button.

5 Position the target area in the middle of a petal on the flower.

Clicking in the middle will help us capture the most representative color to use for the adjustment.

6 Adjust the Hue, Saturation, Luminance, and Range sliders until you've produced a vivid pink flower.

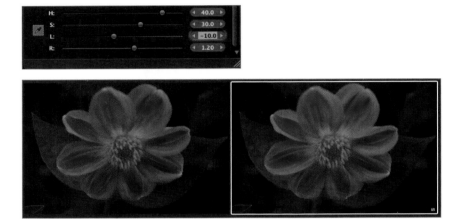

By adjusting the Color controls, you can target specific colors for modification.

TIP ▶ Be sure to experiment with the Color controls on other images. These powerful controls give you lots of options for enhancing your images.

Working with an External Editor

Although Aperture provides great tools for adjusting tone, contrast, and color, it's not intended to be a full-fledged image-editing application. The Aperture toolset will probably be all that you need for the bulk of your images. However, there may be times when it doesn't have the tool required to fix a particular problem. For these instances, Aperture is designed to work seamlessly with an external editing program such as Adobe Photoshop.

Aperture provides a built-in "round-trip" facility for importing and exporting images to another image-editing program. This capability allows you to open Photoshop from within Aperture, and integrate it easily into your Aperture workflow.

NOTE ▶ Many photographers and imaging professionals choose to work with both Aperture and Photoshop. Aperture will work seamlessly with Photoshop and other imaging programs to ensure the greatest flexibility and ease of use. As a point of comparison, this is the same workflow used by other image-management applications like Adobe Photoshop Lightroom.

Choosing an External Editor

If you need to perform more advanced image operations, such as compositing, you can utilize an external editor. You need to specify which application Aperture will use and that it should exchange files using 16-bit file formats. You only have to set these preferences once, then the settings will be used for all future adjustments.

1 Press F to exit Full Screen mode.

2 Choose Aperture > Preferences; then click Export.

3 Click the Choose button below the External Image Editor field.

4 In the dialog that appears, navigate to the application that you'd like Aperture to use when you want to edit an image in an external editor.

For our exercises, we'll be using Adobe Photoshop CS3, so choose it if you have it installed on your system. Click the Select button and close the dialog.

NOTE ▶ If you don't have Adobe Photoshop CS3 installed, you can keep reading without performing the specific steps.

The application's name appears in the External Image Editor field.

5 In the Preferences window, set the External Editor File Format pop-up menu to the format you'd like to use for exchanging files.

We selected PSD because we'll be using Photoshop as our external editor. We could also have selected TIFF, but we know that PSD will support all of the Photoshop features that we might choose to use.

NOTE ▶ Aperture can export an image to your external editor as a PSD or TIFF file, with support for 8-bit and 16-bit files in both formats. The 16-bit exports preserve greater color and tonal fidelity, but may result in reduced functionality in your image editing application.

6 Next to the External Editor File Format pop-up menu is a small field labeled dpi (dots per inch). Set this to 300. This will specify that the image should be exported with a resolution setting of 300 pixels per inch.

7 Close the Preferences window.

Switching between Aperture and an External Editor

As you know, Aperture keeps all of your images organized using its library. When you want to edit an image elsewhere, the easiest way to do so is by using the specified external editor. Aperture will then use its round-trip capability to automatically re-import the image for you.

1 In the Browser, select the image **DSC_0204**.

2 Click the Auto Exposure button in the Adjustments inspector.

3 Choose Images > Edit With > Adobe Photoshop CS3 or press Command-Shift-O.

If it's not already running, Aperture will open the application that you specified in the Preferences window. Your image will be opened automatically (with the Exposure adjustment applied).

4 Click the Aperture icon in the Dock to switch back to Aperture, and then look in the Browser.

NOTE ► When you choose Open With External Editor, Aperture automatically creates a duplicate version of the current selection. Just as it does when you select Images > Duplicate Version, Aperture automatically stacks this new version with your original version. It's this new version that's sent to your external editor.

Let's make it easier to see information about our files.

5 Choose Aperture > Preferences; then click Metadata.

6 Select the checkbox the box next to Image Tooltips and set the pop-up menu to Tooltips. Close the Preferences dialog.

7 Now place your pointer over the second image.

Notice that, because you configured the Tooltips option, the name and extension are visible when you hover the pointer over the image. When the External Editor command is used, a new physical file is created. In this case, a new Photoshop (.psd) file was added to the Aperture library. The physical file must be created in order to apply the Aperture adjustments to the image before opening the image in an external editor.

NOTE ► The new image created by the External Editor command is automatically stored in the same location as the master image. If the image is stored in your Aperture library, the new version will be stored there as well. If the image is a referenced image (see Appendix A for more on referenced images), the new version will be stored in the same location on the hard drive.

TIP ➤ To toggle the visibility of Tooltips, press the T key. If Tooltips don't appear, toggle the T key to make them visible.

8 Switch back to Photoshop and select the Background layer in the Layers panel.

9 Choose Layer > Duplicate Layer to create a copy of the Background layer.

10 Name the layer *Depth* and click OK.

11 Choose the Quick Selection tool (W) and select the tomatoes in the foreground.

> **TIP** ▶ You can hold down the Shift key to add to a selection or the Option key to subtract from a selection.

12 Choose Select > Modify > Feather…, enter a value of 5 pixels, and click OK.

Feathering produces a softer edge when you make a selection in Photoshop. We now want to blur everything in the photo besides the selected tomatoes.

13 Choose Layer > Layer Mask > Hide Selection.

14 In the Layers panel, click the layer thumbnail for the Depth layer.

15 Choose Filter > Blur > Gaussian Blur.

Enter a value of 10 pixels and click OK. The background of the image is now out of focus, but the foreground is in focus because of the mask.

16 Press Command-L to invoke the Levels command.

17 Drag the middle gray slider to the right to darken the image.

18 Click OK to close the Levels dialog.

19 When you've finished editing, press Command-S to save the document, then close it.

20 Switch back to Aperture. The new version that appears in your project should now show all of the edits that you just made.

21 Select the new version and press Command-Shift-O to open it in Photoshop again. Then switch back to Aperture.

Note that this time, Aperture didn't create another new version. Instead, it opened the Photoshop file you were just working on.

> **TIP** If you'd like to create a new version of your image to edit with the external editor command, hold down the Option key when you send the image to the external editor.

22 Quit Adobe Photoshop and return to Aperture.

The image on the left is the original, and the image on the right is the edited version that used compositing techniques to create an enhanced image.

The goal of Aperture is to provide a single application that tends to all of your post-production workflow needs. Because Aperture handles all of the file management, version control, and archiving, taking an image out to another program for additional work is very simple and works seamlessly with your Aperture workflow.

Lesson Review

1. What is the function of Aperture's White Balance adjustment?
2. How does the Auto Levels Separate button determine the adjustments needed to fix an image and apply those adjustments?
3. What's the functional difference between the White Balance and Tint controls?
4. How do you manually remove a color cast in a tonal range?
5. True or false: It's impossible to adjust the hue, saturation, and luminance of a color that does not appear in the Color controls.

Answers

1. The White Balance adjustment lets you control the color temperature and color tint of an image.
2. It fixes an image based on an analysis of each channel's luminance values.
3. The White Balance control makes uniform adjustments to all tonal values in an image. The Tint Controls can selectively neutralize color casts that affect only the shadows, midtones, or highlights.
4. You can manually remove a color cast in a tonal range by dragging the point in the color wheel.
5. False. You can use the Color eyedropper to identify any hue in the image that needs adjusting.

8

Lesson Files APTS_Aperture_book_files > Lessons > Lesson 08 > Lesson08.approject

Time This lesson takes approximately 90 minutes to complete.

Goals Repair images with the Retouch tool

Control vignettes in an image

Create black-and-white and sepia-tone images

Sharpen an image

Remove noise from low-light areas

Sharpen images to compensate for softening

Lesson **8**

Repairing and Enhancing Your Images

Although Aperture offers several tools for improving both exposure and color, its adjustment tools go much deeper. You can repair damaged photos and retouch undesired blemishes using powerful controls like Spot and Patch and Retouch. Additionally, you can correct lens artifacts such as vignettes and increase sharpness with edge sharpening. These powerful repair features allow you to enhance the image.

Besides repairing images, Aperture gives a photographer the ability to simulate traditional techniques. A flexible Monochrome Mixer can be used to create stunning black-and-white images. Additionally, beautiful duotones can be created with ease using the Color Monochrome and Sepia Tone controls. You can also add a stylized vignette to create a focal point in the photo.

In this lesson, we'll use all of these techniques to improve photos from a wedding. We'll both repair and enhance images to create a pleasing collection for the client.

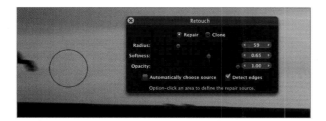

Aperture lets you quickly repair common problems like sensor dust.

Preparing the Project

Up to this point, you've been importing images into projects that you created within Aperture, but the application also allows you to easily import an entire project. This means you can exchange projects with a colleague while preserving all of the work to date. Aperture can pass on all of the metadata, adjustments, albums, Light Tables, web pages, and other information attached to the images inside the project. To start off this lesson, we'll import a project from the APTS DVD files.

1 Choose File > Import > Projects, navigate to the APTS_Aperture_book_files > Lessons > Lesson 08 folder, and import the project **Lesson08.approject**.

For the exercises in this lesson, we'll be referencing many of the images in this project by their version names. Therefore, you'll want to be sure your Browser is configured to show version names.

2 Choose View > Metadata > Customize or press Command-J to open the Metadata Preferences window.

3 Make sure the Browser checkbox is selected, and then select the Set 2 radio button to activate the Set 2 option.

4 Choose Grid View–Expanded from the Set 2 pop-up menu. This will display the version name beneath each image.

5 Click the Close button in the upper-left corner to close the Metadata Preferences window.

Retouching Images

Aperture offers flexible tools for retouching images. You can use the Retouch tool to touch up imperfections such as sensor dust, artifacts, or those caused by environmental conditions. Additionally, you can clone an area of a photo to remove distracting elements from your image.

Aperture offers two methods for retouching photos. Which one you choose depends upon your needs.

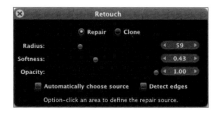

▶ **Repair**—If you need to repair an area that has a hard edge (such as a dust speck), choose the Repair option. This method also works well for copying a texture from a source area and painting it to another while maintaining the underlying color and shading of the destination area.

▶ **Cloning**—The second method can be used to copy pixels from one area of an image and paste them into another. Cloning is useful if you want to reuse an element such as a cloud or tree.

TIP▶ Which retouching tool should you use? In most cases, you'll want to use the Retouch tool to repair your images. The Spot and Patch controls are preserved mostly for legacy purposes to ensure backwards compatibility with older Aperture libraries.

Repairing Your Images

The Repair brush works well when the area surrounding the blemish has high contrast. For example, sensor dust can appear when you change lenses in the field. The dust manifests itself as smudges or flecks in the digital image.

1 Select the photo of the car on the road, **IMG_0059**.

If you look at the left edge of the photo near the horizon line, you can see a large piece of sensor dust. This can be easily removed with the Repair brush. In order to accurately repair an image, you should view it at full size.

2 Press F to enter the Full Screen view.

NOTE ▶ Working in Full Screen mode maximizes the image and makes it easy to work. Although the image is large, it's not at 100% magnification (full size).

3 Press Z to zoom the image.

The image is now quite large, but the sensor dust can no longer be seen. When an image no longer fits in the Viewer or full screen, a small gray box appears on the image with a red rectangle inside. This indicates the portion of the image that is currently visible.

4 Drag the red rectangle to the left edge of the gray box and center it from top to bottom.

The image pans to the left to display the sensor dust.

5 Select the Retouch tool in the Full Screen view toolbar or press X.

The pointer changes to a target, and the Retouch HUD is now visible.

6 Select the Retouch HUD.

7 Click the Repair button.

You now need to adjust the tool settings to get the best result.

8 Adjust the Radius slider to increase the size of the brush.

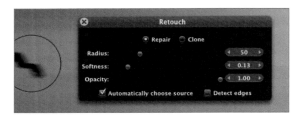

A value of 50 will produce a brush that's large enough to cover the blemish.

9 Drag the Softness slider to the right to create a softer brush.

A value of .45 will produce a gentle blending.

10 Deselect the checkbox next to "Automatically choose source."

This allows you to manually specify a source for the Repair brush.

11 Hold down the Option key and click the cloudy area to the right of the sensor dust.

12 Click the blemish and paint to remove the sensor dust.

The sampled pixels are cloned and used to cover up the blemished area.

13 If the imperfection isn't removed with the first stroke, click and paint additional strokes as needed.

NOTE ► The image sensor on a digital camera is susceptible to dust. This dust can be eliminated with proper care and cleaning of the protective glass of the sensor, but sensor dust is often not detectable by looking through the camera and goes unnoticed until the images reach the post-production stage.

Cloning an Image

Besides repairing, the Retouch brush offers the ability to clone within an image. This works well to copy pixels from one area of an image to another as a way to hide imperfections or repeat objects. The cloning option is faster because it doesn't attempt to blend pixels.

1 Drag the cursor to the bottom of the screen until the Filmstrip appears.

The Filmstrip lets you search for images as well as resize thumbnails, scroll images, and switch images without having to leave the Full Screen mode. You can also use the Filmstrip to search for images, rotate images, and rate images.

2 Select the photo of the groom's party, **5D_IMG_9792**.

If you look to the right of the groom (near his left hand) you'll see a blue trashcan on the beach. This object is distracting and can be removed by cloning.

3 Hold down the spacebar and drag to pan within the image.

4 Pan so you can see the blue garbage can.

5 Press X to select the Retouch tool.

6 Select the Retouch HUD and click the Clone button.

7 In the Retouch HUD, set the brush Radius to 24 and the Softness to .55.

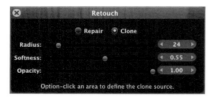

8 Hold down the Option key and click the sandy area below the garbage can.

9 Brush over the garbage can and the people in the background.

10 Repeat brushstrokes as needed.

> **TIP** It's often better to take a few strokes to build up the texture. Be careful as you clone so you don't introduce stray strokes.

> **TIP** If you get an unintended stroke, you can choose Undo. If you return to a retouched image you can also delete a Retouch brush stroke at any time by clicking the Delete button in the Retouch area of the Adjustments pane. Note that brush strokes can be deleted only in reverse order because they're recorded sequentially.

11 Pan to the right of the image until you're looking at the space between the two groomsmen on the right.

12 Hold down the Option key and click to set a new sample point.

13 Brush over the distracting clothes and beachcomber.

14 Press the Z key to zoom back out and view your entire photo.

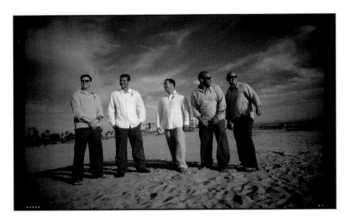

Using the Spot and Patch Tools

The Spot and Patch tools are designed to eliminate small, unwanted elements of an image, such as dust or skin blemishes. Let's use these tools to remove some distracting elements and blemishes in a wedding photo.

1 Press the Esc key to exit Full Screen mode.

2 Select the image of the couple under a canopy called **SD_IMG_9556**.

If you look carefully at the image, there are three distracting elements in the photo: a blemish on the table and two small assembly stickers on the canopy's poles.

3 Press the Z key to view the image at 100% magnification.

> **NOTE ▸** It's a good idea to view the image at full size (100%) to prevent image scaling from obscuring details.

4 Select the Spot and Patch tool in the tool strip.

The pointer changes to a target, and the Spot and Patch HUD appears. Set the Radius to 24.

5 Pan in your image so you can clearly see the blemish on the table.

6 Click the blemish to place the Spot and Patch target overlay on it.

The yellow Spot and Patch target overlay is placed over the blemish. Aperture hides the blemish by blending in pixels from the surrounding area. You can more precisely control the Spot and Patch tool by using the Adjustments inspector.

7 In the Adjustments inspector, locate the Spot and Patch control group.

8 Adjust the Radius and Softness sliders to gently blend the patch better.

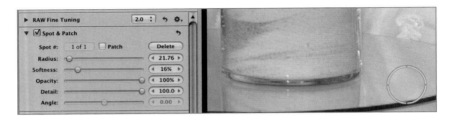

9 Pan the image so you can see the blemish on the left pole of the canopy.

You can see a small sticker on the pole that was used to guide those who built the canopy. This sticker detracts from the final image.

10 Set the Spot and Patch tool radius to 12, then click the blemish to place a Spot and Patch target overlay on it.

A yellow target overlay is placed over the blemish, and the blemish is replaced by the pixels that surround it. The pixel replacement isn't ideal, due to the complexity of the area needing to be patched.

11 Select the Patch checkbox in the Spot and Patch area of the Adjustments inspector.

A white circle appears to indicate the source target for the patch.

12 Drag the white source target overlay to specify the area you want to clone.

The pixels within the source target overlay are copied. Aperture replaces the pixels within the patch using the targeted pixels.

NOTE ▶ You can adjust the size of the target overlay and other properties using the Inspector. Be sure to drag the white target to get the best source.

13 Repeat steps 10 through 12 to remove the other blemish on the right pole.

14 Press Z to zoom back and see your entire image.

The good news is that your image is nice and clean and ready to ship out. The great news is that we never touched the original master image. All of the Retouch brush strokes can be modified or removed at any point in time.

Controlling Vignettes

The term *vignette* is used to describe an image whose brightness fades to its periphery from the center. This produces a darkening at the edges of the image. In some cases, vignettes are desirable and they're applied or enhanced for artistic effect after the image is shot.

In other cases, stacked filters, lens hoods, and wide-angle zoom lenses can cause a vignette. When that happens, you may want to remove the vignette by brightening the edges of the image. Fortunately, Aperture provides flexible controls for both removing and adding vignettes to your photos in a nondestructive fashion.

Removing a Vignette

In order to remove a vignette that was applied to an image when it was shot, Aperture offers the Devignette controls. When you apply a devignette control, it will brighten up the edges of the photo to counter the existing vignette.

> **NOTE ▶** If you combine a devignette and crop adjustment in the same image, Aperture applies the devignette adjustment first. This ensures that the image won't appear distorted.

1 Select the image **MA2N9824** in the Browser.

2 In the Adjustments pane of the Inspector, click the Add Adjustments pop-up menu.

3 Choose the Devignette controls from the pop-up list.

4 In the Devignette area of the Adjustments inspector, set the Amount to 1.0 and the size to 1.5.

NOTE ▶ The Amount slider is used to decrease or increase the brightness applied to the edges of the image. Use the Size slider to adjust the number of pixels Aperture moves towards the center of the image.

Left: Before devignette adjustment; Right: After devignette adjustment.

Adding a Vignette

Aperture offers the Vignette adjustment controls to apply an artistic vignette to an image. With these controls you can add vignettes to a photo after it's shot. This is often done to simulate old-style photographic techniques, such as those used on portraits.

Aperture offers two styles of vignettes: Exposure and Gamma. The Exposure vignette is intended to simulate a lens-created vignette. The other method, the Gamma vignette, intensifies the pixels in the affected area and creates a more pronounced effect.

1 Select the image **MA2N0071** in the Browser.

2 Click the Add Adjustments pop-up menu and choose the Vignette controls.

A Gamma vignette with default values is applied.

3 Choose Exposure from the Type pop-up menu.

4 Drag the Amount slider all the way to the right.

The slider stops at a value of 1.0, but this isn't the limit for the effect.

5 Click the right arrow next to the Amount value slider and set the amount of dark shading to 1.7.

TIP ▶ While you can drag the sliders only so far to the right, you can choose a higher value for the Vignette Amount controls by clicking or dragging on the value slider.

6 Drag the Size slider to the right to set the distance in pixels that will be affected by the darkening vignette.

Choose a value of 1.5.

NOTE ▶ You can use the Lift and Stamp tools to take the vignette from one image and easily apply it to others.

Creating Black-and-White and Duotone Images

Even though most digital cameras shoot in color, many photographers opt to display their photos in ways that simulate traditional film stock and printing techniques. These include both black-and-white photography and the use of duotones. Aperture offers several tools that make it easy to create traditional-looking images. By harnessing the flexibility of versions, you can easily create multiple variations of your image while still leaving your master images untouched.

Using the Monochrome Mixer Controls

Black-and-white photography doesn't mean the absence of color. Rather, the film stock reacts to the presence of color in the image and has an impact on the tonal values used in the final image. Aperture offers the Monochrome Mixer adjustment controls for precise conversion of color images into black-and-white images.

The Monochrome Mixer offers complete control over the tonal relationships and contrast in an image. The Monochromoe Mixer lets you adjust the red, green, and blue channels independently. The effect is similar to using color filters in traditional black-and-white photography.

NOTE ▶ Although you could create a black-and-white photo by simply desaturating the image, it wouldn't compare to the artistic control offered by the Monochrome Mixer controls.

1 Select the image **MA2N9580a** in the Browser.

Before using the Monochrome Mixer, it's a good idea to create a new version of the image. In this way you can easily show multiple variations to the client.

2 Choose Images > Duplicate Version.

A new version of the image called MA2N9580a – Version 2 is created that preserves all of the adjustments made so far. For this image, the color correction and vignette adjustments are carried into the new version.

3 Choose Images > Duplicate Version two more times.

Your Aperture project now contains four versions of the image MA2N9580a.

NOTE ▶ Aperture includes a set of Monochrome Mixer presets that simulate the effects of shooting black-and-white film through color filters. These presets can be used as presets or as starting points for fine-tuning a color mix.

4 Select the image MA2N9580a – Version 2 in the Browser.

5 Click the Add Adjustments pop-up menu (or press Control-M) and choose the Monochrome Mixer controls.

6 Choose the "Monochrome with Yellow filter" from the Preset pop-up menu.

The black-and-white conversion is close, but can be tweaked to better emphasize the skin tones.

7 Adjust the sliders in the Monochrome Mixer with the following values.

▶ Red: 90%

▶ Green: 45%

▶ Blue: -35%

NOTE ▶ As a starting point, be sure the combined values in the Monochrome Mixer equal 100%. In other words, the individual percentages for the Red, Green, and Blue channels should total 100%. Values below 100% lead to a darker image; values above 100% produce a brighter image.

Using the Color Monochrome Controls

In addition to creating fantastic black-and-white images, Aperture has a Color Monochrome adjustment control. This lets you create monotone effects and adjust their color and intensity. The command converts from color to black and white while simultaneously applying a color tint to the midtones.

Let's apply a color monochrome adjustment to the bride's portrait.

1 Select the image MA2N9580a – Version 3 in the Browser.

2 Click the Add Adjustments pop-up menu and choose Color Monochrome.

3 Click the Color swatch in the Color Monochrome controls to choose a color.

4 Select a color in the color wheel and then close the Colors window.

5 Drag the Color Monochrome Intensity slider to the right or left to change the degree of the effect.

The color you defined will be used as a wash over your entire image. The Intensity slider controls how much of the image's original color will remain.

Working with the Sepia Tone Controls

Aperture offers Sepia Tone adjustment controls to quickly generate consistent sepia tone effects. The effect is similar to the Color Monochrome controls, except it already has the sepia color loaded.

1 Select the image MA2N9580a – Version 4 in the Browser.

2 Click the Add Adjustments pop-up menu and choose Sepia Tone.

By default, the sepia tone effect is set to full intensity with the maximum value of 1.0.

3 Drag the intensity slider to the left to 0.8.

The Intensity of the effect is lowered in the midtone areas.

Sharpening and Noise Reduction

All digital cameras soften their images as part of their internal processing when they calculate color values. Fortunately, this softening is nothing that can't be corrected with some simple post-production sharpening. All cameras are able to perform this sharpening internally, and most offer controls for specifying how much sharpening to apply.

If you shoot RAW images, however, no sharpening will be applied to your image by the camera. What's more, even after your camera applies sharpening to non-RAW images, you might still need to add more if your camera's sharpening settings aren't very aggressive. Many JPEG photographers deactivate their camera's in-camera sharpening (or set it as low as possible) so that they can take more control of the sharpening in post-production. Many cameras also produce noise, especially if you're shooting at high ISO settings.

Aperture provides sharpening and noise reduction filters for handling both of these problems. In this exercise, we'll take a look at how to use these tools effectively.

Applying Sharpening

One of the risks of sharpening an image is that the process of sharpening will often increase the noise in your image. At the same time, noise reduction can result in a softening of your image. Therefore, you'll usually want to apply sharpening and noise reduction adjustments at the same time, to try to achieve a balance between the two effects.

Sharpening in Aperture is very simple.

1 In the Browser, select the image **MA2N0464**.

Like some of the other images from this shoot, this image is soft due to the shooting conditions (low light and, therefore, slow shutter speed). This picture needs to be sharpened.

2 Press F to switch to Full Screen mode. Press H to open the Adjustments HUD if it's not already open.

3 Position your pointer over the glass vase and then press Z. This will zoom the image to 100% while keeping the zoom centered around the current pointer position, ensuring that the vase remains visible.

4 In the Adjustments HUD, choose Sharpen from the Add Adjustments pop-up menu. A Sharpen controls group is added to the Adjustments HUD.

Aperture's Sharpen adjustment works just like the Unsharp Mask filter that you might have in your image-editing program. It looks for areas of high contrast in your image—because a high-contrast area is usually an edge—and then it darkens the pixels along the dark side of the edge and lightens the pixels along the light side of the edge. This makes the edge appear to have higher contrast, and therefore looks sharper.

The Intensity slider lets you specify how much of this lightening and darkening you want applied to an edge, although the Radius slider lets you control how thick the brightened and darkened areas will be.

Usually, you'll keep the radius fairly small and perform the bulk of your adjustments using the Intensity slider.

5 Drag the Radius slider to the right until you see some sharpening, at around 3.5. Next, increase the Intensity.

We found good results around 0.6.

6 Click to deselect the Sharpen checkbox to return the image to its unsharpened state.

By selecting and deselecting the checkbox, you can see the improvement in sharpness.

NOTE ▶ It's possible to oversharpen an image. Too much sharpening will result in too much lightening and darkening along your edges, producing an image peppered with strange tiny halos and blotchy, posterized areas.

Applying Edge Sharpening

As you just saw, Aperture's Sharpening adjustment does a good job of sharpening, but it can also get you into trouble. Sharpening sharpens everything in your image, including any noise or artifacts. In a low-light situation, the results can be unpleasant. There are times when you don't want everything in your image sharpened. Portraits are the most common example, because sharpening an entire portrait will often exaggerate unflattering skin textures and blemishes.

Aperture's Edge Sharpen controls group lets you apply subtle sharpening effects to only the edges in your images. A much more subtle effect than the normal Sharpen adjustment, Edge Sharpen is particularly effective when used on portraits, as you'll see in the following example.

1 In the Browser, select the image **IMG_0270**.

2 Press F to enter Full Screen mode, and then press H to bring up the Adjustments HUD.

Knowing how much to sharpen is always tricky, but in a portrait your main concern is that your subjects' eyes are sharp. When you apply any Sharpen filter, you should be looking at your image at 100%.

3 Place your cursor on one of the woman's eyes, and then press Z to zoom to 100 percent.

4 Press Control-S to add an Edge Sharpen adjustment.

Edge Sharpen searches for edges by identifying areas of sudden contrast change. Edge Sharpen provides three controls: Intensity, Edges, and Falloff. Intensity controls the

strength of the effect. Edges lets you control how strong a contrast change must be before Aperture considers it an edge. Falloff controls how the effect transitions between sharpened and non-sharpened areas.

The default Intensity value of 0.81 is a good starting point, so let's work with the other controls.

5 Drag the Edges slider to the right to about 0.50.

Note that the eyelashes, eyebrows, and edges of the face and eyes are sharper. However, the adjustment has not overly sharpened the pores on the woman's face. Already the image looks better, but a slight adjustment to the Intensity slider will improve things further.

6 Slide the Intensity slider to the right to about 0.95.

Our skin texture still looks good, but the eyes have better definition. The Falloff setting is okay where it is, but you should still move it around to try to get an idea of what it does. Pay particular attention to the pores on her face as you move the slider. You'll see them get slightly sharper as you move to the right.

TIP ▶ As a point of comparison, try a quick experiment. Deactivate the Edge Sharpen controls group by deselecting it, and then add a normal Sharpen adjustment. Set its intensity to 0.6 and its radius to around 3.1. Note how the results are not as attractive due to the global sharpening that has been applied. The woman's skin texture has not fared as well under the more aggressive sharpening.

Saving Adjustment Presets

You may often want to apply the same adjustments to many different images. You've already seen how you can use the Lift and Stamp tools to copy adjustments from one image to another, but Aperture also lets you save presets for specific adjustments.

Every controls group has a small menu in the upper-right corner that provides access to the preset-saving options (just look for the gear-shaped icon). After configuring an adjustment, open the menu and choose Save Preset. Next time you use that adjustment, you'll be able to select your saved preset from the Preset menu.

Note that this preset applies only to the specific controls group that it's attached to. You can't save an entire set of adjustments as a preset. For that functionality, you need to use the Lift and Stamp tools.

TIP Sharpen and Edge Sharpen are particularly good candidates for saved presets, as most cameras consistently produce images with the same sharpness issues. Once you find a good set of sharpness settings for your camera, those settings will probably work well for all images from that camera.

Applying Noise Reduction

It doesn't really matter whether you apply noise reduction before or after sharpening. Thanks to Aperture's nondestructive editing, you can continue to tweak these adjustments after you've applied them to get them properly balanced.

TIP If your image needs a lot of noise reduction and some sharpening, you'll get the best sharpening results with the Edge Sharpen controls, as they won't sharpen the noise in your image as much as the regular Sharpen controls will.

Because of the low-light, high-ISO shooting conditions, the reception images have a lot of noise.

1 In the Filmstrip, select the image **MA2N0464**.

2 If you're not already there, zoom to 100%. As with sharpening, it's best to work at 100% when applying noise reduction.

3 In the Adjustments HUD, choose Noise Reduction from the Add Adjustments pop-up menu. A Noise Reduction controls group is added to the Adjustments HUD.

The Radius slider lets you select the size of the noise that you want to reduce. The Edge Detail slider gives you some control over the softening of your image, by telling Aperture how much edge detail to preserve. Again, high-contrast areas are usually edges, so if you don't apply as much noise reduction to those areas, there's a good chance that your image will suffer less from softening.

There's no right or wrong when applying noise reduction. Try it for yourself:

4 Adjust the Radius and Edge Detail sliders, and see what effect you like best.

5 Now set the Radius slider to 1.75 and the Edge Detail slider to 1.20.

6 Select and deselect the Noise Reduction checkbox. You should notice a slight reduction of noise.

NOTE ▶ Digital cameras produce two kinds of noise, luminance noise and chrominance noise. Luminance noise appears in your images as speckled patterns: From one pixel to the next, there will be a sudden change in brightness, or luminance. Chrominance noise appears as brightly colored pixels or splotches of pixels.

Using the Dodge and Burn Plug-In

If you want to do additional editing to your Aperture images beyond the adjustment controls, you have a few options. In Lesson 7 you sent an image to Adobe Photoshop via the External Editor command. Aperture also supports an open plug-in architecture for using specialized third-party imaging software. This architecture allows the Aperture user to purchase specialized tools for fixing issues like lens correction, and addressing tasks such as noise reduction.

Aperture 2.1 also introduced an Apple-developed plug-in called Dodge and Burn, which allows for brush-based adjustments. The act of dodging is used to lighten an image selectively while burning can be used for a targeted darkening. Additionally, the plug-in can be used to adjust saturation, localized sharpening, blurring, and contrast.

Editing with Dodge and Burn

Sending an image to the Dodge and Burn window is pretty easy. Let's apply the Dodge and Burn plug-in to the couple's portrait.

1 Select the image **IMG_0270** in the Browser.

2 Choose Image > Edit With > Dodge and Burn.

A new 16-bit TIFF file is created. Any adjustments that you had made in Aperture are applied to the new TIFF. Aperture opens the image in the Dodge and Burn window.

NOTE ▶ Adjustments made using the Edit With command will be permanently applied. Additionally, any edits made in Aperture will also become permanent in the new version, so it's a good idea to complete all your edits within Aperture before using the Dodge and Burn plug-in.

3 Click the maximize button in the upper-left corner of the window to enlarge the Dodge and Burn window to fill your monitor.

This will give you a larger viewable area as you work with the brush tools.

4 Press the Z key or use the Zoom slider in the lower-left corner to increase the magnification of the image.

5 Using the red rectangle within the gray box, pan until you can see both faces.

TIP You can zoom an image by holding down the Option key and using the scroll wheel on your mouse.

Dodging an Image

Dodging is the process of lightening an image selectively. It's the digital equivalent of a traditional photography process. When developing an image a photographer could shield an area from light (and exposure). This would then lighten that area of the image compared to the rest of the photo.

Let's lighten the faces of the couple, which still seem a little dark.

1 Make sure that the Brush tool is selected and choose Dodge (Lighten) from the Brush Effect menu.

2 Adjust the Size, Softness, and Strength sliders to your taste.

You'll want a brush that's small enough to give you control, but large enough so the dodging goes quickly. A softer brush ensures a gentle transition from affected to non-affected areas. It is generally a good idea to use a lower strength in order to build up strokes over time.

TIP You can use the scroll wheel on your mouse to change the size of your brush dynamically. On a laptop trackpad you can also do this by dragging two fingers up or down. If you're working with a pressure-sensitive tablet you can change the amount of pressure used to impact the strength property.

3 Paint on the faces and hair of the couple to help lighten them.

Before After

TIP ▸ You can press M to show the Master Image. This will show you the image without any brush effects applied. This makes it easier to judge your progress.

The image lightens as you paint. You can paint over an area to build up strokes. You can see the area lighten with each stroke. To make it easier to adjust the affected area, Aperture can show you your brush strokes.

4 Click the Dodge and Burn Action pop-up menu and choose Show Dodge as Overlay (alternately you can press O).

The Dodge and Burn window switches to a grayscale image and shows your brush strokes in red. This process simulates a traditional Rubylith mask.

Aperture offers two tools for cleaning up the brush strokes. You can use the Eraser tool to remove strokes, and you can use the Feather tool to create gentler blends. Both tools offer sliders for greater control.

5 Select the Feather tool and paint on the masked area to refine the colored overlay strokes.

If you have any stray strokes or areas that are lightened too much, use the Eraser tool to clean them up.

6 Press the O key to toggle off the Overlay mode and see the results of dodging. If you'd like to compare the results with the original image, press the M key to toggle viewing the Master image.

Burning an Image

Burning is the process of darkening an image selectively. It, too, is related to a traditional photography process. When developing an image, a photographer could mask most of the image and expose an area to additional light. This would essentially darken the exposed area.

Let's darken the highlights on the surface of the ocean.

1 Select the Brush tool and choose Burn (Darken) from the Brush Effect menu.

2 Adjust the Zoom slider so you can see the whole image.

3 Set the Brush controls so you have a very large, soft brush which uses a low pressure.

4 Paint on the water's surface and horizon to selectively darken the brightest highlights.

TIP ▶ Although there is no Undo command for brush strokes, you can click the Dodge and Burn Action pop-up menu. You will find choices to reset the current tool or to reset all changes made to the image.

5 It's useful to check your progress by toggling the visibility of the burning. Press S to disable just the currently selected Brush Effect (in this case Burn).

Before

After

NOTE ▶ The Dodge and Burn command offers six additional Brush effects that go well-beyond dodging and burning:

Saturate—Selectively increases the intensity of color.

Desaturate—Selectively decreases the intensity of color.

Sharpen—Allows you to sharpen an area with brush strokes.

Blur—Allows you to blur an area with brush strokes.

Contrast—Selectively increases the contrast of an area.

Fade—Reduces contrast in a selected area.

Applying the Adjustments

It's very important to remember that when you apply the Dodge and Burn adjustments. they will be permanently applied (just like any other External Editor application). It's a good idea to closely examine your progress before applying the effects.

1 Look closely at the image and examine your progress.

2 Press the M key to toggle your current view with the Master image.

3 If you're satisfied with your progress, click the Save button.

If you want to modify your brush effects, use the Fade or Eraser tools as described earlier.

4 Aperture processes the effect and stores another version on the image in your project.

> **TIP** ▶ You can tell which version has used an external editor by looking at the badge overlay. The circle badge indicates that the image was edited using an external editor. You can also press T to see the Image Tooltips and look at the version's file name. Images edited with the Dodge and Burn plug-in will be stored as 16-bit TIFF files.

Lesson Review

1. When is cloning the preferred method for retouching photos?
2. True or false: You can delete any Retouch brush stroke at any time.
3. What's the best way to make precise adjustments using the Spot and Patch tool?
4. How can you use Aperture to copy a vignette from one image to another?
5. How does Aperture's Sharpen adjustment work?

Answers

1. The cloning method is better when you want to reuse an existing element from the image such as a cloud or tree.
2. False. Retouch brush strokes must be deleted in reverse order because they're recorded sequentially.
3. You can make the most precise Spot and Patch adjustments using the Adjustments inspector.
4. You can use the Lift and Stamp tools to take the vignette from one image and easily apply it to others.
5. It looks for areas of high contrast in your image and darkens the pixels along the dark side of the edge and lightens the pixels along the light side of the edge.

Printing and Publishing

9

Lesson Files APTS_Aperture_book_files > Lessons > Lesson 09 > Lesson08_End.approject

Time This lesson takes approximately 60 minutes to complete.

Goals Use a website to deliver images for client review

Create a courtesy book for review images

Create contact sheets for web and print use

Send review materials to clients via email

Lesson 9
Delivering Images for Client Review

Once your images are edited, you'll need to present them for review. For many photographers, this stage involves showing the images to a client. For others, the only client may be themselves. In either case, Aperture offers several flexible methods for reviewing images.

You can create a Web Gallery to easily share the images online. This flexible website lets clients quickly view images. Additionally, the Web Gallery is flexible enough to adapt dynamically for playback on other web-enabled devices like iPhones and Apple TVs.

Another popular review method is a courtesy book. You can quickly take selected photos and insert them into an attractive book layout. This book can then be printed or converted to a PDF. Presenting a book to a client is a great way to get them to sit down with the images and review them.

For those on tighter schedules, Aperture makes it easy to create contact sheets or email images for client review. The emphasis in this lesson is on taking your hard work and getting it in front of the people who need to review the images for feedback and selection.

Aperture offers several ways to review images, including books.

Preparing the Project

For this lesson, we'll be preparing images to show a client. The photos we'll use are from Lesson 8, so if you've already completed that lesson, you'll use the same assets.

> **NOTE** ▶ If you skipped Lesson 8, you can import the project **Lesson08_End.approject** into Aperture. These images represent the completion of the previous lesson.

To begin this lesson, we'll create a new project to hold our galleries and contact sheets.

1 Choose File > New Project or press Command-N.

A new Untitled Project is added to your Projects inspector.

2 Name the project *Lesson09* and press the Return key.

3 Drag the complete images from Lesson08 into Lesson09.

If you skipped Lesson 8, import the file **Lesson08_End.approject** from the **Lesson 09** folder.

Publishing a Web Gallery

Aperture makes it easy to publish your images to the Internet. Aperture offers three differ-ent ways to put your images online: a web page, a journal, and a gallery. Each offers a dif-ferent workflow and its own benefits. In this example, we'll use a Web Gallery to publish our images.

> **NOTE ▶** The Web Gallery requires you to have a .Mac account in order to publish. If you don't have a .Mac account, you can get a free 60-day trial at http://www.mac.com.

A Web Gallery is an easy way to publish an album to the web. You simply need to select the images you want to publish, and then create a Web Gallery album. Aperture will auto-matically transfer images to your .Mac account and create a new Web Gallery. The Web Gallery is both stylish and flexible, making it easy to publish your images without the need for HTML coding or file transfer.

Configuring .Mac Preferences

In order to publish a Web Gallery, your computer must be set up to access .Mac. This requires you to know both your member name and password, as well as have admin rights on your computer.

To set up your .Mac preferences, do the following:

1 Click the System Preferences icon in the Dock or choose Apple > System Preferences.

2 Click the .Mac icon in the Internet & Network area of the System Preferences window.

3 Click the Account button.

4 If you haven't already entered it, you'll need to provide your member name and .Mac account.

5 Press Return.

Your computer validates your .Mac account using the entered member name and password.

6 Close the System Preferences window.

Creating a Web Gallery Album

The easiest way to create a Web Gallery is to select the images you want to publish and then create a Web Gallery album.

1 Select the Lesson09 project in the Projects inspector.

2 Select all of the images in the project by clicking in the Browser and pressing Command-A.

3 Choose File > New From Selection > Web Gallery or click the New button and choose Web Gallery.

Aperture asks to use the information stored on your keychain in order to log in to your .Mac account.

4 Click Allow to proceed.

A dialog appears asking you to name the Web Gallery album. This name is used both for the album that's in the Projects inspector and for the Web Gallery album in your .Mac account.

5 Type *Wedding Day* in the Album Name field.

6 You now need to type a short synopsis describing the images in the Album Description field (you can press Option-Return to wrap text to a new line):

Be Yourself - Coronado Beach

Reception: Point Loma Submarine Base

Wedding Coordinator: Liz Beck

7 Set the "Album viewable by" pop-up menu to Everyone.

TIP ▶ You can choose to keep an album private by using access restrictions. You can specify users with the "Album viewable by" pop-up menu.

8 Deselect the checkbox next to "Allow: Downloading of."

NOTE ▶ The gallery supports both the downloading and uploading of images.

9 Deselect the checkboxes next to "Allow: Uploading of photos via web browser" and "Allow: Adding of photos via email."

10 Click Publish.

Aperture creates a new Web Gallery album from the selected images, and then uploads the images to a Web Gallery. The images are stored in your .Mac account. Depending upon the number of images and speed of your connection, this can take a few minutes.

NOTE ▶ When you make a Web Gallery or book, only one version of each image will post. You can specify which version to use by selecting its thumbnail and choosing Stacks > Pick.

TIP ▶ With .Mac, you can publish as many Web Gallery albums as you want. If you reach the storage capacity of your .Mac account, you can purchase more space.

Viewing a Web Gallery Album

Once the album is published, it can be viewed online. Aperture makes it easy to visit the gallery as well as tell others about it. The gallery can be viewed with Safari or any other modern web browser.

1 Click the Web Gallery button and choose Visit Web Gallery….

Safari launches and goes directly to the newly created web page.

2 Explore the web page and its numerous controls.

3 Choose viewing options such as grid, slideshow, mosaic, or carousel. You can also change the color of the background and the size of the thumbnails.

4 Click the Tell a Friend button to send the address link to the clients you want to review the photos.

5 Fill out the fields in the pop-up form and click the Send button when ready.

Updating Web Galleries

Once a gallery is created, it's easy to modify. You can add or remove images from the Web Gallery album in the Projects inspector. Then simply tell Aperture to update the Web Gallery in your .Mac account with the changes.

> **TIP** ▶ Aperture can update your Web Galleries immediately or on an hourly, daily, or weekly, basis. You can adjust Web Gallery preferences in Aperture's Preferences window.

1 Switch back to Aperture.

2 Select the Wedding Day Web Gallery.

3 Select the files **IMG_0560** and **IMG_0562** in the gallery and press the Delete key.

Aperture removes the images from the Web Gallery.

> **NOTE** ▶ If Aperture won't let you delete the images, it's because they are stacked. Close the stack and press the Delete key again.

4 Click the icon next to the gallery name to republish the gallery.

5 Visit the web page to see your changes.

Create a Courtesy Book for Client Review

You can create high-quality printed and bound books using Aperture's built-in book-making feature. After designing the book using Aperture's design tools, you can either save it as a PDF or upload it to Apple's book-printing service. Apple will print the book and mail it to you (or even directly to the client).

These make excellent courtesy books in which clients can review their images. Say, for example, that you photographed an event. Instead of just posting the images to a web page, you could select the best shots and print them in a book for the client to flip through and review. This is a tactile experience and can be very enjoyable for the client.

Creating the Book

Creating a book is easy, and as you'll likely discover, a lot of fun. You can choose from a number of pre-built book themes or design one from scratch. Your first step when creating a book is to select the images you want to include. For this project, we'll use the selected images from earlier in the lesson.

1 Select the project **Lesson09** in the Projects panel.

2 Click in the Browser and press Command-A to select all of the images in the project.

3 Click the New button in the toolbar and select Book or choose File > New from Selection > Book.

Aperture presents a sheet that provides a number of thematic design choices for your book. Different themes simply provide different default layouts. You can always modify the layouts yourself, or even design a new theme from scratch. All of the same editing features and layout tools are available no matter which theme you pick.

TIP If you want to know how much the book costs, click the Options & Prices button to view the latest pricing from Apple.com. Books are available for USA & Canada, Japan, and Europe.

4 Choose the Picture Book theme and then click the Choose Theme button.

Aperture adds a book to your project with its name highlighted and ready to be edited.

5 Change the name of the book to *Courtesy Book*.

Just like an album, a book is simply another element in your project. At any time, you can open it to make edits, just as you would any other type of element.

When you're editing a book, the Browser is visible for selecting images, while the Viewer shows the current page or page spread you're editing. The Pages panel shows thumbnails of all of the pages in your book for easy navigation.

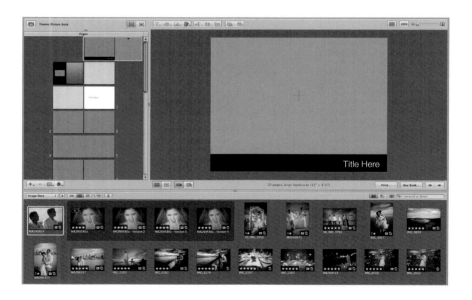

Note the Theme button in the upper left corner of the Viewer. You can click this button to change the theme of your book at any time. However, if you've already edited the content or layout, you may lose some text and custom layouts.

TIP ▶ To prevent losing text when you change your theme, first copy the text to another document as a backup.

By default, Aperture creates a hardback book project. You can change it to a softcover book by clicking the Softcover button at the bottom of the Viewer.

Hardcover Softcover
button button

There's no difference in print quality or layout options between hardcover and softcover books. The only thing that changes is the binding and the price.

For this exercise, choose the Softcover option.

Designing the Cover

Let's start laying out the book by designing its cover.

1 In the Browser, find image **IMG_0270**.

2 Drag the **IMG_0270** image to the book cover displayed in the Viewer. If the stack is open and you see two versions of **IMG_0270**, be sure to select the one on the left, which is the pick of the stack.

3 Release the image over the gray box that contains a crosshair.

NOTE ▸ In a book layout, a gray box with a crosshair is a photo box into which you can drag an image. This is how you can manually place images into your book layouts.

Although the image looks okay, it's a little small. Let's scale the image within the crop to make it look better.

4 Double-click the image in the Viewer.

A selection highlight appears around it, and an Image Scale slider pops up.

5 Drag the Image Scale slider to the right to zoom in on the image as shown in the following figure.

The image is larger than the frame it's sitting in, but that's all right. We can adjust the image's position within the photo box.

6 Drag the image in the photo box to reframe it so that the band is centered.

7 When you're finished, click anywhere in the gray area of the Viewer to deselect the image.

Now we're ready to give our book a title. Let's place the couple's names on the cover.

8 On the cover of the book, double-click the Title Here text to select it. Type *Joe & Stephanie.*

9 Click the gray area of the Viewer to deselect the text.

Notice image **IMG_0270** in the Browser. After you place an image in a book layout, a small badge appears on its thumbnail in the Browser to indicate that it's used in the book. The number on the badge indicates how many times the image appears.

We now need to switch to the interior flap of the cover to make an adjustment.

Designing the Title Page

Designing the pages is similar to designing the cover.

1 In the Pages panel, click the thumbnail for Page 1.

The Viewer will show the first spread of the book: the inside of the front cover and page 1. You can't place anything on the inside front cover. Page 1 is fully editable and customizable, but we're going to leave it as a title page.

2 Single-click the Title Here text on the first page and change it to *Joe & Stephanie*.

NOTE ▶ Book layouts allow you to change fonts and sizes. You can also combine different text sizes in one block of text and create multiple text blocks on a page.

3 Choose Edit > Show Fonts to adjust the properties for the text block.

4 Highlight the text in the block and change its properties. Leave the Family set to Helvetica Neue, but change the Typeface to Bold and the Size to 72.

Now that the title page is complete, we can add images to our layout.

Adding Images to Pages

Now let's add some images to the inside pages of the book.

1 In the Pages panel, click page 2 to select it and view its spread.

Because this is the first photo in the album, let's place a photo of the couple.

2 In the Browser, select the image **MA2N0357** and drag it to the photo box on page 2.

3 In the Pages panel, click page 3 to select it and view its spread.

4 Click the Set Master Page button. The button is located directly beneath the Pages panel.

The Set Master Page pop-up menu provides a selection of pre-built page layouts. You can apply any of these master page selections to the current page. Each theme has a different selection of layouts. For this layout, choose and change the layout to 1-up to have the layout adjust to the size of the photo.

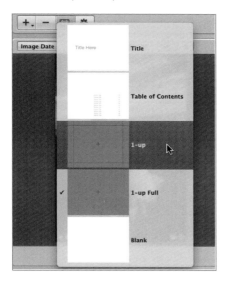

5 Drag the photo **MA2N0353** to the box.

The image is sized to fit to the page.

6 In the Pages panel, click page 4 to select it and view its spread.

This page uses a 1-up Spread. This style of layout will spread one image across both pages.

7 Drag the photo **5D_IMG_9792** into the layout.

Aperture adds the photos to the layout. Some of the images are not framed as well as they could be.

8 Double-click the image to select it.

Drag the image to adjust it within the frame. Drag upward so the groom's party can be seen head to toe.

Automating Page Flow

To speed up the design process, Aperture makes it easy to make several changes at once. This includes the ability to assign a new layout to multiple pages.

1 In the Pages panel, click page 6 to select it.

2 Scroll down and Shift-click the thumbnail for page 20.

Aperture selects pages 6 thru 20.

3 Click the Set Master Page button and choose the 1-up layout.

As you can see, Aperture provides excellent manual layout controls for designing your book, and this is the best way to get exactly the results you want. However, there will be times when you need to produce a book very quickly. When that's the case, you can automate the process of adding images to the book.

Now we're ready to use Aperture's auto-flowing feature.

4 From the Book Action pop-up menu, choose Autoflow Unplaced Images.

Aperture processes the rest of your images, placing one image per page. The images may not be positioned or scaled properly in their photo boxes, but they'll provide a good starting point for other layout ideas.

5 After the images are placed, navigate through the pages and rearrange and fix any pages that have problems.

Finishing the Design

Finally, let's complete the back cover of the book. For this book, we'll remove the photo from the cover and reposition the text. Aperture makes this easy by providing convenient controls for customizing a layout.

1 Click the last page to select the back cover.

2 Click the Edit Layout button.

Aperture changes to allow modifications to the page layout. You can now move, resize, or delete the text, metadata, and photo boxes on pages.

3 Select the photo box that's currently on the page and press the Delete key.

4 Select the text box and drag it on the page to reposition it.

The Book Layout Editor automatically displays yellow guidelines. These show you how the element aligns with the page.

5 Drag so the text block is centered on the page.

6 Click the Edit Content button to return to editing the content on the page.

7 Click once inside the text block to select the placeholder text then start typing to add the following text:

These images are provided for your review. Please contact our offices when you're ready to order.

8 Choose Edit > Show Fonts to adjust the properties of the text.

9 Change the Typeface to Italic and the Size to 18.

The book is complete, so we can now export it to send to the client.

Outputting the Book

Once you've finished laying out your book, you have several options for turning it into an actual printed piece. If you click the Buy Book button beneath the Viewer, Aperture will open a dialog that lets you order a bound, printed book directly from Apple.com.

You need to have an account with Apple in order to use the Buy Book feature; if you don't have an account, you can create one from this dialog.

Aperture provides other output options as well. With the Print command, you can print your books directly to your own printer, or output them to a PDF for electronic distribution or delivery to a non-Apple book-printing service.

Creating a Contact Sheet

A common way to review images is as a contact sheet. Traditionally, this method was used as a reference print. Contact sheets were created making actual-sized prints of the film negative (including frame numbers).

Contact sheets can make the review process easy by condensing a large shoot to just a few pages, with all of the images labeled. Aperture creates contact sheets based on a print preset. You can choose to include or hide image labels and metadata.

To print contact sheets, do the following:

1 In the Projects inspector window, click Lesson09 to select it.

2 Choose File > Print Image… (or press Command-P).

 There are several options that can be specified in the Print dialog; for this exercise, we'll only change a few.

3 In the Layout Options area, specify the number of columns as 3.

 We now need to add labels to the images.

4 Set the Metadata pop-up menu to Name Only and the Font Size pop-up menu to Medium.

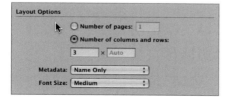

5 Verify the layout of your contact sheet by looking at the preview area.

6 Click Print to send the contact sheet to a printer.

Your contact sheet is now printed.

> **TIP** ▶ If you'd like to email the contact sheets or save them for printing later, choose the Save as PDF… option in the Print dialog.

Reviewing Images with Slideshows

Slideshows are an excellent way to showcase your work. You can use them to create a presentation for clients, to display images, or to run in the background at an event. Slideshows are also one of the best ways to host a review session with a client.

For example, you could create a presentation to show one image at a time and have it manually controlled. This would let you advance through the slideshow at a controlled pace as you review images with a client.

Let's create a slideshow of the images in our wedding collection to review with the client.

1 Select the Lesson09 project by clicking it in the Projects inspector.

2 Choose File > Slideshow or press Shift-S.

The Run Slideshow window appears.

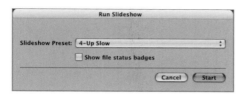

The slideshow displays all the images in the current album or project.

3 Choose Slideshow Preset > 4-Up Slow.

This preset displays four images on a grid, showing them for three seconds each. Then the first image is replaced with the fifth in a two-second cross fade, and so on.

4 Click the Start button to begin the slideshow.

The slideshow begins, with the images appearing one at a time until four of them are onscreen. Then, the images successively crossfade new images into place. The slideshow will continuously loop.

5 Press the Esc key to end the slideshow.

Creating Custom Slideshows

The slideshow presets in Aperture are well designed, but there are a number of options available when you customize your own preset. It's very easy to create a custom slideshow that will better serve the needs of a client review session.

1 Press Shift-S to open the Run Slideshow window again.

2 Click the Slideshow Preset pop-up list and choose Edit.

The Slideshow Presets window appears.

3 Select Manual from the Presets list on the left and click the Add (+) button in the lower left corner to create a new preset based on Slow Dissolve.

4 Name the new preset *Client Review* and press Return.

5 Drag the Padding slider to 25 pixels.

Padding will inset the images, which is a good idea so you have a margin around the photos. This makes it easier to see the edges of the image.

NOTE ▶ You can deselect the "Play slideshow on main display only" checkbox if you use a dual-display system and want your slideshow to play on both displays.

TIP ▶ Using the controls at the bottom of the Slideshow Presets dialog, you can also add music to your slideshow from an iTunes playlist. And using the Quality options in the upper-right corner of the dialog, you can choose the Good setting, which loads more quickly onscreen.

6 Click OK to store the slideshow preset.

7 Click Start to play the Client Review slideshow.

> **MORE INFO** ▶ If your laptop or computer includes an Apple Remote you can use it to control your slideshow. Pressing the Left button goes back one slide and pauses the slideshow. Pressing the Right button goes forward one slide and pauses the slideshow. Pressing the Play button starts or pauses the slideshow. Pressing and holding the Menu button will exit the slideshow.

The slideshow now displays one image at a time onscreen. This allows you to concentrate on your evaluation of each photo.

8 Press the spacebar or Right Arrow key to advance to the next slide; press the Left Arrow key to move backward through the slideshow.

9 Press the Esc key to end the slideshow.

> **TIP** ▶ You can arrange the order of images in your slideshow by arranging the thumbnails in the Browser. An easy way to do this is to create an Album for the project, then arrange the images in the order you'd like to display.

Emailing Images for Client Review

As schedules get busier and busier, more people turn to email as a way to communicate. Fortunately, Aperture offers robust support for emailing images. Although uncompressed images can be large and thus difficult to deliver via email, Aperture offers three export presets that create optimized JPEG files that are easy to send. You can also create your own custom email presets as needed.

Configuring Email Preferences

When properly set up, Aperture can directly transfer images to your email application. By default, Aperture will use Apple Mail, but you can change this and many other properties using the Preferences window.

To specify an email export preset for Aperture to use, do the following:

1 Choose Aperture > Preferences, or press Command-Comma (,).

2 Click Export to view the Export pane.

3 Click the "Email images using" pop-up menu to choose the email application you want.

For this exercise, choose Mail.

4 Next to the Email Export Preset menu click the Edit button.

The Export Presets window opens.

5 Choose the Email Medium – JPEG preset, and then click the Add (+) button.

A new preset appears highlighted in the Export Preset Name list.

6 Name the preset *Watermarked Email*.

7 Select the checkbox next to Show Watermark and then set Position to Lower Right.

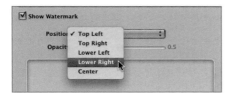

Aperture allows you to specify a watermark to protect files you post online or email.

NOTE ► You can create your own watermark with graphics software, just be sure to save your watermark as a .psd (Photoshop) file with a transparent background.

The .psd format is an open format and can be created using several different image-editing applications.

8 Click the Choose Image button and navigate to the file **Watermark.psd** in the Lesson 09 folder.

9 Select the image and click Choose.

10 Select the checkbox next to "Scale watermark."

The preset is now complete and can be saved.

11 Click OK to set the Email Export preset.

12 Close the Preferences window.

Sending Images with Email

Once your email preferences are configured, sending photos is very easy. In fact, the whole process takes only a few moments.

1 In the Browser, select the images you want to send.

> **TIP** You can hold down the Command key and click to select multiple images.

2 Choose File > Email (or press Option-E).

Aperture begins to process the images. The watermarking process takes a little time, but is a good idea for security. You can check the progress of the export by choosing Window > Show Activity.

The watermarked images are exported directly to your email application.

3 In Mail, simply address the email to a client or friend and click Send.

> **NOTE** ▶ Before you attempt to email an image, find out the maximum file size your email application supports. You may also want to confirm with the client that they want to receive attachments with their email. You can always break a large job up into multiple messages by selecting only part of the project.

> **TIP** ▶ You can share the images in your Aperture library with any iLife or iWork application by using the application's media browser. Additionally, several other applications (including Microsoft Office 2008) feature a media browser.

Lesson Review

1. What viewing options are available for Web Galleries?
2. Are hardcover photo books created in Aperture higher quality than softcover books?
3. What is the function of the crosshair in Aperture's book layout interface?
4. What's the purpose of adding padding to a slideshow preset?
5. Does Aperture offer any mechanism for protecting images that you send out via email?

Answers

1. Grid, slideshow, mosaic, and carousel.
2. No. The only thing that changes is the binding and the price.
3. It's a photo box into which you can drag an image for manual placement of your book layouts.
4. Padding insets the images, which gives you a margin around the photos and makes it easier to see the edges of the image.
5. Yes. Aperture allows you to specify a watermark to protect files you post online or email.

10

Lesson Files
APTS_Aperture_book_files > Lessons > Lesson 10 > Lesson10A.approject

APTS_Aperture_book_files > Lessons > Lesson 10 > Lesson10B.approject

APTS_Aperture_book_files > Lessons > Lesson 10 > FleckLogo.psd

Time
This lesson takes approximately 90 minutes to complete.

Goals
Export masters, versions, and complete Aperture projects

Compose, proof, and purchase a finished book

Prepare and order printed images

Lesson **10**
Delivering Final Images

It goes in—it *must* come out.

After all, what would be the point of getting your images into Aperture and going to the trouble of fine-tuning, sorting, labeling, and rating them, if you couldn't get them out again?

Aperture provides many ways to get your pictures out and into the hands of those who want or need them: clients, friends, family, or the public at large.

In this lesson you'll learn some of the ways to get out of Aperture what you put into it, including your masters and your carefully adjusted versions, along with all the metadata you've assigned—as well as beautifully formatted books and high-quality prints.

Preparing the Project

For this lesson, you'll prepare materials for final delivery to a client, including masters, versions, high-quality prints, and a photo book. You'll use some photos you've worked with in previous lessons.

To complete this lesson, you'll need to copy a watermark file to your Mac, and then create a new project to hold the book you'll build.

1 From the DVD, copy the file **FleckLogo.psd** to a convenient place on your Mac so you can easily get to it later in this lesson.

2 Open Aperture, choose File > Import > Projects, navigate to the APTS_Aperture_ book_files > Lessons > Lesson 10 folder, and import the project **Lesson10A.approject**.

3 Choose File > Import > Projects, navigate to the APTS_Aperture_book_files > Lessons > Lesson 10 folder, and import the project **Lesson10B.approject**.

4 Choose File > New Project or press Command-N.

A new Untitled Project is added to your Projects inspector.

5 Name the project *Lesson10* and press the Return key.

Delivering Electronic Images

Long ago in the analog world, a professional photographer would often contract to deliver carefully prepared selected prints and their photographic negatives to a client. In the digital world, negatives are no more, but the delivery of both raw master photographs along with corrected and enhanced versions can often be included in the contracted deliverables.

Aperture provides extensive output options that you can use to fulfill your contractual obligations to deliver the necessary materials—even if the contract is implicit, and the client is yourself.

Exporting Masters

Handing off copies of referenced masters from an Aperture project to a client is not particularly difficult. Because the raw images are not stored within Aperture's library, you can simply copy them from wherever you've stashed them and turn those copies over. To

deliver managed masters, however, you must export them out of Aperture's library to put them in the hands of your client.

But even if you're working from referenced masters, you still might want to use Aperture's export capabilities. They not only provide you with exact copies to deliver, but offer you versatile sorting and renaming features you can use to help you prepare a tidy delivery package. As an added bonus, you can export any IPTC metadata you've prepared within Aperture to accompany the masters you deliver.

> **NOTE ▶** Exported masters are virtually identical copies of the images that you origi-
> nally imported into Aperture, which means they contain none of the changes you
> may have made subsequently using Aperture's various image manipulation tools.

First, you'll export a set of masters with their original file names into a new folder on your Mac.

1 In the Projects inspector, click the Lesson 10A project and then choose View > Browser Only.

The complete set of images from that lesson appears, arranged in the stacks you created. You want to deliver only those masters that represent the stack Picks you've made.

2 Choose Stacks > Close All Stacks, click in the gray part of the Browser window, and then choose Edit > Select All or press Command-A.

The ten stack Pick masters appear selected in the Browser.

3 Choose File > Export > Masters or press Command-Shift-S.

An export masters sheet appears that you'll use to set up the export.

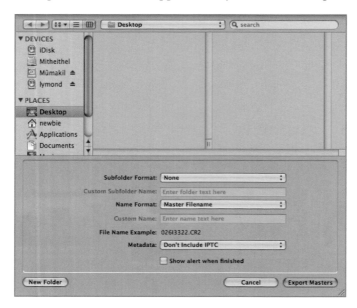

4 In the sheet, navigate to the desktop, and then click New Folder.

5 Name the folder *plain masters* and then click Create.

The sheet now displays the empty plain masters folder.

6 In the sheet, make sure that the Subfolder Format pop-up is set to None, that the Name Format pop-up menu is set to Master Filename, and that the Metadata pop-up is set to Don't Include IPTC.

If you've never used the Export > Masters command before, these should be the sheet's settings.

7 Click Export Masters.

The export begins. The sheet closes and you can continue working while the export proceeds. This export only comprises ten images and takes just a handful of seconds.

TIP For time-consuming exports, you can click Show Alert When Finished in the export sheet to have Aperture display an alert window when the export is done.

Organizing Your Exported Masters

Next, you'll export the same masters into a different folder, this time instructing Aperture to rename the exported masters based upon a name you'll specify. You'll also have Aperture group the exported masters into a subfolder hierarchy within the export folder, organized by the masters' original creation dates.

1 Once again, choose File > Export > Masters, navigate to the desktop in the sheet, and then click New Folder.

2 Name the folder *Masters with custom name* and click Create Folder.

3 In the sheet, choose Image Year/Month/Day from the Subfolder Format pop-up menu.

4 Choose Custom Name with Index from the Name Format pop-up menu, and then in the sheet's Custom Name field, type *West Africa*.

TIP ▶ You can make your own custom folder name and file name presets to suit your exporting needs. Choose Aperture > Presets > Folder Naming to see a window in which you can assemble the naming and sorting elements you want to use for folders, and choose Aperture > Presets > File Naming to create your custom file naming presets.

5 Click Export Masters.

Once again, the export commences, finishing after just a few seconds.

6 In the Finder, open the folder you just created.

The exported masters are placed in a series of nested folders named respectively for the year, month, and day of their creation. The master files themselves are named "West Africa" followed by an index number which indicates the order in which each file was exported from Aperture.

Adding Metadata to Exported Masters

Now you'll go for the full monty: renamed masters, arranged by date in a subfolder hierarchy, and accompanied by metadata sidecar files that contain the IPTC metadata associated with the masters you're exporting.

NOTE ▶ The sidecar files are text files that follow the XML schema for IPTC metadata that was established by the International Press Telecommunications Council in collaboration with Adobe.

1 For a third time, choose File > Export > Masters, navigate to the desktop in the sheet, and then click New Folder.

2 Name the folder *Masters with name and sidecar* and click Create Folder.

3 In the sheet, choose Image Year/Month/Day from the Subfolder Format pop-up menu.

4 Choose Custom Name with Index from the Name Format pop-up menu, and then in the sheet's Custom Name field type *West Africa_iptc.*

5 Choose IPTC4XMP Sidecar File from the sheet's Metadata pop-up menu.

> **TIP** ▶ If you know that your exported masters are going to be used with software that can read embedded IPTC data, you can choose Include IPTC from the Metadata pop-up. Instead of creating an external sidecar file, the export process embeds the metadata in the exported master image files themselves. This eliminates the possibility of an image being separated from its metadata, but also eliminates your ability to deliver the IPTC data to a client separately.

6 Click Export Masters.

When the export finishes, the innermost folders in the export subfolder hierarchy contain two files for each master: the image file itself, and the associated sidecar file.

Exporting Versions

Being able to deliver cropped, corrected, annotated, and enhanced final versions of the images you work on in Aperture is just as important as being able to deliver the original pictures. Aperture provides version export presets you can use to deliver images for almost any purpose; if none of the presets does quite what you need, you can create your own.

1 Make sure the same project and images are selected as you used when you exported masters.

 If you skipped down to here, the pictures that should be selected are the stack Picks from the Lesson03 project.

2 Choose File > Export > Versions or press Shift-Command-E.

 An Export Versions sheet appears.

3 In the sheet, navigate to the desktop, choose JPEG – Original Size from the Export Preset pop-up menu, and then select the Show Alert When Finished checkbox.

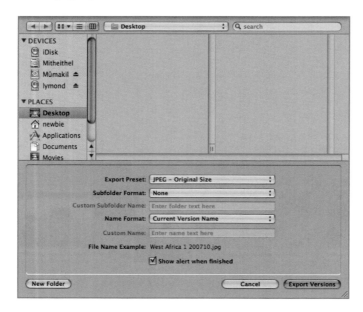

The JPEG – Original Size preset is the default choice if you've never exported a version before. This preset creates high-quality JPEG versions of the selected images which incorporate any changes you've made to the images, and embeds any metadata

you've assigned to them. Because Aperture must create the versions directly from the masters and apply the changes you've made to each of them, the version export process takes rather longer than an equivalent master export does. Choosing to have Aperture inform you when the version export is complete is usually convenient.

4 Click New Folder, name it *West Africa jpegs – original size*, and then click OK.

5 Make sure that the Subfolder Format is set to None and that the Name Format is set to Current Version Name, and then click Export Versions.

> **NOTE ▶** Although you can choose the same file renaming and subfolder creation presets when you export versions that you can choose when you export masters, here you'll stick with the basic settings.

Aperture begins creating the export files in the background so you can get back to work. When the export is complete, Aperture alerts you.

6 In the alert, click Reveal in Finder.

The Finder opens the folder that contains the exported images. If you like, you can open up one of them with Preview and choose Tools > Inspector. The More Info pane in Preview's Inspector window shows you the image details, including the metadata that is embedded in the image.

Adding Watermarks

Now that you've performed a basic version export, you'll perform one that creates reduced-size versions and that adds watermarks to the images.

1 In Aperture, choose File > Export > Versions or press Shift-Command-E.

2 In the sheet that appears, navigate to the desktop, and then create a new folder and name it *West Africa – half size jpeg watermarked*.

3 Click the Export Preset pop-up menu.

The menu appears, listing the currently available export presets. You're going to add a new one.

4 In the Export Preset menu, choose Edit.

An Export Presets dialog appears in which you can create new presets or customize existing ones.

TIP ▶ You can create custom export presets without going through the Export Preset pop-up menu in the sheet by choosing Aperture > Presets > Image Export.

5 In the left panel of the Export Presets dialog, click JPEG – 50% of Original Size, and then click the + button below the panel.

 A duplicate of the preset is created. Its name is selected so you can change it quickly.

6 Name the new preset *JPEG – 50% of Original Size watermarked* and then click Show Watermark in the window's right panel.

 The controls in that portion of the panel become active.

7 In the Finder, locate the **FleckLogo.psd** file you stashed away at the beginning of this lesson and drag it into the image well below the watermark controls in Aperture's Export Presets window.

 A ghostly watermark logo appears in the well. Watermark files are Photoshop files that have a transparent background.

8 Choose Lower Left from the Export Presets dialog's Position pop-up menu, make sure that the Scale Watermark checkbox is selected, and then click OK.

 Aperture saves the watermark with the preset. When Scale Watermark is selected, Aperture scales the watermark down to fit the image if necessary when it exports; however, it won't scale watermarks up.

9 Click Export Versions.

 The export begins. When it finishes, you can take a look at one of the exported images with Preview to see what the watermark looks like.

Exporting Higher-Quality Images

JPEG images are fine for many uses, but sometimes you need to deliver higher-quality images than JPEG can provide. Aperture can export high-quality, 16-bit images in TIFF, PNG, and Photoshop formats. You can also apply various ColorSync profiles to the exported images to make them look their best when printed or displayed on a suitable device. That's what you'll do next.

1 In Aperture, choose File > Export > Versions or press Shift-Command-E.

2 Choose Edit from the Export Preset pop-up menu, and then create a new preset in the Export Presets dialog, basing it upon the TIFF – 50% of Original Size preset.

 This preset already produces 16-bit exports, as you can see from the Image Format pop-up menu at the top of the window's right panel.

3 Name the new preset *TIFF – 16-bit 50% of Original Size print optimized.*

4 From the ColorSync Profile pop-up menu, choose a profile compatible with your printer.

ColorSync manages how color information maps between the information stored in an image and the range of colors available on the device on which the image is displayed

or printed. Which profiles you'll find listed in the menu depends on the printers you have installed on your Mac and whether those printers came with custom ColorSync profiles. If you don't see a suitable profile, stick with the default choice.

5 Click OK to save the new preset and close the Export Presets dialog.

6 In the sheet, navigate to the desktop, create a new folder, and name it *West Africa – tiff_16bit_halfsize_print_optimized*, and then click Create.

7 Click Export Versions.

High-quality print-optimized versions are created. Depending on the ColorSync profile you chose, the colors in the images when displayed in an application such as Preview might look different from the way they do in Aperture.

As you can see, Aperture's image export capabilities can be tailored to produce image files suitable for a very wide range of uses. But that's not the end of Aperture's export story.

Exporting Metadata and Projects

From time to time you may find that you need just the metadata associated with some of your images, such as for cataloging purposes or for including on an invoice of deliverable materials. You may also have an occasional need to copy an entire Aperture project so that you can use it on another machine or to hand it off to a colleague. Aperture can handle both of these cases.

Exporting Project Metadata

Aperture can export the metadata you've added to your images to a standard text file so that you can use it in a variety of ways.

1 With the same images selected that you've used previously in this lesson, choose File > Export > Metadata.

A sheet appears.

2 In the sheet's Save As field, type *West Africa metadata* and then click Export Metadata.

Aperture exports the metadata into a file at the location you specified in the sheet. This file is a standard tab-delimited text file that uses Unicode encoding to support any foreign characters or symbols in the metadata. The file can be opened with any text editor or word processor. It can also be imported into spreadsheet programs like Apple's Numbers or Microsoft Excel, where the tabs are converted into spreadsheet columns.

Exporting an Aperture Project

Exporting a project so you can hand it off to a colleague or move it to a different machine is almost as easy as exporting metadata.

1 In the Projects inspector, click the Lesson03 project.

2 Choose File > Export > Project.

3 In the sheet that appears, type a name for the exported project in the Save As field, or leave the name as is if you prefer, and then navigate to the location where you want to store the project.

 The sheet also contains a Consolidate Images Into Exported Project checkbox. If your project uses referenced masters, select this checkbox to include those masters in the exported project file.

4 Click Save.

 Aperture exports the project to the location you specified. Depending on the size of the masters and the complexity of the project, it may take a few minutes.

However, the export takes place in the background so you can continue working during the export process.

Keep in mind that exported projects can be quite large. Make sure you have enough disk space to store the exported project!

Using Export Plug-ins

In addition to all of its built-in export capabilities, Aperture supports a plug-in architecture so that software developers can create specialized export methods. Such plug-ins often work with third-party software or with commercial services. For example, you can find plug-ins that produce images suitable for use with nonlinear video editing systems such as Apple's Final Cut Pro, and plug-ins that can upload selected images directly to services such as Flickr.

You can find plug-ins on various websites, including Apple's, where you'll find a growing collection of useful and interesting export plug-ins. For this part of the lesson, you'll download and take a look at a plug-in designed to upload your images directly to Flickr. (If you don't want to actually download and install the plug-in, just read along.)

1 Quit Aperture.

 When you install a plug-in while Aperture is running, it isn't available for use until you quit and restart the application.

2 Open a web browser and go to www.apple.com/downloads/macosx/aperture/.

 The Aperture download page opens in your browser. It contains a list of the available Aperture plug-ins.

3 Scroll down the page until you find the FlickrExport for Aperture plug-in, and then click the download link.

 Depending on how your browser is configured, the disk image that contains the download may open automatically. If it doesn't, find the downloaded disk image and open it manually.

4 In the Finder, in the disk image window, double-click the Install file.

To protect you, a warning appears. Because this download comes directly from Apple's site, it's probably safe for you to proceed.

5 Click Open.

The installer's main window appears.

NOTE ▶ We chose this plug-in because it has a full-featured installer that lets you install the plug-in either for the currently logged-in user or for all users on your Mac, and because it has an uninstall option. Different installers may provide different options.

6 Follow the installer's instructions to complete the plug-in installation.

TIP ▶ Don't discard the installer disk image when you finish installing. You can use the installer's uninstall option to remove the plug-in when you finish this lesson if you like.

7 Open Aperture and select the same images you've exported previously in this lesson.

8 Choose File > Export > FlickrExport.

This new item now appears on the Export submenu. When you select it, the Flickr-Export offers you various export options. Because it's a shareware product that requires a Flickr account, you're asked to register the software or use it unlicensed to try it out, and you're asked to authorize your plug-in with Flickr before you can upload any files.

9 Respond to the plug-in's prompts as you desire, and then explore the FlickrExport plug-in's features.

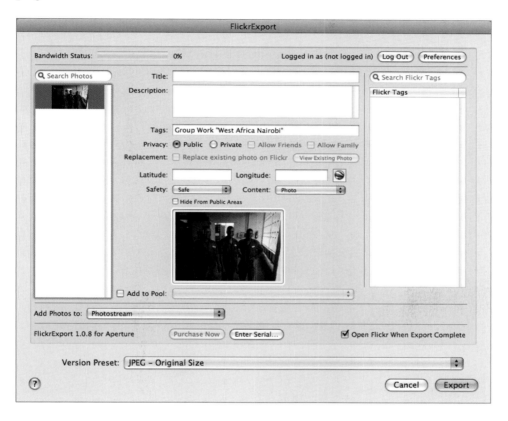

10 When you finish exploring, click Export or Cancel, depending on whether or not you have a Flickr account and have authorized the plug-in.

As you can see, with the variety of export options that Aperture makes available to you, you don't ever have to worry about how to get out of Aperture what you put into it.

But you're not limited to getting images, metadata, and projects out of Aperture. Next you'll see how to use your images to make something special for your clients—or yourself.

Creating Books

You've already taken a quick look at creating a book when you prepared a courtesy book for client review in Lesson 9, but that just skimmed the surface of the depth and flexibility of Aperture's book-creation capabilities. Now you're going to dive deeper as you prepare a final deliverable for a client: a hardcover photo book.

Exploring Book Themes

When you created the courtesy book, you quickly chose a theme and began laying the book out. Here you'll take a few minutes to become more familiar with the available themes and their variations that Aperture offers.

You've already created an empty project for this lesson, and that's where you'll put the book you're about to create.

> **NOTE ▶** You don't have to create a book inside a project; you can create a book that doesn't exist in any project at all, and you can always move a book from project to project if you like with a simple drag and drop.

1 If it isn't already selected, click the Lesson10B project in the Projects inspector. Then click the New button on the toolbar and choose Book from the menu that appears.

The Theme selection sheet drops down. By default, the sheet shows you the themes available for large books, as indicated in the Book Type pop-up above the theme list.

2 In the Theme selection sheet's left pane, click a different theme from the one that's currently selected.

Each time you click a different theme, the sheet's right pane gives you a preview that shows how a book will look using the selected theme. If you want, you can continue clicking themes in the list to see previews of the different book themes. Notice that

some themes provide different stylistic choices, whereas other themes—such as the Stock Book themes, for example—are intended for specific professional purposes.

3 Click the Book Type pop-up and choose Medium.

The appearance of the currently selected theme in the right pane of the Theme selection sheet changes to show you a softcover book preview. Although large book types are available in both hardcover and softcover, medium-size books are only available in softcover.

4 Click the Book Type pop-up menu and choose Small.

Now the available themes in the sheet's left pane are reduced to a single theme: Small Book.

5 Click the Book Type pop-up menu again and choose Custom.

The left pane of the sheet is now empty and the New Theme button at the bottom of the sheet is enabled. Notice as well that the Options & Prices button in the sheet is now disabled. That's because you can't order professionally printed custom books from Apple, although you can print them yourself.

6 Click the New Theme button.

A New Custom Book dialog appears. You can use this dialog to create a new book theme, to give the theme a name, and to specify the theme's book dimensions and its

general layout characteristics. If you were to click OK in the dialog, the new theme you've specified would appear in the list of custom book themes in the sheet. But you aren't going to do that; right now, you're just looking.

7 In the New Custom Book dialog, click Cancel, and then choose Large from the Book Type pop-up.

The list of themes reappears in the sheet's left pane.

8 Click the Modern Lines Theme and then click Choose Theme.

Aperture creates a new book inside the currently selected project.

9 Rename the new book *A World Book*.

Because you haven't chosen any pictures—after all, the Lesson10B project doesn't contain any pictures for you to choose—the book is empty. You're about to take care of that.

Adding Pictures to a Book Album

When you made the client review book, you were working in a project that already contained pictures. However, the project you've made for this lesson is empty.

Even if the project weren't empty, though, the book album would be: Unless you create a book from a selection of pictures, as you did with the client review book, a book album starts out with no pictures in the book album's Browser. However, you can easily add the pictures you want to the album, and not just from the project that contains the book: You can add pictures to a book album from any Aperture project or album.

Next, you'll add the pictures from the Lesson10B project to the book you've just created.

1 In the Projects inspector, click the Lesson10B project.

2 In the toolbar, click View and then choose Browser Only.

3 Click anywhere in the Browser to focus Aperture's attention on it, and then choose Edit > Select All.

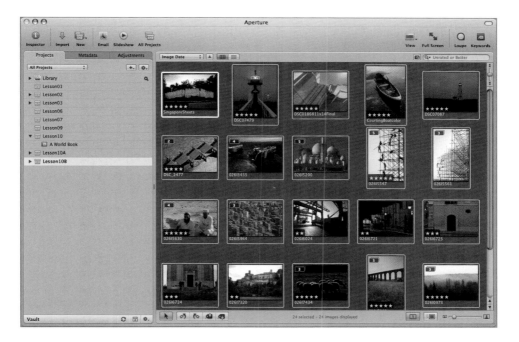

4 Drag a picture from the Browser to the A World Book album in the Project pane and release the mouse button.

NOTE ▶ When your pointer is over the book album it displays a plus symbol; by default, dragging pictures from a project to an album in a different project copies the pictures instead of moving them.

5 Click the A World Book book album.

The pictures you dragged now appear in the book album's Browser.

Placing Pictures and Pages

When you dragged the pictures from the Lesson10B project to the new book album, you probably noticed that the number of pictures being dragged—24—appeared in a red badge at the bottom left of the icon that followed your pointer on its journey.

Now take a look at the book layout shown in Aperture's Pages pane. Although the book has twenty pages, plus a cover, the number of picture boxes in the layout that Aperture created is considerably more than twenty: several of the pages have two, three, or four picture boxes.

If you want to fill this book with pictures, you have two choices: add more pictures to the book album, or reduce the number of pictures needed to fill the book. In this instance, you'll take the second approach. The process should be familiar to you, because you did something like it when you created the client review book in Lesson 9.

1 In the Pages pane, click page 4 in the layout, then scroll down and Shift-click page 20.

2 Click the Set Master Pages pop-up menu button at the bottom of the Pages pane.

It's the third button from the left. As you've seen before, clicking it produces a menu showing the available master pages for the current theme.

Notice that several of the master pages in the Set Master Pages menu have a hyphen beside them. The hyphen indicates master pages that are currently included in the book's layout.

3 Choose 1-up from the Set Master Pages menu.

The selected pages now use the 1-up master page, and the book's layout more closely matches the number of pictures you have available to place.

4 Click the Book Action pop-up menu button (it's just to the right of the Set Master Pages pop-up menu button), and then choose Autoflow Unplaced Images from the menu that appears.

The book is now filled with pictures.

Arrange Your Pictures in a Narrative

Autoflow has placed the pictures in the order in which they appear in the Browser. The next step is to arrange the pages to tell a more interesting—or, at least, less random—story.

> **TIP** You can arrange the order of the pictures in the Browser before you perform an autoflow if you prefer, but often it's easier to rearrange the pages after you autoflow pictures instead. Moving the pages into a more pleasing or interesting order directly in the Pages pane can give you a better sense of the book's narrative or aesthetic structure.

You'll start by replacing the cover picture with a more dramatic photo.

1 In the Pages pane, click the book's front cover.

2 In the Browser, find the picture that has the big domes; its name is **02615203**.

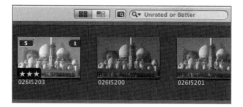

NOTE ▶ When you work on a book, the Browser can display either all the available images or only the ones that haven't yet been placed. You can switch between these two modes with the Show All Images and Show Unplaced Images buttons that appear just above the Browser's right side beside the search field.

TIP ▶ When working on a book, you may find it helpful to use the Browser's Filmstrip view to make it easier to scan through the available images.

3 Drag the image from the Browser into the Book Layout Editor and drop it on the current cover picture.

The picture you dragged replaces the cover picture. Notice that the same picture of the domes also appears on page 6 of the book, and putting it on the cover doesn't remove it from that page; you can use an image multiple times in a book. Also notice that the image you replaced is not moved elsewhere in the book—no flowing takes place—but it does remain in the Browser so that you can put it elsewhere in the book.

NOTE ▶ You can tell how many times an image appears in a book by looking in the Browser. Every picture placed in a book has a red badge in the upper right containing a number that indicates how many times the image appears in the book.

Create an Opening Pictorial Sequence

With a new cover picture in place, you'll next move some pages within the book so that the book opens with a pictorial sequence showing the construction work being performed on the domes.

1 In the Pages pane, click page 7 and then Shift-click page 8.

The images on these pages show details of the construction scaffolds and some of the workers clambering over them.

2 Drag page 7 up until the your pointer is just to the left of page 1 and drop the pages.

As you drag, a green line appears to the left of each page the pointer passes over to show you where the pages will appear if you release the mouse button at that moment. When you drop the pages you've dragged, the other pages in the book move to accommodate the new placement.

3 Click page 8, then drag it between pages 2 and 3.

4 Click page 9, Command-click page 11, and then drag these pages to the left of page 4.

The two pages you've dragged become pages 4 and 5 in the book. You can drag non-contiguous pages in the Pages pane to move and consolidate them.

5 Finally, find the image in the Browser of the two men that now appears on page 4—its title is **02615630**—and then drag it onto the picture that appears on the front flap of the book's dust jacket.

You've now completed a simple pictorial narrative about the dome construction work for the book's cover and opening pages. Next you'll add a small amount of visual drama to that narrative.

Adjusting Page Layouts

Each book theme, as you've seen, comes with a set of master pages that you can apply to any page in the book. However, you aren't limited to the available master pages for your page layouts. You can add picture and text boxes to any page and change their sizes and appearances to meet your artistic and professional requirements.

On the first page, the picture of workers climbing on open-air scaffolding hundreds of feet above the ground is rather dramatic, but, when it was flowed into the book, the picture was scaled to fill the page's picture box, cropping the image's top and bottom and eliminating some of its inherent vertiginous drama. Let's restore it.

1 Click page 1 in the Pages pane to show it in the Book Layout Editor.

2 Control-click the picture on the page and then choose Photo Box Alignment > Scale To Fit Left-Aligned from the shortcut menu that appears.

The picture resizes to show its full contents and moves to the left of the picture box, which is highlighted.

3 In the row of buttons above the Pages pane, click the Edit Layout button.

Handles appear around the picture box's edge, which you can use to resize the picture box.

4 Drag the right edge of the picture box to the left until it touches the right edge of the image.

The picture box now snugly surrounds the image.

Adding Photo Boxes

There are some additional images of this open-air construction project in the Browser that have not yet been placed. You'll fill in the newly emptied right side of the page with those. But first, you have to add some photo boxes to the page to hold them.

1 In the row of buttons above the Book Layout Editor, click the Add Photo Box button.

An empty photo box appears on the page ready to be filled and resized.

NOTE ▶ The Edit Layout button must be selected to enable the Add Photo Box button.

2 Below the Pages pane, click the Book Action pop-up menu button and choose Show Layout Options.

The Layout Options Inspector appears at the top of the Pages pane. The Inspector's controls show the dimensions and position of the currently selected object in the Book Layout Editor. You'll use the Inspector's controls to modify the picture box you just created so that it's exactly half the size of the other picture in the box.

3 In the Inspector, click the Width field and type *2.5*. Then click the Height field and type *3.75*.

The empty picture box changes size and shape to match the dimensions you typed. Next you'll create two more copies of the empty box.

TIP ▶ You can click the arrows in a Layout Options Inspector field to increase and decrease the field's value by small increments. You can also drag to the left or right in an Inspector field to increase or decrease the field's value.

4 Control-click the resized photo box, choose Duplicate from the shortcut menu that appears, and then repeat the process.

Nothing seems to have changed, but you now have three empty photo boxes on the page stacked directly on top of each other.

5 Drag one of the empty photo boxes below and to the right of the other two, and then drag the next one up and to the left, so that you see the three boxes arranged diagonally across the empty area of the page.

As you drag the boxes, alignment guides appear to help you position the boxes more accurately.

6 In the row of buttons above the Book Layout Editor, click the Send Backward button.

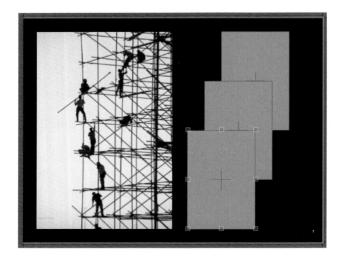

The three boxes now overlap, with the bottom one overlapping the middle one, and the middle one overlapping the one at the top left.

Placing Images in the Photo Boxes

With the new photo boxes in place, it's time to fill them. These images are in the stack that contains the main image on the page. Aperture doesn't let you use alternate images from a stack in a book, though, so you'll have to unstack the images before you can place them. Once they're placed, you'll stylize them with Aperture's book layout filters.

1 In the Browser, find the stack that contains the images you want to place.

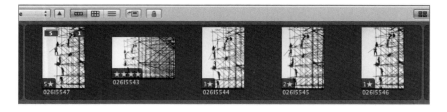

If you have trouble locating them, the images are named **02615544**, **02615545**, and **02615546**. One of the images has a three-star rating, one has a two-star rating, and one has a one-star rating. If necessary, click the Show All Images button above the Browser.

2 Click any of the pictures in the stack and then choose Stacks > Unstack.

The pictures are now unstacked.

3 Drag the three-star image to the lower-left photo box, drag the two-star image to the center photo box, and drag the one-star picture to the upper-right photo box.

4 Click the bottom-left photo box, then, in the row of buttons above the Book Layout Editor, click the Photo Filter pop-up menu button and choose Sepia.

The image takes on sepia tones.

5 Click the middle photo box, and then choose Sepia Wash – Light from the Photo Filter pop-up menu.

6 Click the top right photo box and apply a Sepia Wash – Strong filter to it.

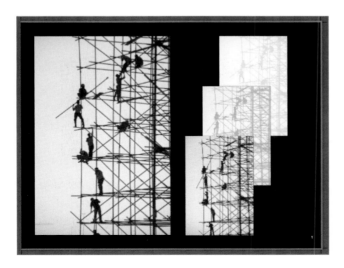

The washes provide a nice aging and softening effect to the smaller photos, but seem to fight against the stark black page background.

7 In the row of buttons above the Book Layout Editor, click the Set Background pop-up menu button and choose Sand.

A light sandy color suits the sepia-toned images, and is also appropriate for the desert setting of the pictures. In fact, it's a suitable background color choice for all of the pages in this sequence.

8 In the Pages pane, click page 2, Shift-click page 5, and then choose Sand from the Set Background pop-up menu.

Designing a Cover

With one photo sequence taken care of, it's time to turn your attention to the book's cover, adding a filtered background image to the back cover and adjusting the text box that appears there.

1 In the Pages pane, select the book's back cover.

2 In the Browser, find the dome image that appears on the book's front cover and drag it onto the back cover, making sure not to drop it in the small picture box that's already there.

The dome image now serves as the background of the back cover.

3 Click the small picture box on the back cover and press Delete.

4 Click the background image, and then choose Sepia Wash – Light from the Set Background pop-up menu.

The light sepia image now acts as a subtle echo of the front cover image. However, the white placeholder text in the back cover's text box has become all but unreadable.

5 Double-click inside the text box to put an insertion point in the placeholder text, and then choose Edit > Select All.

The placeholder text is selected.

6 Control-click the text box and choose Font > Show Colors from the shortcut menu that appears.

The standard Color panel is displayed.

7 In the Color panel, drag the slider on the right all the way down.

The placeholder text becomes black.

8 Type some suitable text in the text box to replace the placeholder text.

What you type is your choice, but it should be something suitable for a back cover, such as image credits or information about the book's contents.

9 In the Pages pane, select the book's front cover, and then edit the book's title to read *A World Book.*

10 Resize the title text box so that it's just wide enough to contain the new title.

11 Change the color of the title text to black.

You won't be able to see the text against the cover's black background, but that won't be a problem after the next two steps.

12 Drag the title box over the cover picture, and then enter *270* in the Angle field of the Layout Options Inspector.

The text box rotates vertically.

13 Drag the text box to the upper-right corner of the cover picture.

The alignment guides help you position the title text box properly.

If you like, you can continue customizing the book. For example, you can remove the text boxes on the front and back cover flaps (or fill them with suitable text), rearrange the order of pictures in the rest of the book, add more images, change some more page backgrounds, and possibly add some text box captions.

When you finish, you'll proof your book for printing.

Soft-Proofing a Book

Printing a book is neither a particularly cheap nor a particularly speedy process, so before you take the time and incur the expense, you want to make sure that the book is ready to be printed.

Aperture provides sophisticated preview and color management features that you can use to check your book thoroughly before you print it. You access these features in Aperture's Print dialog.

1 In the row of buttons below the Book Layout Editor, click Print.

The Print dialog for book albums appears. On the left is a pane with various presets for printing different kinds of books, on the right is a preview pane that shows you how the book will look with the current print settings, and in the center is a pane sporting various print and printer options.

TIP You can save your specified printing settings as a custom printing preset by clicking the Save As button in the lower left of the dialog. That preset becomes available in the dialog's left column for future use.

2 Click the ColorSync Profile pop-up menu.

The default profile, System Managed, is a good choice only if you can't find an output profile on the menu that corresponds to the printer you intend to use. In addition to the output profiles, the menu offers other device profiles that you can use for special purposes.

Because the difference in appearance from one printer profile to another can be subtle, in the next step you'll use one of the device profiles that produce more dramatic color conversions so you can more easily see how changing ColorSync profiles can affect printed output.

3 In the ColorSync Profile menu, choose Gray Tone.

The page preview shown in the right pane of the Print dialog now appears in gray-scale. You can use the arrow buttons below the preview to page through it and see how the currently selected profile affects each page.

4 Click the ColorSync Profile pop-up menu again, and, if your printer's profile appears on the menu, choose it; otherwise, choose System Managed.

The preview in the Print dialog changes to reflect how the book will appear using the current profile. However, the dialog's preview is a small, low-resolution version of a book page. The next step produces a much more detailed version you can use to check the book's final appearance.

5 At the bottom of the Print dialog, click Preview.

A progress window appears as Aperture goes through the complex process of converting each page into an output format that matches the profile you specified. Depending on the size of the book, and the speed of your Mac, this can take a few minutes. When it finishes, a preview of your book appears in the Preview application.

TIP ▶ You can use the Save As PDF button to create a file to print elsewhere, such as at a specialized print service. If you have an output profile for that printer, and select it before you create the PDF, the profile is embedded in the PDF and is used when the file is printed.

6 In the Preview application window, at the lower left, select the "SoftProof using embedded profile" checkbox.

Depending on the profile you've chosen, the appearance of the page shown in Preview visibly changes to show the page as it will print. You can use commands in Preview's View menu to zoom in and out of each page; the preview contains the full-resolution document scaled for the printing device you specified.

7 In the Preview window, click Cancel.

MORE INFO ▶ Aperture offers several options when creating books. When you click the Print button for a book, be sure to click the PDF pop-up menu and look at the many PDF options. You'll find a number of useful options, including the following:

Mail PDF—Generates a PDF and automatically attaches it to a new mail message.

Save Books as JPEG or TIFF images—Exports each page of the book as a separate graphic file.

Save PDF to Aperture—Creates a PDF from the book and re-imports it into Aperture. You can then add the file to a web page or Web Gallery.

Now that you've proofed your book, you *could* print it yourself, but there's an easier way.

Ordering Books

Aperture, like its sibling consumer application, iPhoto, provides access to Apple's professional printing service for books. In fact, the themes that Aperture provides are designed specifically to work with Apple's print vendor.

In this next exercise, you'll go through the steps of setting up an Apple account and placing a book order.

> **NOTE** ▶ If you don't actually want to set up the account and buy a book, you can merely read through this section to see what's involved.

1 In the row of buttons below the Book Layout Editor, click Buy Book.

Aperture quickly checks through the book and, if it finds any problems in the book, such as empty text fields, it presents an alert.

2 If a warning alert appears, and you wish to proceed, click Continue.

> **NOTE** ▶ You can select the "Do not show again" checkbox before you dismiss the alert if you don't want to see that warning in the future. You can always reset Aperture to show such warnings again by selecting Reset All Warnings in Aperture's General preferences.

Aperture checks your Internet connection and then, if you've ever established an Apple account, asks you to allow it to access your stored account information so that it can connect to the print service using that information. Click Allow and enter your Mac's user account name and password in the authentication dialog.

If you've never established an Apple account, a book ordering sheet appears with a Set Up Account button in the lower-right corner. Otherwise, the button in the lower-right corner of the sheet is a Buy Now button.

The next steps assume you've never established an Apple account.

3 Click Set Up Account.

A Set Up Account dialog appears with fields for your Apple account ID and password on the right, and a Create Account button on the left.

4 Click Create Account.

The Set Up Account dialog expands to allow you to enter the information necessary to establish an Apple account. The information requested includes an email address, a

password, a security question, your name, a mailing address, and credit card information. The account creation process comprises three steps.

5 Follow the instructions presented in the dialog for creating an Apple account, supplying the information requested for each of its three steps.

When you finish supplying the requested information, your account is created, and the Set Up Account button in the book ordering sheet now reads Buy Now. The Buy Now button is disabled, because you haven't specified how many copies to order.

6 In the book ordering sheet, choose a cover color for the book from the Cover Color pop-up menu, and then specify the number of copies you wish to order in the Quantity field.

When you enter the number of copies in the Quantity field, the Buy Now button is enabled, and the sheet shows you how much your order will cost. By default, the book will be shipped to the address associated with your Apple account, but you can add additional shipping addresses.

7 Choose Add New Address from the Ship To pop-up menu.

An Add New Address dialog appears, in which you can add another shipping address. Each time you add an address, it gets added to the Ship To pop-up menu so you can ship orders to that address in the future. You can also specify that the address that you've added be made your default address for future orders.

8 Choose a shipping method from the Ship Via pop-up menu.

The cost of your order shown in the sheet is adjusted to accommodate the shipping method you've chosen.

9 If you actually wish to buy the book, click Buy Now; otherwise, click Cancel.

If you choose to buy the book, Aperture uploads all of the necessary images and text needed to print the book to the print service. Depending on the size of the book, the number of images, and the speed of your Internet connection, this process could take some time.

Relax and take a break. In a few days, your book will be on its way.

Delivering Printed Images

The images you have in your Aperture library can end up almost anywhere, in almost any form: webpages, video picture frames, Mac desktop backgrounds, online greeting cards, coffee mugs, t-shirts. Yet, with all the uses to which you can put your images, and with all the places you can display them, demand for the venerable, familiar, simple color print still lives on. Aperture, you shouldn't be surprised to learn, provides ample support for that most basic and enduring of image output modalities.

In this part of the lesson, you'll see how to proof your images on your screen in preparation for printing, learn how to set up a printing preset customized for your printer and paper, and take a look at how to order prints from Apple's professional photo printing service.

Proofing On Screen

With all of the differences of color gamut, resolution, and underlying imaging technology between your Mac's screen and your printer, WYSIWYG (*What You See Is What You Get*) is more of an unattainable ideal than an actuality when it comes to seeing—even on a finely calibrated monitor—how your digital images will look when printed. Aperture's onscreen proofing features, however, can get you as close to WYSIWYG as is possible given the unavoidable technological constraints.

1 In the Projects inspector, select the Lesson10A project, and then in the Browser, select the image **West Africa 16 200710**.

2 Display the image in Aperture's Viewer.

The image provides a good mix of bright and dark areas, including both areas of fine detail and large swaths of gently graded color—a good image for testing proofing and printing.

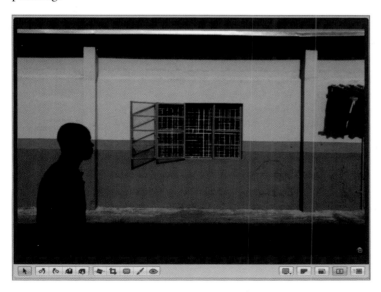

3 Choose View > Proofing Profile > Web Safe Colors.

The Proofing Profile submenu, as you can see, provides a large selection of output profiles from which to choose. You use these profiles to get a reasonably accurate idea of how your selected image will look when output to a particular device. The Web

Safe Color profile you've chosen, for example, renders your image to show how it would look when viewed in a late 20th-century web browser that supports only 216 "standard" colors.

4 Choose View > Onscreen Proofing or press Shift-Option-P.

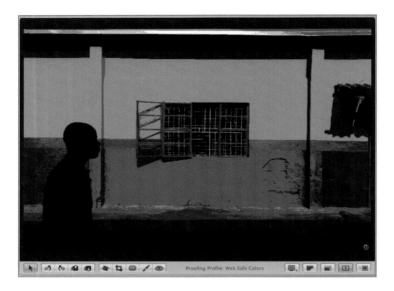

My, what a difference a few years makes! Notice that Aperture tells you the proofing profile in effect at the bottom of the Viewer. Now let's see what the image looks like on your printer—a more realistic use of this feature.

5 Choose View > Proofing Profile, and then pick a profile that matches your printer from the Proofing Profile submenu.

If you don't see an appropriate profile listed, choose Generic CMYK Profile. The image changes to match the profile.

6 Press Shift-Option-P a few times to switch back and forth between the normal screen display and the proofing profile display so you can see the slight color differences that the proofing profile imposes.

Now that you've seen what the image will look like when you print it, it's time to set up a printing preset.

Printing with Presets

When you print an image with Aperture, you're presented with a variety of controls and options you can use to fine-tune the printed output. Although it is possible to set these controls each and every time you print, chances are that you'll want to use the settings you make more than once. That's where printing presets come in.

> **NOTE** ▶ If you don't have an appropriate color printer installed on your Mac, just read along to see how printing presets work.

1　If it isn't already selected, select the image **West Africa 16 200710** from the Lesson10A project, and then choose File > Print Image or press Command-P.

Aperture's Print window appears. Its layout resembles the Print window you saw when you soft-proofed your book. The Sample Single Image preset is selected in the window's left panel.

2 In the lower left of the Print window, click the action pop-up menu and then choose New Single Image Preset and name it *Single image my printer*.

You'll use this preset to save the settings you'll make in the Print window's center panel.

3 In the Printer Selection area of the central panel, click the Printer pop-up menu and choose your printer, and then click the Paper Size pop-up menu and choose 4x6 in./10x15 cm.

The preview image shown in the window's right panel rotates to show how the image looks when printed on paper of the chosen size.

NOTE ▶ Aperture automatically sends 16-bit color image data to your printer if the printer supports it. 16-bit color provides a wider color gamut than 8-bit color image data, and produces smoother color transitions and less color clipping in the printed output.

4 From the ColorSync Profile pop-up menu, choose a profile appropriate for your printer, or choose Generic CMYK Profile if there's no appropriate printer profile available.

The preview image changes slightly, displayed with the color range associated with the chosen profile. Next, you'll make some additional minor adjustments to improve the output image quality.

5 Select the Black Point Compensation checkbox, and then set the Gamma control below it to 1.10.

You can use the arrows in the Gamma control to raise or lower the value, or you can select the text in the control and type the value directly. The Black Point Compensation modifies the output slightly so that details in the darkest part of the image aren't completely lost when you print. The Gamma control adjusts the midpoint tones of the image while leaving the whites and blacks unchanged. A slight increase in the gamma often produces a more pleasing printed result; too much gamma, though, can result in somewhat washed-out looking images.

6 Adjust the Sharpen Amount and Sharpen Radius sliders to sharpen the edges shown in the preview.

Because onscreen images tend to look sharper than their printed counterparts (onscreen pixels don't spread out and soak into the paper the way inks do), slight sharpening adjustments can make the printed output correspond more closely to what you see onscreen.

TIP Click the Show Loupe button at the bottom of the Print window to examine the edges in the preview image through the Loupe as you adjust the sharpening controls.

7 At the bottom of the Print window, click Save.

The adjustments you've made in the Print window are saved in the preset so you can use them again on other print jobs.

> **TIP ▶** Aperture remembers the settings you last made in the Print window and saves them automatically in a preset named Last Preset. If you forget to save your settings, you can choose Last Preset the next time you print and create a new preset using the Last Preset settings.

8 Load the appropriate size and quality of paper into your printer to match the profile you've selected, and then click Print, or click Cancel if you don't want to print right now.

If you decide not to print at this time, you can click Preview instead to see what the output will look like, and you can save the preview PDF that Aperture generates so you can print it later.

Using printing presets makes it much easier for you to produce uniformly high-quality prints, time after time.

But there's another way to get high-quality prints if you don't want to make them yourself.

Ordering Prints

You can order prints of your Aperture images from the same professional printing service that provides the printed books that you saw elsewhere in this lesson. The service lets you order them in a variety of sizes and in multiple copies.

1 Make sure that the image **West Africa 16 200710** from the Lesson10A project is still selected, and then choose File > Order Prints.

Aperture establishes an Internet connection with the printing service and displays a print ordering sheet. You can order one or more prints in one or more sizes, from small 4x6 prints to large 20x30 prints.

NOTE ► The remainder of this lesson assumes you've already established an Apple account with the print service, as was described in "Ordering Books."

2 In the ordering sheet, enter the number of prints you desire in the field to the right of each size for which you want prints.

 As you enter the number of prints you want in each size, the order sheet adjusts the total cost of the order, including estimated taxes and shipping charges.

3 If you've added additional addresses to your Apple account, click Ship To and choose the address to which you want the prints shipped from the pop-up menu.

4 Click Ship Via and choose a shipping method from the pop-up menu.

5 Click Buy Now to order your prints, or click Cancel.

If you've chosen to buy prints, Aperture uploads the image you've selected to the printing service. Note that you can select several images in Aperture if you want prints of all of them: The Order Prints sheet calculates the total cost of your order, and uploads all the selected images to the printing service when you click Buy Now.

Your prints are now on their way to their destination. When it comes to final images, Aperture delivers.

Lesson Review

1. True or false: An exported master contains all the edits and adjustments you've made to an image in Aperture.

2. What are metadata sidecar files?

3. Name two ways to create custom export presets in Aperture.

4. How can you tell how many times an image appears in a book?

5. Can alternate images from a stack be placed in a book?

Answers

1. False. Exported masters are virtually identical copies of the images that you originally imported into Aperture, which means they contain none of the changes you may have made subsequently using Aperture's various image manipulation tools.

2. Sidecar files are text files that follow the XML schema for IPTC metadata that was established by the International Press Telecommunications Council in collaboration with Adobe.

3. Choose Edit from the Export Preset pop-up menu, and then create a new preset in the Export Presets dialog; or, in the sheet, choose Aperture > Presets > Image Export.

4. Look in the Browser, and you'll see that every picture placed in a book has a red badge in the upper right containing a number that indicates how many times the image appears in the book.

5. No. Aperture doesn't let you use alternate images from a stack in a book, so you'll have to unstack the images before you can place them.

11

Lesson Files	APTS_Aperture_book_files > Lessons > Lesson 11
Time	This lesson takes approximately 90 minutes to complete.
Goals	Build and customize a Web Journal to showcase photos
	Use iWeb to publish a website
	Create a Keynote portfolio presentation
	View a portfolio on an iPhone, iPod Touch, or Apple TV
	Create a business card using Pages
	Create a leave-behind portfolio

Showcasing and Promoting Your Work

Lets face it; one of the main reasons photographers take pictures is to share them with others. Whether it's for the joy of viewing or to attract new customers, it's important to showcase your images for others. Fortunately, your Mac comes with several software tools that make it easy to show off your photos. You can easily present your portfolio as a website, a DVD, a printed book, or even an interactive slideshow. In this lesson we'll touch upon the many ways you can use Aperture, along with iLife '08 and iWork '08, to create a compelling portfolio and promotional items.

Building Webpages

One of the most popular ways to showcase photos is with a webpage. With Aperture you can easily create webpages from your images, then post them to a website. In Lesson 8 you harnessed Aperture's easy-to-use Web Gallery, which requires you to use a .Mac account. The other choices Aperture offers, Web Journal and Webpage, can be placed on any web server.

The primary benefit of web delivery is that it can be very convenient for your potential clients. They don't need to schedule an office visit, they don't need to request work samples, and geography is no longer a major factor. In fact, a great portfolio can help you establish your work on a global scale. Although Aperture can't fill every web need, it does offer a robust set of options for publishing your work.

Building a Web Journal

When you need to create webpages that mix text and photos, the Web Journal option is your best choice. For example, you could add several images to a page from a particular shoot, then add text describing the shoot to put the images in context. When you create a Web Journal, you manually add pages, images, and text. Although this is slower than the Web Gallery option, it does offer precise control.

Let's import a project and start building webpages.

1 Choose File > Import > Projects, navigate to the **APTS_Aperture_book_files > Lessons > Lesson 11** folder, and import the project **Lesson11.approject**.

 This project contains several images that we'll use throughout this lesson.

2 Click in the Browser and choose Edit > Select All.

3 Choose File > New From Selection > Web Journal.

 A new Web Journal page is created from all of the images. The new Untitled Web Journal has its name highlighted so you can rename it.

NOTE ▸ Although all of the images are added to the Web Journal pages, you don't need to use every image in your final site.

4 Name the new Web Journal *John Fleck Portfolio* and press Return.

The Web Journal offers several controls for customization. The first option you should change is the site's theme.

5 Click the Site Theme button to choose a theme, or layout style, for your webpage.

The Choose Web Theme window appears and prompts you to select a theme to use in the webpages.

6 Select the Picture theme and click Choose.

Populating the Web Journal

Now that the new site is built, it's time to add images to it. You don't need to use all of your images in the journal. Let's limit this journal to only those images rated with four stars or more.

1 Press Command-F to open the Query HUD.

2 Select the Rating checkbox and set the Rating slider to four stars.

The Browser displays only images with four stars or more. Close the Query HUD.

3 Click in the Browser and press Command-A to select all the images.

4 Drag the images into the Web Journal album.

All of the images are added to one page. Let's customize the page further.

5 Choose Edit > Deselect All then select the image **Portfolio 3** in the Browser and drag it into the Header Image well.

Customizing the Web Journal

The Web Journal page can be customized to better showcase your work. By customizing the text on the page, you can add important information to your images.

1 Click the placeholder text and type *John Fleck Portfolio*. Press Return to name the page.

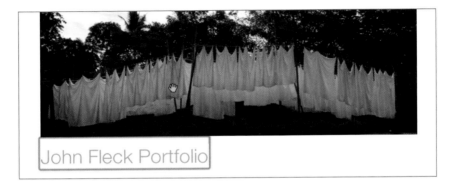

2 Scroll to the bottom of the page and triple-click to select the text block that contains the text "© Your document copyright here."

3 Enter © *John Fleck*.

Next, let's make the image thumbnails larger by reducing the number of columns.

4 Click the left arrow to change the number of columns from 4 to 3.

The number of columns is reduced to 3, but you'll need to scale them larger to fill the space.

5 Change the Width value slider to 200 to make the images larger.

Let's add some text about the shoot itself to the first page of the Web Journal.

6 Click the Add Text Block button to add a text block to the page.

Scroll to the bottom of the page to see the text block.

7 Enter the following text into the block:

John Fleck is a 27-year professional photographer with a global reach. John has traveled the world on photographic assignments for a variety of clients.

Publishing the Web Journal

When the Web Journal is completed, you can publish it to your .Mac account or export the pages for loading to a server of your choice.

1 Click the Export Web Pages button.

A sheet opens so you can specify where to write the files.

2 In the Export As field enter *john_fleck*.

NOTE ▶ When creating webpages, keep in mind that many servers require that you avoid spaces in file names.

3 Specify your desktop as the destination and click Export.

Aperture exports the Web Journal to a folder on your desktop.

TIP ▶ If you want to check the progress of the export operation, choose Window > Show Activity.

4 When the Export is complete, hide Aperture by pressing Command-H.

Let's view the site locally.

5 On the desktop, double-click the folder john_fleck.

6 Double-click the file **index.html** to view the website in Safari.

You can now browse the website to see how the Web Journal pages look.

TIP You can move the exported folder onto a website with an FTP program. You can also compress the folder to a ZIP archive and email it to a client to view.

Other Web Options

Although we've explored the Web Journal and Web Gallery options, there are two other options you can choose. Within Aperture, there is a third option simply called Webpage. The Webpage templates offer less customization than the Web Journal. The Webpage translates an album into a page, and then allows you to specify a number of columns and rows for each page.

If Aperture's three webpage options aren't enough for you, then you can turn to iWeb (part of the iLife suite that is standard on all Macs).

1 In the Dock, click the iWeb icon.

> **TIP** ▶ If iWeb isn't located in your Dock, you can navigate to your Applications folder and launch it.

2 Choose File > New Site.

A new sheet opens so you can specify a template for your webpage.

3 Select the Darkroom theme.

4 Select the Photos template and click Choose.

5 Click the placeholder text and name the site *Portfolio*.

6 Click the Media button in the toolbar to open the Media Browser.

7 Click the Photos button, then click the disclosure button next to Aperture.

8 Locate the Lesson11 project, then click the disclosure triangle to open the project and see its contents.

9 Select the Project 11 icon and drag the whole project over the Photos page.

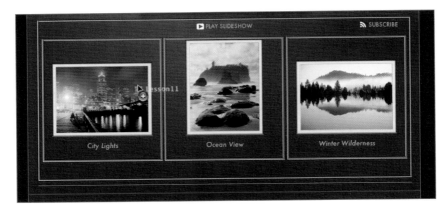

As you drag, a blue rectangle indicates the area of the photo grid. The first photo you add replaces all the placeholder photos on the page.

TIP ▶ You can click the placeholder text below a photo and type a custom caption for each image.

10 Customize the remaining text on the page to refine the site's appearance.

NOTE ▶ If you have an active .Mac account, when you click the Publish button, iWeb will automatically upload your website. Otherwise you can choose File > Publish to a Folder to export iWebpages without needing a .Mac account.

Creating Dynamic Slideshows

A popular way for photographers to showcase their work is to use a slideshow. Although Aperture offers its own slideshow functionality, your Mac has several other ways to show off your images. These additional options extend Aperture's capabilities and allow you to author an interactive slideshow that can run on your laptop, from a DVD, or even on an iPhone.

Having your work in hand and ready to show is important to your professional success.

Keynote

You'll find Apple Keynote included in the iWork productivity suite. Keynote offers you the ability to create cinema-quality presentations that are an excellent way to showcase your work. Although many creative people associate slideshows with boring meetings, Keynote helps combat this perception with its rich support for photos and video and an excellent set of controls for artistic design.

> **NOTE** ▶ Apple iWork is included as a free trial with most Macs and it will function fully for 30 days. If you find the software useful, you can activate the software with an online purchase. Even if the software isn't activated, you'll be able to complete this lesson, but you won't be able save the final document.

Building the Presentation

The first steps to creating a slideshow involve creating the document at the desired size and applying a theme (or template) to format the document for use as a portfolio. Once the document is created, you'll format the opening slide.

1 In the Dock, click the Keynote icon.

If Keynote isn't located in your Dock, you can navigate to your Applications folder and then open the iWork folder and launch it.

2 In the Theme Chooser select Modern Portfolio, set the Slide Size to 1280 x 720, and click Choose.

A new document opens based on the Modern Portfolio theme. A Keynote theme provides pre-designed layout templates (much like the themes you used in Lesson 10 to create a book).

3 On the front page, double-click the first text box to edit the text. Enter the text *John Fleck Photography*.

4 Double-click the second text box and enter the text *2008 Portfolio*.

5 Click outside of the text box to deselect it.

6 Click the first text box to select it, then Shift-click to select the second.

The text is a little small. Let's make it larger.

7 With the text boxes selected press Command-Plus (+) to increase the point size to your taste.

Adding Photos to Slides

Now that the presentation file is built, it can be populated with the desired photos. This exercise will guide you through the first few slides.

1 Click the New Slide button in the upper-left corner.

A new slide is added, but it doesn't contain any areas for photos.

2 Click the Masters button and choose the Photo – Big layout.

The slide layout changes and a placeholder image is added.

3 Click the Media button in the toolbar to open the Media Browser.

The Media Browser opens to show you the photos, movies, and audio files in your media library.

4 Type *Lesson11* in the search field.

The Media Browser shows you all photos associated with the Lesson11 project in Aperture. The search field makes it easy to search by file name or metadata.

5 Drag Portfolio 3 from the Media Browser onto the placeholder image.

When the edges of the photo turn blue, release your mouse button. The image drops into the well, but can be resized for better layout.

6 Click the photo to select it, then drag the slider at the bottom of the photo to the right in order to resize the image.

The photo is better sized, but can be positioned within the mask for better impact.

7 Click the Edit Mask button.

The masked portions of the photo are now visible as a ghosted image.

8 Drag the photo to reposition it within the mask.

9 Click the Edit Mask button to exit Edit Mask mode.

You have successfully added a photo to your slideshow.

10 Repeating the steps above, add a few more slides to your presentation. Be sure to try different slide master layouts.

NOTE ► You can adjust the masks to reveal more of an image. Just click the Edit Mask button to make adjustments.

11 Save your work-in-progress to the default location.

Finishing the Presentation

Once the slides are built, you can add transitions to complete the presentation. Transitions are used to help indicate a change from one slide to another. Once the presentation is built, we can view it.

1 Click Slide 1 in the slide sorter and choose Edit > Copy.

This places the title page onto your clipboard.

2 Click the last slide in your presentation and choose Edit > Paste.

The title page now starts and ends your presentation.

3 Choose Edit > Select All to select all slides in the Slide Navigator.

4 Click the Inspector button to open the Inspector.

5 Choose the Slide inspector and then click Transition.

6 Choose the Reflection transition from the Effect pop-up menu.

Keynote applies the transition to all slides.

NOTE ▶ You can apply individual transitions to slides by selecting their individual thumbnails in the Slide Navigator.

7 Click the Play button in the toolbar to view your slideshow.

8 Press the spacebar to advance your slides.

9 When finished, press the Esc key to exit full-screen viewing.

10 Close Keynote and save your work.

MORE INFO ▶ You can learn more about Keynote by reading *Apple Training Series: iWork '08* by Richard Harrington.

TIP ▶ You can send a Keynote presentation directly to an iDVD project by choosing File > Send to > iDVD…

iDVD

Another popular way to show a presentation is on DVD. Producing a DVD allows a photographer to leave her images behind for others to view. Making a DVD on your Mac is affordable and easy.

1 In the Dock, click the iDVD icon.

If iDVD isn't located in your Dock, you can navigate to your Applications folder and launch it.

2 Click the "Create a New Project" button.

3 In the Create Project window, name the project Photo Portfolio.

4 Set the Aspect Ratio to Widescreen (16:9) and click Create.

5 In the Themes window, choose the Modern theme.

6 Click the Drop Zones button at the bottom of the window to view the drop zones for the menu.

Drop zones are customizable areas that allow you to add images to the menu template. Your photo library is now available in the Media Browser.

7 If it's not selected by default, click the Photos tab, and then click the Aperture icon and enter *Lesson11* in the search field to see your portfolio images.

8 Drag three images of your choice into the drop zones.

The menu updates to show you the photos.

9 Double-click the text box at the top of the page and enter *John Fleck Photography*.

Format the text to your taste by experimenting with the font family and point size.

10 Click the plus symbol at the bottom of the window and choose Add Slideshow from the pop-up menu that appears.

A new slideshow is added called My Slideshow. Single-click and rename it *2008 Portfolio*.

11 Double-click the 2008 Portfolio button to edit the contents of the portfolio.

12 In the Media Browser, click the Aperture icon and enter *Lesson11* in the search field to see your portfolio images.

13 Click the thumbnail for Portfolio1; then press Command-A to select all of the images in the portfolio.

14 Drag the images into the Slideshow window.

iDVD adds all 29 images to the slideshow.

15 Set the Slide Duration to 5 seconds and the Transition to Dissolve.

16 Click the Return button to stop editing the Slideshow.

17 Click the Play button to simulate the DVD.

18 Click the 2008 Portfolio button to view the DVD.

When finished, click the Exit button to exit the slideshow.

19 To burn a DVD, click the burn icon at the bottom of the window and follow the on-screen directions.

20 Close iDVD and return to Aperture.

MORE INFO ▶ You can learn more about iDVD by reading *Apple Training Series: iLife '08*.

Viewing Slideshows on an iPhone or iPod Touch

The popularity of the Apple iPhone and iPod Touch products has put mobile computing devices in the pockets of many users. These two products are quite capable of showing photo slideshows. How you choose to showcase your images depends on whether you want to store the images on your device or access them from the web.

Browsing Web Galleries

If you're concerned about having access to multiple albums on your phone or iPod, but don't want to fill up its internal memory, then Web Galleries will work well for you. You learned how to make a gallery in Lesson 9, so for this exercise you can use the gallery you previously made.

1 From the home screen of the iPhone or iPod touch, click the Safari button.

2 Enter the following address in the toolbar: *http://gallery.mac.com/iphone/membername.*

 NOTE ▸ You'll need to substitute your .Mac account name for the member name.

3 A gallery page loads showing you thumbnails of any galleries you've made.

4 Click the Wedding Day gallery to load it.

5 Click an image thumbnail to view the image full screen.

> **TIP** ▶ You can use the controls at the bottom of the page to navigate through the Web Gallery.

6 Click the plus (+) symbol, then tap the Add to Home Screen button.

You now have a shortcut for jumping directly to the portfolio.

> **MORE INFO** ▶ You can find out more information about the iPod Touch or iPhone at Apple's website (www.apple.com). View the User Guide online to learn more about customizing your Home Screen.

Transferring to iPhone or iPod Touch

Many users choose to transfer images directly to their mobile devices by syncing an album. This ensures that you can show your photos to a potential client or peer without being connected to the Internet or dealing with download times.

1 Connect your iPhone or iPod Touch to your computer via a high-speed USB 2.0 port.

2 Open iTunes (if it doesn't launch automatically).

3 Select your iPhone or iPod Touch in the iTunes window (just below Devices, in the left column).

4 Click the Photos pane.

5 Select the checkbox next to "Sync photos from:", and then select Aperture from the pop-up list.

6 Select the checkbox for "Selected albums."

7 Select the albums you'd like to sync.

8 Click the Apply button.

iTunes automatically compresses the images to a proper size for the screen and converts the files to JPEG for easier viewing.

Other Slideshow Options

Although Keynote, iDVD, or the iPhone are excellent options for showcasing your work, there are two more choices worth mentioning. Apple software is designed to allow you to seamlessly share media across multiple mediums. Your photos can easily make the jump to a television set or an RSS feed with little work.

Apple TV

If your Apple TV is connected to the Internet, it can easily access Web Galleries published from Aperture. This works well if you're showcasing your work in a conference room or living room. There's no need to sync photos with iTunes.

1 From the main menu of the Apple TV, select Photos.

2 Select .Mac.

3 Choose Add .Mac Web Gallery.

4 Enter your .Mac member name and click Done.

 NOTE ▸ You can also view other users' Web Galleries on your Apple TV.

5 Select the Web Gallery and album you want to view.

GarageBand

The Media Browser in GarageBand can access your entire Aperture library. This will let you create an enhanced audio podcast to showcase your photography. Let's take a look at the workflow to create a podcast.

> **MORE INFO** ▶ The exact steps to create a podcast can be found in the online help for GarageBand or in the Apple Training Series book *iLife '08*.

1 Launch GarageBand.

2 Click the Create New Podcast Episode button.

3 Attach a microphone to your computer and record yourself discussing your portfolio.

4 Browse your Aperture library in the Media Browser.

5 Add images to the Podcast Track to synchronize your words and portfolio.

6 Export your Podcast to iTunes or use iWeb to publish it and begin sharing.

Creating a Business Card

A standard promotional item for photography and imaging professionals is an attractive business card. The business card makes it easy for active and prospective clients to reach you. Apple offers a flexible word processing and page layout tool called Pages. You'll find Pages bundled with Keynote and Numbers as part of the iWork suite. Pages offers several business card templates, but to get you started we've built a custom template for this exercise.

NOTE ▶ Most new Macs have a demo version of Pages installed that you can use to try it out.

1 Launch Pages by clicking its icon in the Dock or navigate to Applications > iWork 08 > Pages.

2 Choose File > Open, and then Navigate to the Lesson11 folder and open the file **Business_Cards.pages**.

The template file opens. It contains media placeholders (the green rectangles that can be replaced with images). The text on the card is also placeholder text that can be replaced with a card from your Address Book. If you get a warning about font substitutions, click Don't Review.

3 Launch the Address Book application by clicking its icon in the Dock or navigating to it in your Applications folder.

4 Select an address book card that contains complete entries for business contact information.

> **NOTE ▶** You can load the file **John Fleck.vcf** from the Lesson 11 folder if your Address Book is empty.

5 Drag the Address Book card onto a text field on the business card.

The text on the business card updates on all the cards. Text can be assigned to specific fields using the Link inspector in Pages. Now that the text is replaced, let's add photos.

6 Click the Media button to open the Media Browser.

7 In the Media Browser, click Aperture to see your Aperture library.

8 In the search field, type *Lesson11* to filter the results.

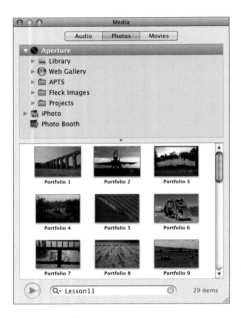

9 Select the image **Portfolio 3** and drag it onto the first green rectangle in the Pages document.

The image is added to the page on the first business card.

NOTE ▶ Placeholder images must be replaced individually.

10 Choose View > Zoom > Actual Size to see the business card at full magnification.

11 Double-click the image to edit its mask.

12 Drag the image down to reposition it within the masked area.

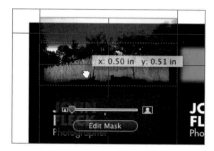

13 When you're finished positioning the image, click the Edit Mask button.

14 Using the rest of the portfolio images, populate the remaining media placeholders. You can use as many photos as you like.

NOTE ▶ You can print your own business cards or use a printing vendor to produce them. Many will accept PDF files for printing purposes.

MORE INFO ▶ If you'd like to learn more about Pages, read the book *Apple Training Series: iWork '08*.

Creating a Leave-Behind Book

We've explored books in depth in our past two lessons. You've seen how books can be used to help clients select photos or prepared as a final deliverable to the end client. Fortunately, Apple offers an affordable book option that can be used effectively for

showcasing your work. Through the use of Small Books, you can create affordable "leave-behind" portfolios for prospective clients.

> **MORE INFO** ▶ Small Books must be ordered in packs of three. Each book has 20 pages by default and costs about $4 (additional pages are .29 per page).

1 In Aperture, select the Lesson11 project.

2 Choose File > New from Selection > Book.

A new dialog opens.

3 Click "Create with All Images."

A new sheet opens, prompting you to select a book size and template.

4 From the Book Type pop-up menu, choose Small.

5 Click the Choose Theme button to create a new book with the Small Book layout.

A new Untitled Book is added to the project.

6 Name the book *Mini Portfolio* and press Return.

7 Click the Book Actions menu and choose Rebuild Book With All Images.

The book is automatically populated with all of the images from the project. The layout can be quickly refined to better suit the needs of a portfolio.

8 Replace the cover image by dragging the image *Portfolio 3* onto the cover.

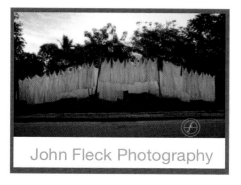

9 Double-click the placeholder text and enter *John Fleck Photography*.

Let's adjust the layout of a few pages.

10 Click the page 1 thumbnail, then hold down the Command key and click the thumb-nails for pages 4, 12, 20, 23, and 25.

11 Press Delete to remove the text pages and then click Yes to confirm that you want to remove the pages.

Next, let's adjust the layout so the images that are currently spread across two pages use a single-page layout instead.

12 Click the Page Layout menu for page 5 and change the page layout to 1-up Full.

The layout adjusts to fit the image onto a single page, and the remaining pages are re-flowed.

13 Repeat for the remaining full page spread layouts.

14 Click the thumbnail for page 2 (which has a repeated image) and press Delete. Click Yes to confirm the removal of the page.

The book is now 20 pages long (the minimum size). Delete any blank pages if needed.

MORE INFO ▶ Go ahead and create a book for your own images. If you wanted to order the book, you'd click the Buy Book button. For this exercise, don't order this book because the copyright for the images in the book is held by the photographer.

Lesson Review

1. What publishing options are available for Web Journals?
2. How can adding transitions enhance your presentations?
3. When using iTunes to sync your slideshow to an iPod or iPhone, is it necessary to format and size them for iPod/iPhone display?
4. Is it necessary to sync photos with iTunes to export them for playback on Apple TV?
5. When creating a Small Book in Aperture, how do you change a two-page photo layout to a single-page layout?

Answers

1. You have two choices: Export Webpages (for publishing to the server of your choice) and Publish to .Mac.
2. Transitions are used to help indicate a change from one slide to another.
3. No. iTunes automatically optimizes the images to a proper size for the screen and converts the files to JPEG for easier viewing.
4. No. You can publish them directly to a .Mac Web Gallery and access that gallery from your Internet-connected Apple TV.
5. Click the Page Layout menu for the page you want to alter, and change the page layout to 1-up Full.

12

Lesson Files No files for this lesson.

Time This lesson takes approximately 45 minutes to complete.

Goals Capture images from a tethered camera

Create a workflow that automatically executes a series of tasks in Aperture

Incorporate other software applications into an automated workflow

Save your workflow as a standalone application

Lesson **12**

Aperture Automation

Although software can do all sorts of amazing things, such as changing the color of a photograph, it's particularly adept at the types of tedious tasks that most people find painfully boring. Sorting this or finding copies of that are the types of repetitive tasks that computers are good at.

Many tedious, repetitive tasks in a digital photography workflow can be simplified using Aperture. You've already seen how the Lift & Stamp tools can be used to speed the process of applying the same edits to multiple images, but Aperture has other capabilities that make it possible to streamline your work.

If you ever shoot with a tethered setup (that is, with your camera connected directly to your computer so that you can immediately download and review your images), then you'll appreciate Aperture's facility for automatically importing images from the camera.

If you work in a production environment, then you'll want to take a look at how you can automate the importing of images from other people in your workgroup. In this lesson, we'll introduce you to two possibilities.

Tethered Shooting

In certain cases, such as studio shoots, it's useful to see your shots immediately on the computer. This lets you harness the powerful analysis options in Aperture (such as a histogram) and see the image on a much larger screen. This type of setup requires that your camera be tethered to your Mac using a USB or FireWire cable. As you shoot with the camera, your images are automatically transferred to your computer via the connecting cable.

NOTE ▶ To see a list of all cameras supported by Aperture for tethered shooting, visit http://support.apple.com/kb/HT1085.

If Aperture supports your camera for tethered shooting, then the process is quite easy. For best results you should set your camera up on a tripod or a camera stand, then connect it with a cable to your computer.

1 Properly connect the camera to your computer and ensure that it's powered on.

 TIP ▶ Be sure to check your camera's owner's manual for instructions on configuring your camera for tethered shooting. Most cameras ship with a cable that should be used.

2 Open Aperture.

3 Select an existing project or create a new project to hold the imported images.

 NOTE ▶ The Import dialog may open automatically if you have a memory card loaded in your camera. You can close the Import dialog.

4 Choose File > Tether > Start Session.

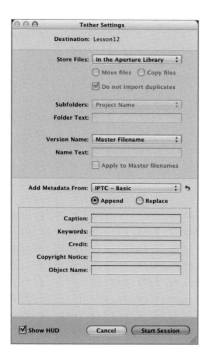

The Tether Settings window appears and prompts you to adjust your import settings. You can adjust the import settings with much the same parameters as you'd find in the standard Import dialog. Aperture allows you to specify where the images should be stored as well as naming conventions and metadata options.

5 Click Start Session.

The Tether HUD appears.

6 Compose your shot and adjust your camera.

7 Capture your photo by pressing your camera's shutter-release button or by clicking the Capture button in the Tether HUD.

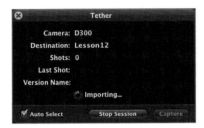

After you take the photo, it will be automatically transferred to the selected project.

8 When you're done, click Stop Session to end the tethered session.

Using Aperture with Automator

Automator is an application that's included with OS X (version 10.4 and later). With Automator, you can easily create custom automation routines that can perform complex tasks for you. Automator performs *actions,* or individual commands, such as Choose Projects or Set IPTC Tags. An action relays data to the next action. A string of actions constitutes an Automator *workflow.* With Automator, you can easily build simple automated workflows that can be saved as standalone applications or attached to folders.

For example, you might use Automator in conjunction with Aperture to do the following:

▶ Create a special "hot folder." You can configure this hot folder so that any images dropped into it are automatically processed by Aperture. For example, you could specify that the images be assigned specific keywords, and tagged with particular IPTC tags.

▶ Create a standalone application that automatically exports all of the images from the selected project, compresses them into a ZIP archive, and then uploads them to an FTP server.

▶ Automatically open an image in Adobe Photoshop and perform operations using tools that aren't available in Aperture, and then save the image directly back into your library.

Automator is handy not only because it allows you to automate tasks within Aperture, but also because it lets you automate processes that span multiple applications.

Building an Export Workflow

The easiest way to learn Automator is to start using it. In this exercise, we're going to build a simple workflow that exports all of the images in an album, compresses them into a ZIP file, and then attaches that ZIP file to a message using Apple's Mail.

1 Open Aperture. Then open Automator. You should find it in your Applications folder.

 An empty Workflow document will appear.

2 Select Custom and click the Choose button.

 The Library pane on the left side of the Workflow window displays all of the currently installed applications that can be controlled by Automator.

3 Type *Aperture* into the Search field. All the Aperture actions you can execute from within Automator will be displayed in the Action pane.

4 Click each action once in the Action pane. A description of what the action does appears in the panel in the lower-left corner of the Workflow window.

In Automator, you link actions together to create a workflow. A workflow simply does a bunch of tasks that you would normally perform by hand.

Creating the Workflow

To create a workflow, it's best to think about how you'd perform a series of tasks if you were doing them manually. In this example, the first thing we want to do is export the images; if we were driving Aperture ourselves, we would need to select the album of images we want to export.

Once you've decided what task you want to perform, look through the Action list to find the action that appears to do that task.

1 Click the Choose Albums action.

The description says, "This action will pass references of the chosen Aperture albums to the next action in the workflow." Automator workflows function by passing chunks of data from one action to the next for processing.

2 Double-click the Choose Albums action to add it to the workflow. It will appear in the Workflow pane on the right side of the window.

In the Workflow pane, you'll see a panel that contains controls for configuring the action. For the Choose Albums action, you'll see a list of all of the albums in your current Aperture library.

3 Select the checkbox next to one of your albums.

4 In the Action pane, double-click the Export Versions action to add it to your workflow just beneath the Choose Albums action.

Notice there is a link between the two actions.

The link between the actions indicates that data is flowing from the first action to the second. In this case, the name of the album that you selected in the Choose Albums action is being passed on to the Export Versions action.

Now you need to configure the Export action.

5 In the Export Versions pane, select "JPEG – Fit within 640 x 640" from the Export Preset pop-up menu.

The items in this menu are simply the Export presets defined in Aperture. In this case, we're telling the Export Images action to export JPEG images that have been resized to fit within 640 x 640 pixels.

6 From the Destination pop-up menu, choose Other.

7 In the dialog that appears, create a folder on the desktop called *Test Export* and click Create.

8 Click Open.

This is the location that Aperture will export your images into.

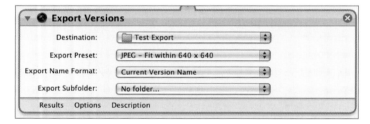

9 Click the Description button for the Export Versions action.

Note that at the bottom left of the Export Versions action, the Results indicator says Files/Folders. This indicates that this action passes the name of a folder (in this case, Test Export) to the next action. This is good news for the rest of our workflow.

Compressing the Folder

After the workflow exports the images, we need it to compress the folder as a ZIP file and archive it. Aperture can't perform this function, so we'll tell Automator to use a different application.

1 Select Library before searching to ensure that the entire library of actions gets searched.

2 In the Search field, enter *zip*.

The Action pane shows the results. Most likely, you'll have only one entry, Create Archive. However, if you've installed any other applications that provide Automator support for file compression, then they'll appear here also.

3 Double-click the Create Archive action in the Action pane to add the action to the end of the workflow.

Now we need to configure the Create Archive action to tell it where we want the ZIP archive placed.

4 In the "Save as" field, enter *test archive* as the name for the archive. Leave the Where pop-up menu set to Desktop.

Setting Up Mail

Our workflow begins by selecting an album in Aperture, and it then exports the contents of that album to a folder. That folder is compressed into a ZIP archive on the desktop. Now we want to create a new message in Mail and attach the ZIP file to that message.

1 In the search field, click the small X on the right side to clear the search criteria.

We want to be able to view all of our actions now, not just the ones that have to do with ZIP compression.

2 In the Library pane, click Mail to view the Mail actions provided. In the Action pane, you should see New Mail Message.

3 In the Action pane, double-click New Mail Message to add it to the end of your workflow.

Note that our workflow is now running Mail instead of Aperture. You can move seamlessly from one application to another in a workflow without having to issue any special commands.

4 Configure the Mail message as desired. If you want, you can go ahead and fill in address and subject lines, or leave them blank and fill them in after running the workflow.

5 In the Action pane, double-click "Add Attachments to Front Message."

This will add the archive created in step 3 of our workflow to the new Mail message created in step 4.

At this point we could add a Send Outgoing Message action to the end of our workflow, which would cause our new Mail message to be sent. We don't want to actually

send the mail; we just want the message to be prepared, so we're going to end the workflow here.

6 Choose File > Save and save the workflow on your desktop. Name it Export Album to Mail.

Now, anytime you want to perform this series of tasks, you can simply double-click the Export Album to Mail file to open it in Automator.

7 Click the Run button in the upper-right corner of the window, or press Command-R.

Automator will begin executing your workflow. A progress indicator in the lower-left corner of each action will show where the workflow is in its execution. Depending on the size of the album you choose to export, and the speed of your computer, the workflow may take more or less time. When it's finished, you should have a new, empty message in Mail, with a ZIP file attached to it. You can now address and send the message.

This workflow demonstrates one of the biggest advantages of Automator: its ability to employ multiple applications. However, to make your workflow even more useful, you'll want to give more thought to how you save it.

> **NOTE ▸** The workflow that we built in the previous exercise is handy, but you need to open Automator to run it. In fact, you can take this workflow even further: You can create a standalone application that will run directly from the Finder. See the user manual for more information.

Pre-built Workflows and Other Actions

You can download a number of pre-built workflows from Apple's Automator website, including some fantastic Automator actions that let you easily perform complex operations with a single click.

From the Automator website, http://www.automator.us/leopard/aperture, you can download the following workflows:

▸ Auto-Backup on Import

▸ Import from Desktop Hot Folder

▸ Aperture to Keynote Slideshow

- ▶ Export Image Metadata to Excel
- ▶ Auto-Import Mail Image Attachments into Aperture
- ▶ Create iDVD Magic DVD from Albums
- ▶ Create iDVD Slideshow from Albums
- ▶ Instant Web Publishing
- ▶ Burn Masters to Disk

All of these workflows are small, free, and ready to download.

> **NOTE** ▶ You'll also find great AppleScript examples on Apple's website including the Aperture Caption Palette. Be sure to visit http://www.apple.com/applescript/aperture/.

Photoshop Round-Trip Action

If you find yourself sending a lot of images to Photoshop via Aperture's round-trip feature (the Open in External Editor command), then you might want to consider downloading the Photoshop Round-Trip action.

This action lets you incorporate Aperture's Open in External Editor command into your Aperture workflows. If you combine it with the Photoshop Action Pack—a collection of more than 70 Automator Actions for Photoshop—you can easily create complex workflows that take your images from Aperture to Photoshop for processing, and back again.

You can download both the Photoshop Round-Trip action and the Photoshop Action Pack for free from Complete Digital Photography (http://www.completedigitalphotography.com/?p=339).

Lesson Review

1. In Automator, what's the difference between a workflow and an action?
2. Does Aperture provide tethered shooting support?
3. Name two methods of executing an Automator workflow.

Answers

1. An action is an individual command performed by Automator. A workflow is a string of these commands.

2. Yes, but not all cameras are supported.

3. You can execute an Automator workflow (1) by clicking the Run button from within Automator, or (2) by saving the workflow as a standalone application and opening it.

Appendix **A**

Advanced Media Management for Professionals

As you've seen throughout this book, Aperture provides exceptional organizing and image-management tools. With its integrated library management, powerful search tools, and automatic versioning controls, Aperture makes short work of complex organizational workflows. However, there's no single workflow that works for everyone. Depending on the type of shooting you do, and the way that you like to approach your post-production, you may have very particular organizational needs.

One of the most common media-management concerns for working photographers is how to move images from a desktop to a laptop, so that they can work on the road. Another concern, if you're a high-volume shooter, is how to handle squeezing all of your images into a single Aperture library.

In this appendix, we're going to take a look at a few different strategies you can employ to deal with these issues.

Importing Images as References

So far in this book, you've been importing images into your Aperture library. When you import images into Aperture, you can specify where you'd like them to be stored. In the Import dialog, if you choose "In the Aperture Library," then images are copied into the library on your Mac's hard drive.

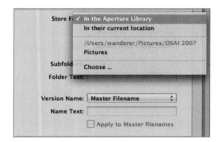

But if you choose "In their current location," Aperture will leave your images where they are and, instead, store a *reference* to those images in the Aperture library. A reference is exactly like an alias in the Finder: a pointer that tells Aperture where the original master image file is. All other Aperture functions work exactly the same as if you'd imported into the Aperture library.

The advantage to working with referenced images rather than managed images is that your images can be stored wherever you like—on another hard drive, or on a network server, for example. This means you're not limited to trying to fit all of your images onto a single hard drive.

When you import an image as a reference, Aperture still does all of the things that it does when you choose to store images in the library. It still builds a thumbnail image, a preview image, and a version document, and it stores all of these things in the library. If you create new versions of the image, those new version documents are kept in the library, and if you do anything that would create a new master image, such as "Edit with External Editor" or "Edit with a Plug-in," then that master is kept in the same location as your referenced original.

Because your imported file is left in its original location, you can still see it in the Finder, just as you would any other file. This makes it easy to use those images in other applications.

The downside of a referenced image is that it's not included in backups to Aperture's vault system. All of your versions, edits, and additional masters will be backed up, but you'll be responsible for backing up your original master files.

An image that has been imported as a referenced image shows this badge:

For the rest of this appendix, we'll refer to images that you import this way as *referenced images*, and to images that you import into the Aperture library as *managed images*.

Move or Copy Images

Obviously, you don't want to import an image as a referenced image directly from a media card. Instead, it first needs to be copied to your hard drive. There are two ways to handle this initial transfer: The first option is to copy the images yourself using the Finder. Place the images wherever you want them, and then choose "In their current location" from the Store Files pop-up menu when importing.

However, Aperture can also handle this copy step for you. In the Store Files pop-up menu in Aperture's Import dialog, select the Choose option. Aperture will present you with a standard Open dialog, which lets you choose any folder that you want.

Note that when you select a folder this way, the Move and Copy buttons below the Choose menu become active. These let you specify whether you want the images copied into the specified location, or moved there.

After moving or copying, Aperture will import the images as references. The advantage to importing this way is that in one step, you can copy your images from your card to a specific location on your drive, import them as referenced images into Aperture, and use all of Aperture's other import features to automatically add metadata to your images during import.

Finally, the Choose menu provides one other option. If you choose Pictures, Aperture will automatically copy or move your images into your Pictures folder, just as if you had selected it using the Choose option.

What You Can Do with a Referenced Image

Just as with managed images, you can rate referenced images, sort and arrange them, stack them, move them from project to project, and edit their metadata. The only thing you can't do with referenced images is add any image adjustments.

This means you can perform all of your organizational tasks, from arranging projects to adding keywords and metadata, without having your original master files on your computer.

Later, we'll look at a few different ways that you can use this capability to build your library in a way that makes it easy to take files on the road and move them from computer to computer. First, we need to address a few more issues that may arise with referenced images: fixing broken links, locating original images, converting referenced images to managed images, and vice versa.

Repairing a Broken Link

Aperture is very good at keeping track of original files as you move them around, which means it's difficult to break a link to a referenced image. However, if you do break a link, Aperture will show this badge to indicate that the link has been broken.

The most common way that a link gets broken is if a master image is stored on an external hard drive and you forget to turn on the drive where the image is stored. If you see a broken link badge, make sure all of your drives are powered up. If a drive was off, turning

it on will usually fix any broken links. If that still doesn't fix it, Aperture provides some special tools for reconnecting broken links.

1 When you see an image with a broken link badge (or a range of images with broken links) select them, and then choose File > Manage Referenced Files.

Aperture will display the Manage Referenced Files dialog. The files you selected will be listed in the middle list at the top of the dialog.

2 If you haven't already, click the Show Reconnect Options button to display the file path selector.

3 Using the selector, navigate to the location of the original files.

4 Click the original file, and then click the Reconnect button.

5 If all of the images you need to reconnect are in the same folder, then click the Reconnect All button. Aperture will relink the files.

6 Click Done to close the Manage Referenced Files dialog.

You should now see that none of your referenced images are showing a broken link badge.

Finding Your Original Images

When working with referenced images in Aperture, you may find at some point that you want to locate the original image, although its location may not be immediately apparent. If you select a referenced image in Aperture, and want to access the original file (perhaps you want to copy it, or use it in another application), do the following:

1 Select File > Show In Finder.

The Finder will come to the front and a window will open containing the original file.

Converting a Referenced Image to a Managed Master

There might be times when you want to convert an image that you've imported as a reference into a managed master. For example, you may want to convert some (or all) of your referenced images into managed masters so that they can be backed up to a vault. Or maybe you just got a bigger hard drive and so want to have all of your images in one place, on that new drive.

You can easily convert a referenced image to a managed master by doing the following:

1 Select the image(s) in Aperture and choose File > Consolidate Masters.

Aperture will present a dialog asking whether you want to move the masters into the library or copy them into the library.

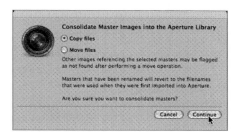

2 Choose copy to leave the original files where they are, or choose Move to delete the original files after they're moved into the Aperture library.

Converting a Managed Master to a Referenced Image

Just as you can convert a referenced image to a managed one, you can also turn an image that's stored in the Aperture library into a referenced image. When you do this, the image is moved from within the Aperture library to a location of your choice, in any folder of any volume connected to your Mac. A pointer is then stored to this image, just as if you'd imported it as referenced.

To convert a managed master to a referenced image, do the following:

1 Select the image(s) in Aperture, then choose File > Relocate Master.

Aperture will present you with a dialog that allows you to choose the location where you want the master image stored.

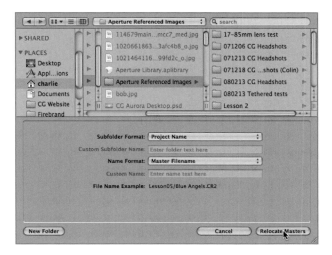

2 To tell Aperture to create a folder structure, or to rename the master images, use the same controls that you find in the Import dialog.

When the command is finished, your files will be in their new location, and Aperture will show referenced badges on their thumbnails.

TIP ▸ You can also use Relocate Masters to move an original referenced file from one location to another. For example, say you import some images as references from a drive called Drive A. Later, you decide you want those masters located on a drive called Drive B. You can use Relocate Masters to move the master images to Drive B. In Aperture, your image will still appear as a referenced file. Aperture itself won't behave any differently because you've moved the files, so you can routinely move master images around without upsetting your normal workflow.

Managing Previews

One of the things that happens when you import an image as a referenced master is that Aperture creates a JPEG preview file and stores it inside its library. This means that even if the original master file is not available, Aperture still has a high-quality image to display. This is why it's possible for you to work with your library even when the master images aren't available.

You can control the pixel dimensions of the previews, as well as how much JPEG compression should be applied. If you want, you can create full-resolution previews that have the same pixel dimensions as your original files, which will allow you to view fine details even when your master images are offline (unavailable). Or you can specify lower-resolution previews with more compression so that you can fit more preview images onto your drive.

1 To set the size and compression settings for Aperture's previews, open the Preferences window and select the Previews tab.

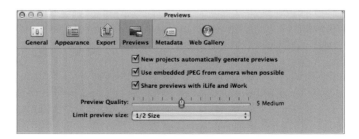

The Preview Quality slider lets you select the amount of compression that's applied to the preview, while the Limit Preview Size pop-up menu lets you select the size of the preview.

The three checkboxes should be selected by default. Their functions are as follows:

▶ "New projects automatically generate previews" tells Aperture to always build new previews when images are imported. You can disable this if you need a little more speed out of Aperture.

▶ "Use embedded JPEG from camera when possible" tells Aperture to use any JPEGs that the camera might have embedded in the image, rather than generating its own. This can speed up image display, but the embedded previews might not look as good as the ones that Aperture would create on its own.

▶ "Share previews with iLife and iWork" is required if you want to be able to use the Media Browser in those applications.

Aperture will also let you regenerate previews for images that are in your library. If you start to run out of disk space, you may find that rebuilding previews at a lower pixel count, or with more compression, will free up some additional space. Building previews can take time, of course, so you may want to limit your construction of new previews to only images that are older, or that you're not using at the moment. You'll need to have access to the original master files to create new previews.

2 To build new previews for a set of images, select the images.

3 Hold down the Option key and open the Images menu. The Update Preview command changes to Generate Preview.

4 Choose Generate Preview.

TIP ▶ You can also discard previews altogether. For example, maybe you have a lot of stacks that have Picks that you're certain about, and so you don't necessarily need to see the alternates for those images when you're on the road. To discard the previews for those images, select the images, and then choose Images > Delete Preview. Aperture will completely delete the preview, freeing up space.

Library Architecture Strategies

Because you can import images as managed or referenced, and because you can do a lot of work with referenced images even if their masters are offline, and because Aperture provides so many tools for managing and moving master files and referenced masters, there are a lot of ways to build your Aperture library. In this section, we'll look at a few different options and approaches to library management in Aperture.

Designing Large Libraries

By default, Aperture is set to copy all images into its library. This means that, by default, your Aperture library can't be any larger than the amount of free space you have on the drive that contains the library. Depending on the size of your drive, this could mean that your library will quickly fill up.

You can work around this problem in two ways. First, you can keep multiple libraries. Aperture's Preferences window lets you specify where the Aperture library is, so there's no reason you can't keep multiple libraries on different drives.

1 To change the location of the Aperture library, choose Preferences. The Preferences window opens.

 The first item in the General tab is Library Location.

2 Click the Choose button. Aperture presents you with a standard Open dialog.

3 Navigate to the folder where you'd like your new library stored, and click the Choose button.

4 Quit Aperture, and launch it again.

When Aperture opens you should see a completely empty library. Aperture has not deleted the images from your old library. Your old library is still sitting, intact, in its original location. Instead, it has created a new library package at the location you specified.

5 In the Finder, open the folder that you selected from the Preferences window. You'll find your new library there.

> **TIP** You can switch back and forth between libraries at any time by quitting Aperture and then double-clicking the library you want to work with. Aperture will launch using that library. Note that Aperture's preferences will be changed to open that library next time you launch the program.

Creating Separate Libraries on Multiple Drives

The ability to create new libraries means you can create separate libraries on multiple drives. So, for example, you might keep all of your personal work on one drive, and all of your professional work on another. Or you could have one drive with a library dedicated to landscape photos, and another drive with a library dedicated to street shooting.

Although this approach allows you to circumvent Aperture's single-drive library limit, it's not the most convenient way to work. With multiple libraries, there's no quick and easy way to move images from project to project, and there's no way to perform searches across *all* of your images, because they're scattered across multiple libraries.

A much better way to go is to exploit Aperture's ability to import images as referenced files. If you want some images stored on another drive, just copy them to that drive, and then import them as references into Aperture. You can have images spread over as many drives as you want, and Aperture will keep track of them. Later, if you want to move them, you can use the Relocate Masters command to move the original files to another folder, or an entirely different drive.

In this way, you can think of Aperture as kind of a Finder replacement (or as an image-specific Finder). You can browse for images using Aperture, and then use Relocate Masters to copy or move the images as you need. This makes it simple to manage a huge library that's spread over multiple drives.

However, unlike a multiple-library approach, keeping all of your images in one library means you can easily search across every image that you have.

And, of course, you can freely mix and match managed and referenced images, or change images from one type to the other.

Designing Libraries for Desktop/Laptop Workflow

For photographers on the go, Aperture is a great road tool. Because you can quickly get images in and display them side by side, Aperture provides a speedy way to assess the day's shoot. However, on-the-go work happens on mobile computers, and laptops typically have smaller hard drives than desktop machines, as well as smaller screens. Also, serious color-matching work can be trickier on a laptop screen, as they don't always have as broad a gamut as a desktop monitor.

You can work around the drive-size issue by keeping your images on an external drive, and then importing them as references into your Aperture library. But this means you have to carry around an external drive.

A better solution, which addresses all of the problems mentioned here, is to have a desktop Mac at home, where you can use a big monitor, and multiple large hard drives. Your Aperture library will live on this machine, and you will import *all* of your images as references. Once you have them all imported, copy the Aperture library to your laptop. By default, Aperture's preferences dictate that the Aperture library should be in the Pictures folder. (If you already have a library there, then you'll want to copy your new library to a different location.)

Because your copied library has preview files for all of the images that you've imported, you can now take your library on the road and perform all of the sorting, organizing, rating, and metadata edits that you want. You can even mail low-resolution copies of images, because your preview files are probably bigger than what you need for an email.

If your library won't fit on your laptop drive, then you'll need either to clean off space on the drive, or to rebuild your previews at a higher compression rate, or with lower pixel dimensions.

Creating New Projects on the Road

On your laptop computer, you'll create projects as normal. Depending on the amount of space you have available, you can either import the images into the Aperture library, or store them on an external drive and import them as references. Obviously, if you're trying to travel light, it's more convenient to store them in the Aperture library (assuming your library is located on your internal drive).

Syncing Your Libraries

When you get back home, you'll need to make sure that you copy any changes you've made on the road to your desktop Mac—including any new projects that you've created on your laptop, any new images that you've imported, and any changes that you've made to organization or metadata in any projects. Aperture doesn't provide any built-in facility for syncing multiple libraries, but you can easily copy your changes using a simple command.

If you created a new project on your laptop, and loaded it with images, you'll want to get the project and the images back to your desktop Mac. The easiest way to do this is to export the project.

1 To export a project, select the project in the Projects inspector, then choose File > Export Project.

If the project contains only managed images, then those will be included in the exported package.

If the project contains referenced images, then you have a few options. You can copy the original masters by hand from their location on your laptop to a location on your desktop machine, or you can select the "Consolidate images into exported project" checkbox. This will create a package that has the entire project, including all of the master images.

2 Once the file is exported, copy it to your desktop machine.

3 To import the project file into Aperture, select File > Import > Projects, navigate to the project, and click Import; or drag the project from the Finder into the Projects inspector.

 Aperture will copy the project into your Aperture library. If it contains master images, then they will be copied into the library as managed images. If it contains referenced images, and you moved the images by hand to a drive on your desktop machine, then you will need to use the Manage Referenced Files dialog to connect the images in your project to the master images that you copied over.

4 One the import is finished, delete the project file that you copied from your laptop.

 NOTE ▶ Keep in mind that you'll need to go through this process for any project that you edit on your laptop. If you edited some metadata or ratings or re-arranged some photos, you'll need to move those projects back to your desktop Mac as well. Before you import into your desktop library, delete any existing copies of the project that you're moving.

Between referenced images, the ability to import and export projects, and Aperture's controls for managing referenced files, you should find that you can easily move select portions of your library from machine to machine, making it easy to spread your work across multiple machines.

Aperture and iPhoto Integration

For many iPhoto users, switching to Aperture is a natural progression. Aperture offers versatile photo editing and management tools that create a powerful but easy-to-use working environment. You can easily import images from a memory card or even from a camera directly connected to your computer. Aperture quickly displays image thumbnails and lets you intelligently organize images by adding copyright, captions, keywords, and other metadata as you import images.

Aperture allows you to store your images however you want—directly in the Aperture library, on external hard drives, or even on a network. Aperture can track all of the images and allows for even greater organization though the use of folders, projects, albums, and Smart Albums. With intelligent organization tools it's possible to search for specific images in a large photo library. In fact, you can even sort by camera model or image adjustments made.

Although iPhoto offers great controls for image adjustment, Aperture contains several more powerful tools. Aperture is designed to make your good photos look great with easy-to-use image adjustments. You can quickly straighten, crop, or even flip an image. Controls like Vibrancy and Definition help create enhanced detail and saturation. Additionally, Aperture is perfect for handling RAW images with its precise controls for RAW decoding and image enhancement.

Nondestructive Image Processing

Both Aperture and iPhoto offer nondestructive image processing. At any point during the image adjustment process you can restore your image to its original state. Although both iPhoto and Aperture feature nondestructive imaging, they take a different approach to achieve it.

iPhoto

iPhoto gives you several ways to make adjustments. When the adjustments are applied, iPhoto creates a new copy of the master image and applies the effects. This creates two copies of the image in your library.

In the future, you can choose to restore an image to its original state. You can also return to the edited image and modify your settings. When you finish editing, the second image is updated in your library.

The iPhoto workflow is designed to offer flexibility while protecting the user. Unlike Aperture, which allows multiple versions of an image, iPhoto allows for only one. If you want to create another look, you must duplicate the image (Command-D), thus adding another copy to your hard drive.

Aperture

Aperture's image adjustments are designed to offer professionals the control they need. Aperture adjustments can be easily adjusted or even disabled in an individual manner. Adjustments can also be stored as presets so they can be reused in the future. Aperture can even store multiple versions of an image, which allows you to experiment with adjustments.

Aperture's image library is also much more flexible than iPhoto's. You can choose to use a managed library or simply reference images based on their current location. This allows for images to be located on multiple drives and can greatly cut down on the disk space required to store your photos. Additionally, Aperture offers several ways to archive your library and projects to ensure that your images are thoroughly backed up.

Importing iPhoto Images into Aperture

As an iPhoto user chooses to migrate to Aperture, they'll likely have a large library of images to bring with them. Aperture offers two easy ways to migrate iPhoto images into your Aperture library. Which method you select will vary depending upon your needs.

Migrating an Entire iPhoto Library

When you launch Aperture for the first time, a dialog offers to let you import your entire iPhoto library. You can choose to copy the images into your Aperture library or to simply reference the images in their current location. Even if you choose not to import your Aperture library the first time you launch, you can do so at any time.

TIP ▶ If you'd like to take advantage of Aperture's Vault feature for backing up photos, migrate the images and import them into your Aperture library.

Because Aperture and iPhoto are both manufactured by Apple, the two programs are designed to share information seamlessly. For example, any organization you did to create albums in iPhoto will translate into projects in Aperture. The EXIF, keywords, ratings, and applied adjustments are also maintained.

NOTE ▶ You must upgrade to iPhoto 5.0.4 (part of iLife '05) or a later version to import your library. Although you can import most items from iPhoto, you can't import slideshows, books, or Smart Albums.

Importing an iPhoto library is very easy. To import your iPhoto library, do the following:

1 Choose File > Import > iPhoto Library.

Aperture navigates automatically to your current iPhoto library.

2 Select the iPhoto Library folder using the file browser.

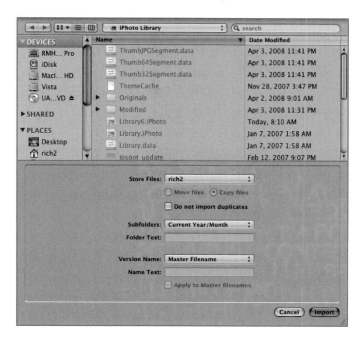

3 Choose the location where you'd like Aperture to store your images.

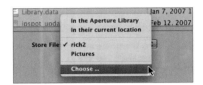

▶ Choose "In the Aperture Library" from the Store Files pop-up menu to store imported masters in the Aperture library. This will allow Aperture to manage the images in its library architecture.

▶ Choose "In their current location" from the Store Files pop-up menu to import the files as referenced images. This means the files are stored in their current locations on your hard drive.

▶ Choose "Pictures" from the Store Files pop-up menu to store imported masters in the Pictures folder for the current user. The images are treated as referenced images.

▶ Choose "Choose" from the Store Files pop-up menu and pick a folder where you want to store the imported masters as referenced images. You can also specify an organization method for the images by clicking the Subfolders pop-up menu.

NOTE ▶ If you choose to import images from your iPhoto library into your Aperture library, you'll end up with two copies on your hard drive. This can double the amount of disk space each copied image uses on your computer. After importing your iPhoto images, you may choose to delete your images from iPhoto.

4 Specify a naming convention from the Version Name pop-up menu.

You can choose Master Filename from the Version Name pop-up menu to store your images using the current master filenames assigned by the camera. There are also several options for assigning custom names.

5 Click Import to add the images to your Aperture library.

TIP ▶ If you're unsure about importing your entire iPhoto library, you can choose to import individual albums or Events.

Browsing an iPhoto Library

Aperture offers an iPhoto Browser to let you review iPhoto images and import specific images, albums, or Events into the Aperture library. The iPhoto Browser is a handy way to look at your iPhoto library without having to import your entire iPhoto library.

The iPhoto Browser lets you view your iPhoto library Events as a grid. If you click an album or item in the upper list, you can view the images as a list as well as see all albums in a grid, list, or detailed view.

To open the iPhoto Browser and select images, do the following:

1 Choose File > Show iPhoto Browser (or press Command-Option-I).

2 Select the iPhoto Event or album that you want to work with.

TIP ▶ Just as in iPhoto, you can slowly drag a cursor over an Event to see a quick preview of its contents. You can show larger image previews by dragging the slider at the bottom of the iPhoto Browser.

3 Double-click an Event or single-click an album to see its contents.

NOTE ▶ If you want to see a larger preview of an image in the iPhoto Browser, double-click its thumbnail. A new preview window will open that can be easily resized by dragging the lower-right corner. You can click the Next Image and Previous Image buttons to display other images in the Preview window.

4 Select the images you want to import. You can drag with the pointer to select multiple images or hold down the Command key and click multiple images.

5 Once the images are selected, drag them into an existing or new project in your Aperture library.

6 Aperture adds the images to your managed image library.

> **TIP ▶** If you hold down the Command and Option keys when dragging, Aperture will import from the iPhoto Browser as referenced images.

Integrating Aperture with Your Mac

Choosing to organize your images in Aperture is not a limiting choice. You can easily access your Aperture library from iPhoto, the rest of the iLife applications, and even iWork. This ensures that you can use your photos to create a variety of media-rich projects. The exact way you access images varies slightly for each application, but is easily learned and well covered in each application's Help Menu.

> **TIP ▶** If you're interested in integrating your Aperture library with iLife and iWork, be sure to complete Lesson 11.

Integrating Aperture with iPhoto

An Aperture user may choose to return to iPhoto initially because of its familiarity. iPhoto offers additional book templates that are more consumer- or theme-oriented. The iPhoto books do not support the custom-sized options that Aperture does, but they do offer additional options including more themes and a wirebound option. Additionally, you can create items like cards and calendars for gifts.

To access your Aperture library from iPhoto, do the following:

1 Choose File > Show Aperture Library.

The Aperture Photos window opens. You can now browse your Aperture library.

Click the disclosure triangle next to Aperture or an album name to see more details. Additionally, you can use the search field at the bottom of the library.

2 Select one or more images in the Aperture Photos window and drag them into your iPhoto Library window.

> **NOTE ▶** iPhoto adds a duplicate of your selected photo (or photos) to iPhoto. Although the images are identical, they're independent. Deleting or modifying the image in iPhoto will not affect Aperture (and vice versa).

3 When finished, close the Aperture Photo window by clicking the red button in its upper-left corner.

Integrating Aperture with iLife and iWork

Not only can you easily see your Aperture library in iPhoto, but you'll also find that it appears in all of iLife, iWork, and even several third-party software tools. This makes it easy to integrate photos into a variety of media-rich projects.

▶ **iWeb**—You can use iWeb to create a media-rich website for sharing your photos. If your photos aren't visible, choose View > Media Browser, and then click the Photos button. Your Aperture library will appear in the list of sources and can be browsed. We explore this option in Lesson 11.

▶ **GarageBand**—You can create podcasts using your photos. If your photos aren't visible, click the View Media Browser button at the bottom of the main window and then click the Photos button. Your Aperture library will appear in the list of sources and can be browsed.

▶ **iMovie**—You can use photos in your edited iMovies. Choose Window > Photos to browse your Aperture and iPhoto libraries.

▶ **iDVD**—You can create a DVD slideshow using your images. If your photos aren't visible, click the Media button at the bottom of the main window, and then click the Photos button. Your Aperture library will appear in the list of sources and can be browsed. We explore this option in Lesson 11.

▶ **Pages**—Pages is a word processing and page layout program that's part of iWork. You can use your images in all sorts of print projects including business communication, personal letters, and more. If your photos aren't visible, choose View > Media Browser,

and then click the Photos button. Your Aperture library will appear in the list of sources and can be browsed. We explore this option in Lesson 11.

▶ **Keynote**—Keynote is a slideshow application that's part of iWork. It makes it easy to add your images to an electronic portfolio or business presentation. If your photos aren't visible, choose View > Media Browser, and then click the Photos button. Your Aperture library will appear in the list of sources and can be browsed. We explore this option in Lesson 11.

▶ **Numbers**—Numbers is a spreadsheet application that's part of iWork. You can use Numbers to organize your data and present it in a visual way; in fact, Numbers supports the use of photos as easily as Pages or Keynote. If your photos aren't visible, choose View > Media Browser, and then click the Photos button. Your Aperture library will appear in the list of sources and can be browsed.

▶ **Mail**—You can easily browse your Aperture library directly in Mail under OS X Leopard. Simply create a new message, and then click the Photo Browser button. You'll then see your Aperture and iPhoto libraries. You can drag any images you'd like into a message as an attachment or use Leopard's Stationery options for HTML formatted email with photos.

The tight integration of Aperture, iPhoto, and all of the Apple software on your computer ensures that you can easily access your media library. As an experienced iPhoto user, you'll find Aperture an easy transition and one that's worth making for its powerful tools and professional workflow. Your Mac will make it easy for you to develop your own workflow, whether you choose a total conversion from iPhoto to Aperture or prefer to work with both applications simultaneously.

Index

John Fleck *Photography*^{Inc}

www.johnfleck.com 317.514.1800 john@johnfleck.com

The Apple Certified logo

The Apple Pro Training Series

The official curriculum of the Apple Pro Training and Certification Program, the Apple Pro Training books are comprehensive, self-paced courses written by acknowledged experts in the field. Focused lessons take you step by-step through the process of creating real-world digital video or audio projects, while lesson files on the companion DVD and ample illustrations help you master techniques fast. In addition, lesson goals and time estimates help you plan your time, while chapter review questions summarize what you've learned.

Final Cut Pro 6
0-321-50265-5

Cut a scene from the USA Network television series *Monk*, create a promo for Seaworld's *Belief* documentary, master filters and effects as you edit a segment of BBC's *Living Color*. In this best-selling guide, Diana Weynand starts with basic video editing techniques and takes you all the way through Final Cut Pro's powerful advanced features. You'll learn to mark and edit clips, mix sound, add titles, create transitions, apply filters, and more.

Final Cut Pro 6: Beyond the Basics
0-321-50912-9

Director and editor Michael Wohl shows how to master advanced trimming techniques, make polished transitions, work with nested sequences, edit multi-camera projects, create fantastic effects, color-correct your video, and composite like a pro. Also covers Soundtrack Pro, and managing clips and media.

The Craft of Editing with Final Cut Pro
0-321-52036-X

Superbly fitted to a semester-length course, this is the ideal curriculum for a hands-on exploration of advanced editing. Director and editor Michael Wohl shares must-know techniques for cutting dialogue scenes, action scenes, fight and chase scenes, documentaries, comedy, music videos, multi-camera projects, and more. Two DVD-9s of professional footage and project files give students the chance to work with every genre as they learn.

Motion Graphics and Effects in Final Cut Studio 2
0-321-50940-4

This practical approach focuses on just the parts of Final Cut Studio that editors and designers need to create motion graphics in their daily work.

Motion 3
0-321-50910-2

Top commercial artists show you how to harness Motion's behavior-based animations, particles, filters, effects, tracking, and 3D capabilities.

Soundtrack Pro 2
0-321-50266-3

Audio producer Martin Sitter is your guide to the only professional audio post application designed specifically for the Final Cut editor.

DVD Studio Pro 4, Second Edition
0-321-50189-6

Learn to author professional DVDs with this best-selling guide. Build three complete DVDs, including the DVD for the Oscar-nominated *Born into Brothels* documentary.

Color
0-321-50911-0

This guide to Apple's masterful new color grading software starts with the basics of color correction and moves on to the fine points of secondary grading, tracking, and advanced effects.

Apple Pro Training Series: Logic Pro 8 and Logic Express 8
0-321-50292-2

Create, mix, and polish your musical creations using Apple's pro audio software.

Apple Pro Training Series: Logic Pro 8 Beyond the Basics
0-321-50288-4

Comprehensive guide takes you through Logic's powerful advanced features.

Apple Pro Training Series: Shake 4
0-321-25609-3

Apple-certified guide uses stunning real world sequences to reveal the wizardry of Shake 4.

Encyclopedia of Visual Effects
0-321-30334-2

Ultimate recipe book for visual effects artists working in Shake, Motion and Adobe After Effects.